MOBY-DICK
IN PICTURES

MOBY-DICK

IN PICTURES

ONE DRAWING FOR EVERY PAGE

MATT KISH

Tin House Books / Portland, Oregon & New York, New York

For my wife, Ione. I'm finally finished!

Published by Tin House Books, Portland, Oregon, and New York, New York
Distributed to the trade by Publishers Group West, 1700 Fourth St., Berkeley, CA 94710, www.pgw.com

First U.S. edition 2011
Interior design by Janet Parker, Diane Chonette, and Alexandra Boyd

www.tinhouse.com
Printed in China

FOREWORD

by Matt Kish

Really, I just wanted to make a version of *Moby-Dick* that looks like how I see it. That's all.

I've been obsessed with *Moby-Dick* for most of my life. Although it has drifted in and out of my mind, it has never disappeared entirely. My first encounter with the White Whale was the classic 1956 film of the same name starring Gregory Peck as Captain Ahab. I remember seeing bits and pieces of it at my grandmother's house on one of the many Saturday afternoons I spent with her as a child in the mid-1970s. I was smitten. I already had a voracious appetite for any and every monster movie I could lay my eyes on, but here was something new and shocking—a monster that could almost have been real!

Some family member must have been paying attention, because soon after that I was given a tiny square paperback version of the novel. Heavily abridged, it was printed on cheap newsprint with inky, scribbly black-and-white illustrations on every other page. I must have read that book a dozen times, and I probably spent more hours looking at the pictures than I did reading the words. Some of those images are embedded so deeply in my memory that I can see every line of them

simply by closing my eyes, and, not surprisingly, a few of my own illustrations for this project were made in homage to them.

It wasn't until 1984, when I was a freshman in high school, that I read the unabridged novel for the first time. I'm not quite sure what I expected, but I will admit to being a bit surprised by how dull some of it seemed to me. The characters were as vivid as I had remembered, and the chapters describing the chases and the battles with the mighty leviathans were visceral and thrilling, but I wasn't prepared for the lengthy digressions on the history and nature of the American whaling industry or the dry, semiscientific expositions on the nature of the whale. Still, I pushed my way through it, partly out of an adolescent sense of pride in reading what most of my school friends vocally derided, and in the process I was truly hooked (or harpooned!) for life. While I didn't get much out of that first reading that I hadn't already gotten from watching the film, I sensed that there was more lurking beneath the words, and I knew it was a story I would come back to again and again.

Since then, I've read the book eight or nine times: again in high school, several times as an undergraduate, a few times while working as a high school English teacher and as an assistant manager in a bookstore, again in graduate school, and most recently while making these illustrations. Each and every reading has revealed more and more to me and hinted tantalizingly at even greater truths and revelations that I have yet to reach. Friends often question my obsession with the novel, especially since I am not a scholar or even an educator any longer, and the best explanation I have been able to come up with is that, to me, *Moby-Dick* is a

book about *everything*. God. Love. Hate. Identity. Race. Sex. Humor. Obsession. History. Work. Capitalism. I could go on and on. I see every aspect of life reflected in the bizarre mosaic of this book.

Paralleling my lifelong obsession with *Moby-Dick* is an equally obsessive, almost frantic appetite for images. I spent my childhood in a household full of garishly colored and fantastically exaggerated 1970s album covers, bookshelves packed with fantasy and science fiction paperbacks, children's books on monsters and dinosaurs, comics running the gamut from the Bronze Age madness of Jack Kirby to the European exoticism of *Heavy Metal* magazine, and early video games like *The Legend of Zelda* and *Kid Icarus*. I simply couldn't get enough, and my head became a seemingly limitless warehouse for these images. It wasn't much of a leap for me to begin drawing, or at least trying to draw, monsters and spaceships and dinosaurs, but I was often frustrated at my inability to create art that looked as good as what I saw in my books and comics. Over the years, I tried my hand at building a darkroom and printing my own 35mm black-and-white photos, drawing and xeroxing my own comics and zines, and illustrating my own personal mythology. While the results were predictably mixed, the process always felt good, and eventually I started to like what I was making more often than not.

Despite these parallel obsessions, I never thought about illustrating *Moby-Dick*. Then I spent a summer of boredom and creative restlessness, wanting to do something but unsure of what. Most of the art I was making had become painfully overwrought and so detailed that it was no longer fun to create. A good friend of mine from college reminded me of how often he and I used to talk about Melville

and *Moby-Dick*, and that comment sparked something. I was already aware of, and in awe of, Zak Smith's illustrations for every page of Thomas Pynchon's novel *Gravity's Rainbow*, and the idea of something that nakedly ambitious appealed to me enormously. I don't know if Smith was the first artist to illustrate every single page of a novel, but he was certainly the first I knew about. Within a day or two, by a process I still can't quite explain, I decided I would create an illustration for every single page of *Moby-Dick*.

It's important to know that I do not consider myself an artist. In spite of all the drawing and photography and comics I have worked on over the years, I have no formal artistic education. However, I have never viewed this as a limitation, and for this project it was actually quite liberating. Since I have never had to depend on art for an income, I have always been able to make whatever kind of art I want. The work is for me. Still, I knew how easy it would be to give up on the project if I didn't set at least some rules for myself.

The version of *Moby-Dick* I decided to use for this project is the Signet Classics paperback edition with the Claus Hoie painting *Pursuit of the Great White Whale* on the cover. So many editions of the novel have boring historical illustrations on the cover; this one really appealed to me for its fearless modernism. The Signet edition has 552 pages, and the first chapter starts on page one, so it was a perfect fit. To force myself to learn new ways to make art that wasn't so overly detailed and stiff, I decided to challenge myself to make one illustration per day. I would simply have to find ways to be creative each and every day for 552 days in a row, until I reached the end of the book. The only other rule I set for myself was to move

through the novel in a linear manner, starting with page one and ending with page 552. I wanted to see how my art would change during the year-and-a-half-long journey. Beyond that, I freed myself to do just about anything I wanted. I could and would use any media, from ballpoint pen to crayon to acrylic paint to stickers and collage. I wouldn't limit myself to a specific size, a specific orientation, or even a specific style. I would take each image as it came and do what I wanted with it, fitting them all into the mosaic narrative of Melville's complex and mighty book.

When I was in grad school, I worked in a used bookstore where we had boxes and boxes of paper ephemera. These pages always fascinated me, especially the diagrams, electrical repair charts, and maps. I started taking a lot of them home, thinking there had to be some better fate for them than the dumpster. I had experimented with painting robots on the more abstract television repair diagrams, and I was fascinated with the way certain elements of the diagrams showed through the paint, almost at random. To me, this hinted at a greater complexity and a hidden structure. When it came time to begin the *Moby-Dick* project, I thought back to those robot paintings and decided to use my supply of found paper as backgrounds for the illustrations. Melville's book is so densely, deeply, and at times confusingly layered with narrative and symbolism that I wanted to mirror that structure in the art I was making. With each image, I wanted there to be bits of text or strange lines and pictures showing through the paint or peeking around a sailor or a harpooneer to hint to the viewer that there is much more to all of this than he or she might see at first. Also, in a world absolutely saturated with digitally created content, where original art often doesn't exist as a physical object but is

instead simply a JPEG on a computer somewhere, it was deeply important to me to reconnect these *Moby-Dick* illustrations to the older and more physical world of books and printing. Much of the paper I had stockpiled was faded, discolored, stained, and even creased, but I wanted the art to show the signs of human hands, the presence of years, and the marks of hard use.

I started the illustrations on August 5, 2009, and began posting them on my blog immediately, so that I could share the project with friends and family who were out of state and wouldn't get to see the work in person. I had no idea what was in store or how soon everything would change. Within a day or two, bloggers and *Moby-Dick* aficionados were leaving comments for me, sending encouraging e-mails, and even asking to interview me. All this attention was quite a shock. Then, just a few short months after beginning this project, my wife and I moved from our relatively comfortable and spacious apartment twenty minutes from where we each work to a single room in a shared house ninety minutes from where we work. Not only would I be spending three hours in the car every workday, but I also had to move my drawing table, stacks of found paper, and all my art supplies into a closet that measures about three feet wide by six feet deep. There was just enough room to slide the table inside; I had to shut the door to sit down and draw. I painted the walls a beautiful warm turquoise blue, which helped, but it was still a closet, and I still had almost five hundred pages to go. It wasn't easy. There were many late evenings when I was exhausted, doubtful of my ability to go on, and full of regrets about what I had gotten myself into. I thought about giving up. Sometimes I hated the whole thing. But after the first hundred pages, the burden seemed lighter, and when I was feeling

crushed by the weight of the task, I would look at all of the illustrations I had made so far and that gave me the drive to continue.

Since the entire endeavor was so deeply personal, I was able to explore what the novel truly means to me. Through every reading, I simply could not fathom how these whalers would willingly give up the comforts of a warm bed in a tidy home on dry land to sail the unknown seas for years at a time, battling the most colossal and brutally powerful creatures on earth with little more than iron spears and rope. That kind of courage and strength seemed to me almost inhuman, so when it came time to depict my first whaler, I was unable to see him as anything other than a thing of iron, almost resembling a ship. All of the whalers and sailors became abstract, metal, shiplike constructs, while the harpooneers were pure predators of flesh and blood. The whales were monsters, each and every one of them, and the seas that the *Pequod* sailed upon were as mythical as any fabled fantasy land.

Page after page flew by, and more and more people found out about the project. Eventually I was invited to Brooklyn to give a talk about my obsession. The illustrator Sophie Blackall, herself a whale obsessive and Melville admirer, read about my presentation, and although she was not able to attend, she did visit the blog and e-mailed me some very kind words. She suggested that her friend, an agent, look at the work, and he contacted me as well. I had never expected any of this, and initially I was suspicious of the entire thing, but the agent earned my trust and convinced me that turning the project into a book was possible. Amazingly, within a month, a deal was struck for the book you now hold in your hands. And I had completed only half of the illustrations.

The second half was even harder to complete. At first, I had identified with Ishmael, feeling like a passenger, a silent observer, on a doomed journey that I had no real control over. But as I started working through the second half of the book, I began to identify more and more with Ahab, obsessed with the idea of the White Whale and the task of finally finishing the art and slaying the monster. I worked harder and harder each day. I lost sleep. I drew in the car while my wife drove us home from work. I ate my meals in minutes and rushed back to the closet studio to keep drawing and painting. It was all I could think about, and it started to devour every waking moment.

And then, suddenly, I was done. Five hundred and forty-three days after I began, I put down my pens for the final time. I knew it was coming, but nothing could have prepared me for the awful finality of it. In spite of the dark times, the exhaustion, the anger, the helplessness, and the obsession, it was almost heartbreaking to say good-bye. These characters, Ishmael and Ahab, Queequeg and Pip, Starbuck and Stubb, had been my companions most of my life and had never been closer to me than during the long year and a half I spent illustrating their adventures. I would miss them.

In the end, I am proud of what I was able to do. I look back at these illustrations and I can see flaws. I can see what I might like to change, and I can see where I may have stumbled, but ultimately I believe they are good. This is how *Moby-Dick* looks to me. This is the book I have always envisioned.

MOBY-DICK IN PICTURES

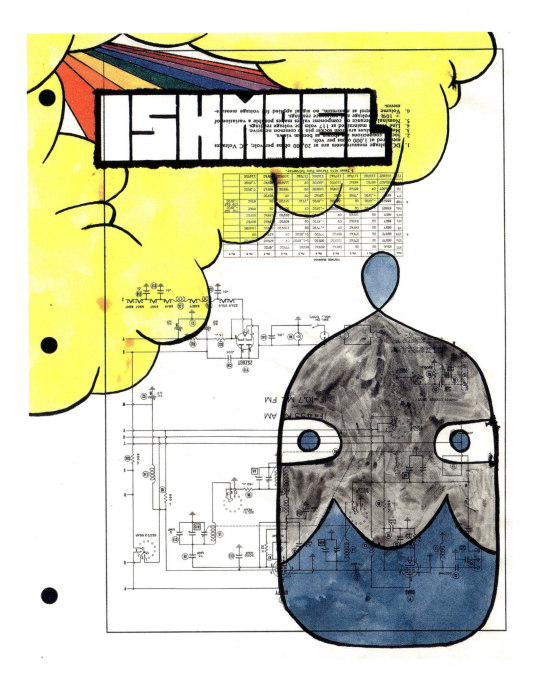

1

Call me Ishmael.

COLORED PENCIL AND INK ON FOUND PAPER
8.5" × 11"
08/05/09

2

But look! here come more crowds, pacing straight for the water, and seemingly bound for a dive.

COLORED PENCIL AND INK ON FOUND PAPER
7.75" × 11"
08/06/09

3

It is the image of the ungraspable phantom of life; and this is the key to it all.

ACRYLIC PAINT, BALLPOINT PEN AND
COLORED PENCIL ON FOUND PAPER
7.75″ × 11″
08/07/09

4

*What of it, if some old hunks
of a sea-captain orders
me to get a broom and
sweep down the decks?*

ACRYLIC PAINT, HIGHLIGHTER
MARKER AND INK ON FOUND PAPER
7.75" × 11"
08/08/09

5

…this the invisible police officer of the Fates, who has the constant surveillance of me, and secretly dogs me, and influences me in some unaccountable way…

ACRYLIC PAINT AND INK ON FOUND PAPER
7.75″ × 11″
08/09/09

6

*Chief among these motives
was the overwhelming idea
of the great whale himself.*

**ACRYLIC PAINT ON FOUND PAPER
7.75″ × 11″
08/11/09**

7

With anxious grapnels I had sounded my pocket, and only brought up a few pieces of silver…

**COLLAGE, COLORED PENCIL AND SPRAY PAINT ON FOUND PAPER
7.75" × 11"
08/12/09**

8

*...and beyond, a black
Angel of Doom was beating
a book in a pulpit.*

**BALLPOINT PEN, COLORED PENCIL,
INK AND SPRAY PAINT ON FOUND
PAPER**
7.75" × 11"
08/13/09

9

...where that tempestuous wind Euroclydon kept up a worse howling than ever it did about poor Paul's tossed craft.

**ACRYLIC PAINT AND BALLPOINT PEN
ON FOUND PAPER
8.5″ × 11″
08/13/09**

10

But what most puzzled and confounded you was a long, limber, portentous, black mass of something hovering in the centre of the picture over three blue, dim, perpendicular lines floating in a nameless yeast.

ACRYLIC PAINT AND COLLAGE ON FOUND PAPER
7.75″ × 11″
08/13/09

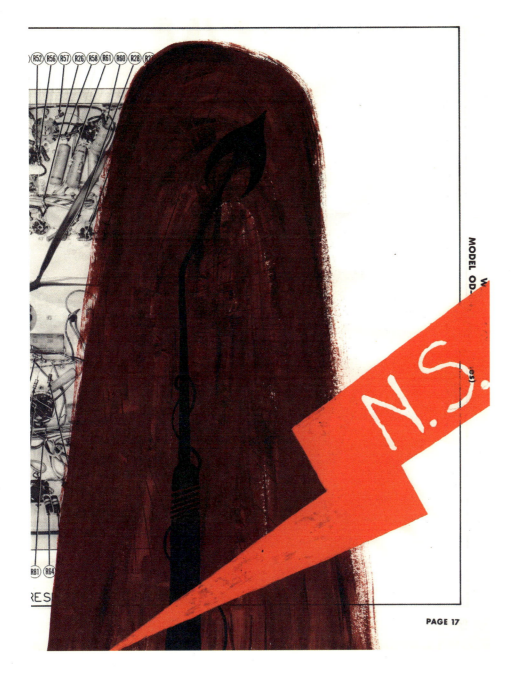

11

With this once long lance, now wildly elbowed, fifty years ago did Nathan Swain kill fifteen whales between a sunrise and a sunset.

ACRYLIC PAINT AND INK ON FOUND PAPER
7.75″ × 11″
08/13/09

12

*Abominable are the tumblers
into which he pours his poison.*

**ACRYLIC PAINT, COLLAGE AND INK ON
FOUND PAPER
7.25" × 11"
08/17/09**

13

One young fellow in a green box coat, addressed himself to these dumplings in a most direful manner.

ACRYLIC PAINT AND INK ON FOUND PAPER
7.75" × 11"
08/18/09

14

He stood full six feet in height, with noble shoulders, and a chest like a cofferdam. I have seldom seen such brawn in a man.

ACRYLIC PAINT AND INK ON FOUND PAPER
8.5″ × 10.5″
08/19/09

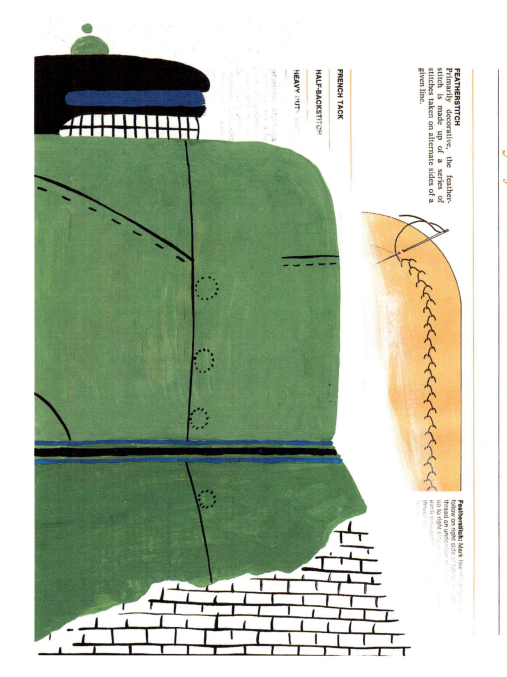

FEATHERSTITCH
Primarily decorative, the feather-stitch is made up of a series of stitches taken on alternate sides of a given line.

FRENCH TACK

HALF-BACKSTITCH

HEAVY-DUTY

Featherstitch: Mark line
follow on right side of
thread on underside
up to right side
each stitches
thread

15

I don't know how it is, but people like to be private when they are sleeping.

ACRYLIC PAINT, COLORED PENCIL AND INK ON FOUND PAPER
8.5" × 10.5"
08/19/09

16

*For who could tell but what
the next morning, so soon
as I popped out of the room,
the harpooneer might be
standing in the entry, all
ready to knock me down!*

**ACRYLIC PAINT AND INK ON FOUND
PAPER
8.5" × 10.5"
08/19/09**

Hand needles

Many types of needles are made for hand sewing, each for a specific purpose. These vary according to eye shape (long or round), length (in proportion to eye), and [...] sharp, blunt, ball-point or wedge). The char[...] describes the ba[...] [...]. Each embraces a [...] of sizes; the large[...] [...]

GENERAL HAND SE[...]
This group of hand needle[...] is used for general-purpose sewing[...] of them are sharp needle[...] [...] has a size range su[...] commodate most weight[...] fabric[...]

NEEDLECRAFT
This group of [...] is used primarily for needlecraft [...]poses, [...]idery, [...]ilepoint, [...]

DARNING
These needles are used primarily for darning. They vary in length and diameter to accommodate most darning or mending jobs.

HEAVY-DUTY SEWING
These hand needles are ideal for heavy sewing jobs. Both the gl[...] and sailmaker types have wedge-shaped points that pierce leather and leatherlike fabrics in such a way that the holes resist tearing.

[...]ber, the sho[...] illustrated [...] tion from [...] to job, com[...] [...] of work being done (some needles ar[...] their principal purpose, su[...] [...]'cro[...]mitted[...]

[...]ven), weight, and thread thickness. Generally, a needle should be fine enough to slip easily through [...] show the propor[...] or matching needle [...] heavy enough not to bend or break. [...] needles are designed to accommodate [...] d or several strands. Whatever the type, [...] k with a clean, well-pointed needle.

Ball-points (sizes 5–10) resemble sharps except for the point, which is rounded to penetrate between knit yarns.

Calyx-eyes (sizes 4–8) are like sharps except thread is pulled into a slot rather than through an eye.

Sharps (sizes [...] hand sewing [...]

Betweens (sizes 1–12) are [...]own as quilting nee[...]

Yarn darners (sizes 14–18) are long and heavy, necessities for darning with yarn.

Sailmakers (sizes 14–17) are like glovers except that their triangular point extends part way up the shaft. Sailmak-ers are used on canvas and heavy leather.

Glovers (sizes 3/0–[...] short, round-eye with triangular points that will pierce leather, vinyl, or plastic without tearing them.

Cot[...] [...] are [...]

"…ain't there too many heads in the world?"

ACRYLIC PAINT, BALLPOINT PEN, INK AND PENCIL ON FOUND PAPER
8.5" × 10.5"
08/22/09

18

"Depend upon it, landlord, that harpooneer is a dangerous man."

ACRYLIC PAINT, COLLAGE AND INK ON FOUND PAPER
8.5" × 10.5"
08/23/09

19

I can compare it to nothing but a large door mat, ornamented at the edges with little tinkling tags something like the stained porcupine quills round an Indian moccasin. There was a hole or slit in the middle of this mat, as you see the same in South American ponchos.

INK ON FOUND PAPER
8.5″ × 10″
08/23/09

20

*Lord save me, thinks I, that
must be the harpooneer, the
infernal head-peddler.*

**ACRYLIC PAINT, INK AND MARKER ON
FOUND PAPER
8.5" x 11"
08/25/09**

21

His bald purplish head now looked for all the world like a mildewed skull.

ACRYLIC PAINT AND BALLPOINT PEN
ON FOUND PAPER
7.75" × 11"
08/26/09

22

*…he fumbled in the pockets,
and produced at length a
curious little deformed image
with a hunch on its back,
and exactly the color of a
three days' old Congo baby.*

ACRYLIC PAINT ON FOUND PAPER
7.75" × 11"
08/27/09

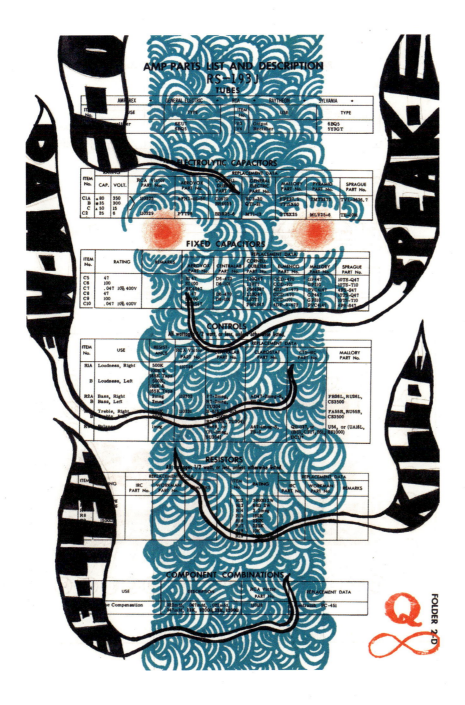

23

"Speak-e! tell-ee me who-ee be, or dam-me, I kill-e!" again growled the cannibal…

COLORED PENCIL, INK AND MARKER
ON FOUND PAPER
7.75" × 11"
08/27/09

24

*Better sleep with a
sober cannibal than a
drunken Christian.*

INK ON FOUND PAPER
7.75" × 10.75"
09/22/10

25

Indeed, partly lying on it as the arm did when I first awoke, I could hardly tell it from the quilt, they so blended their hues together; and it was only by the sense of weight and pressure that I could tell that Queequeg was hugging me.

ACRYLIC PAINT ON FOUND PAPER
7" × 9.5"
08/30/09

26

…the nameless, unimaginable,
silent form or phantom,
to which the hand
belonged, seemed closely
seated by my bedside.

SPRAY PAINT ON FOUND PAPER
9″ × 11″
08/31/09

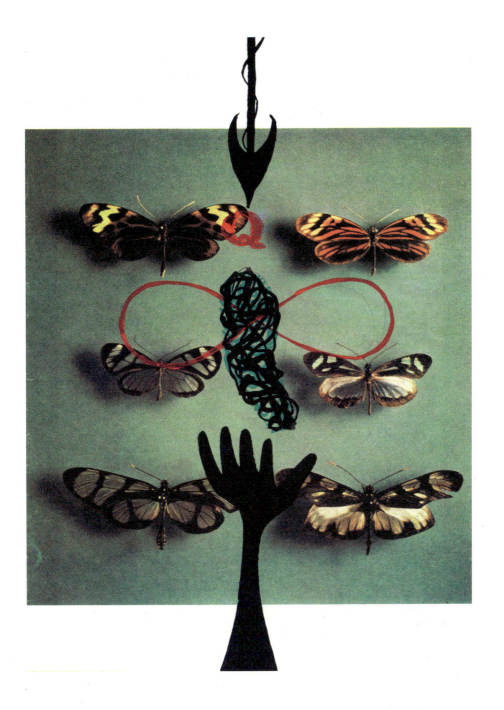

27

But Queequeg, do you see, was a creature in the transition state—neither caterpillar nor butterfly.

ACRYLIC PAINT, INK AND MARKER ON FOUND PAPER
7" × 9.5"
09/02/09

28

However, a good laugh is a mighty good thing, and rather too scarce a good thing…

INK ON FOUND PAPER
7.75″ × 10.75″
09/22/10

They were nearly all whalemen; chief mates, and second mates, and third mates, and sea carpenters, and sea coopers, and sea blacksmiths, and harpooneers, and ship keepers…

ACRYLIC PAINT AND INK ON FOUND PAPER
11″ × 8″
09/04/09

30

Yes, here were a set of sea-dogs, many of whom had boarded great whales on the high seas—entire strangers to them—and duelled them dead without winking…

ACRYLIC PAINT, COLORED PENCIL AND INK ON FOUND PAPER
8" × 11"
09/05/09

31

Look there! that chap strutting around the corner. He wears a beaver hat and swallow-tailed coat, girdled with a sailor-belt and sheath-knife.

ACRYLIC PAINT AND INK ON FOUND PAPER
8.5" × 10"
09/06/09

32

*And the women of New
Bedford, they bloom like
their own red roses.*

**ACRYLIC PAINT AND COLLAGE ON
FOUND PAPER
9″ × 11″
09/07/09**

CHRISTIAN MARTYR

"Is this true?" the high...

Stephen then spoke to... e story of Abraham,
... and Jacob, w... ...d the story of
Jewish history... ...cif... of Jesus

"Your fathers were...l... ...ory will tell you," he
concluded. "You are just... ...ecuted and killed the
prophets who told of Jes... ...ve killed the Saviour
himself."

WHAT YOU ... NEED IS

BEHOLD, I stand at the door, and knock:

Stephen looked up to... ...erful light. In clear,
ringing tones he spoke.

"I see the heavens ope... ...right hand of God,"
he said.

At this the elders of t... ...e him stop speaking.
They held their hands ov... ...ld not hear his voice.
In their fear and rage, the... ...d stoned him to death.
The lying witnesses who had appeared against Stephen threw the first
stones, this being the custom.

To give their arms... freedom, these men removed their outer gar-
ments and left them in the care of a young man named Saul until such time
as they would be ready to... ...m on again.

JESUS

As the stones were being hurled toward Stephen he knelt down on the
ground and prayed.

"Oh, Lord, forgive them for this sin!" he prayed, and then he died—the
first Christian martyr after the crucifixion of Jesus.

After Stephen was killed, there was a great deal of persecution of the
Apostles and their disciples. Many fled out of Jerusalem and went to other
places and countries. Wherever they went they preached the gospel to all
who would listen.

707

33

*Each silent worshipper
seemed purposely sitting
apart from the other, as if
each silent grief were insular
and incommunicable.*

**ACRYLIC PAINT, COLLAGE AND INK ON
FOUND PAPER
6" × 9.25"
09/21/10**

34

Affected by the solemnity of the scene, there was a wondering gaze of incredulous curiosity in his countenance.

ACRYLIC PAINT, INK AND MARKER ON FOUND PAPER
7" × 9.5"
09/07/09

of entry into Christian Europe of all the classics that the Arabs had brought together from Greece, from the Middle East, from Asia.

We think of Italy as the birthplace of the Renaissance. But the conception was in Spain in the twelfth century, and it is symbolised and expressed by the famous school of translators at Toledo, where the ancient texts were turned from Greek (which Europe had forgotten) through Arabic and Hebrew into Latin. In Toledo, amid other intellectual advances, an early set of astronomical tables was drawn up, as an encyclopedia of star positions. It is characteristic of the city and the time that the tables are Christian, but the numerals are Arabic, and are by now recognisably modern.

The most famous of the translators and the most brilliant was Gerard of Cremona, who had come from Italy specifically to find a copy of Ptolemy's book of astronomy, the *Almagest*, and who stayed on in Toledo to translate Archimedes, Hippocrates, Galen, Euclid – the classics of Greek science.

And yet, to me personally, the most remarkable and, in the long run, the most influential man who was translated was not a Greek. That is because I am interested in the perception of objects

35

What deadly voids and
unbidden infidelities in
the lines that seem to
gnaw upon all Faith, and
refuse resurrections to the
beings who have placelessly
perished without a grave.

**ACRYLIC PAINT AND INK ON FOUND
PAPER**
7.75" × 11"
09/07/09

36

Yes, it was the famous Father Mapple, so called by the whalemen, among whom he was a very great favorite.

ACRYLIC PAINT AND INK ON FOUND PAPER
9″ × 11″
09/08/09

tions were made by the other belligerents, and had as brief an influence as the British order. From a variety of motives – perhaps vanity or a concern for his ship's *esprit de corps* or a deep-grained tradition that rich ornamentation raised the will to fight of his own company and depressed that of the enemy – carving, gilding and painting were soon once again much in fashion. In Britain this was acknowledged officially by a relaxation in 1727 of the order of 1703. Long before this the gilders and varnishers, the painters and carvers, had been in full employment, working on their angels and their oxen and their unicorns, their greyhounds and lions. St George fought the Dragon time and again, cupids and dragons, figures supported patiently the royal coat of arms, all surmounted on by tiers of massed angels.

Eastern influence spread by way of the great British East Indiamen, whose decoration had for long had to impress the locals, and had in some cases adopted motifs for this purpose.

37

Can it be, then, that by that act of physical isolation, he signifies his spiritual withdrawal for the time, from all outward worldly ties and connexions?

ACRYLIC PAINT AND INK ON FOUND PAPER
7.75″ × 11″
09/12/09

A model of a 60-gun ship of 1715 showing the influence of Chinoiserie in its decoration. The men's lavatories can also be seen; the officers' are inside the bows. The chaplain was classed with the men for this purpose, and there is a sad poem, 'The Chaplain's Lament', about how he wanted a key to the indoor lavatories

38

*But high above the flying
scud and dark-rolling
clouds, there floated a little
isle of sunlight, from which
beamed forth an angel's face;
and this bright face shed a
distant spot of radiance upon
the ship's tossed deck…*

**ACRYLIC PAINT, COLLAGE AND INK ON
FOUND PAPER
11″ × 7.75″
09/13/09**

39

"Awful, yet bright, as lightning shone / The face of my Deliverer God."

ACRYLIC PAINT, INK AND MARKER ON FOUND PAPER
8" × 11"
09/14/09

40

*"Yet what depths of the
soul does Jonah's deep
sea-line sound!"*

**ACRYLIC PAINT, COLLAGE AND
MARKER ON FOUND PAPER
8.5" × 11"
09/15/09**

41

"Miserable man! Oh! most contemptible and worthy of all scorn; with slouched hat and guilty eye, skulking from his God…"

BALLPOINT PEN AND CRAYON ON FOUND PAPER
7.75" × 11"
09/16/09

42

"...*Jonah feels the heralding presentiment of that stifling hour, when the whale shall hold him in the smallest of his bowel's wards.*"

BALLPOINT PEN ON PAPER
8.5" x 11"
09/17/09

43

"'Oh! so my conscience hangs in me!' he groans, 'straight upward, so it burns; but the chambers of my soul are all in crookedness!'"

ACRYLIC PAINT AND INK ON FOUND PAPER
7.75" × 11"
09/18/09

44

"And ever, as the white moon shows her affrighted face from the steep gullies in the blackness overhead…"

ACRYLIC PAINT, COLLAGE, INK AND MARKER ON FOUND PAPER
11" × 7.75"
09/19/09

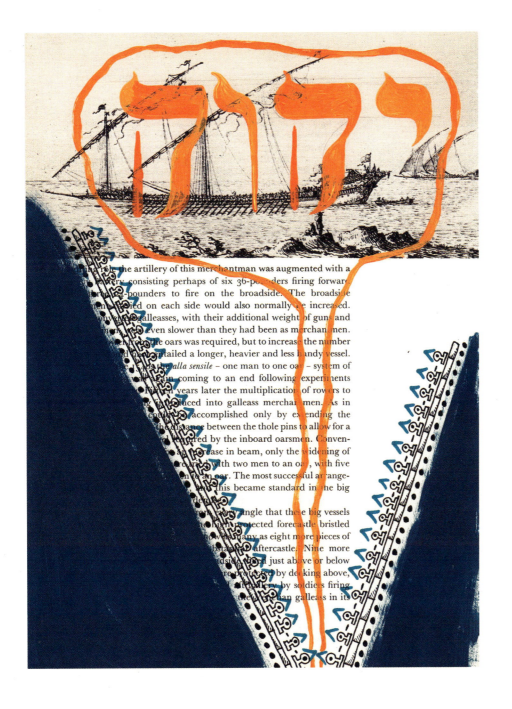

45

"Then Jonah prayed unto the Lord out of the fish's belly."

ACRYLIC PAINT, INK AND MARKER ON FOUND PAPER
7.75" × 11"
09/20/09

46

"...and from the shuddering cold and blackness of the sea, the whale came breeching up towards the warm and pleasant sun, and all the delights of air and earth…"

COLORED PENCIL AND INK ON FOUND PAPER
7.75" x 11"
09/21/09

47

"Delight is to him, who gives no quarter in the truth, and kills, burns, and destroys all sin…"

ACRYLIC PAINT AND COLLAGE ON FOUND PAPER
9" × 11.25"
09/22/09

48

Queequeg was George
Washington cannibalistically
developed.

ACRYLIC PAINT, COLLAGE, INK AND
MARKER ON FOUND PAPER
11" × 8.5"
09/23/09

49

I'll try a pagan friend...
since Christian kindness has
proved but hollow courtesy.

INK ON FOUND PAPER
7.75" × 10.75"
09/23/10

50

…he pressed his forehead against mine, clasped me round the waist, and said that henceforth we were married…

INK AND MARKER ON FOUND PAPER
11″ × 7.75″
09/25/09

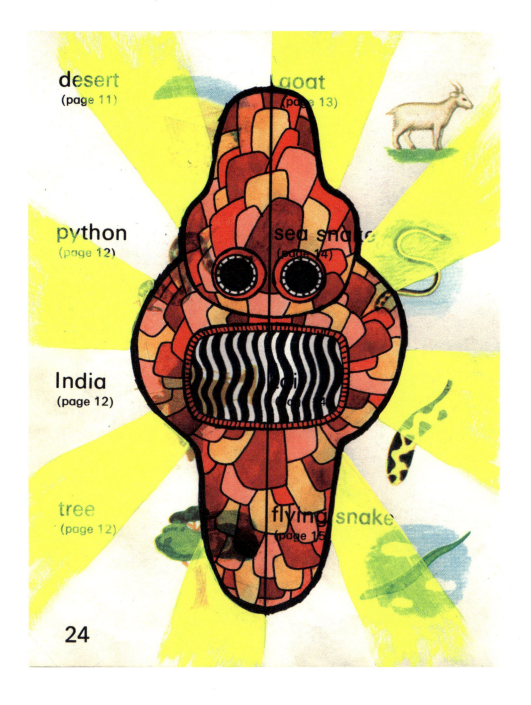

24

51

…I must turn idolator.

ACRYLIC PAINT AND INK ON FOUND
PAPER
6" × 7.75"
09/26/09

Nothing exists in itself.

INK ON FOUND PAPER
7.75″ × 10.75″
09/23/10

53

His father was a High Chief, a King; his uncle a High Priest; and on the maternal side he boasted aunts who were the wives of unconquerable warriors.

INK ON FOUND PAPER
11″ × 7.75″
09/28/09

54

...and when the ship was gliding by, like a fish he darted out; gained her side; with one backward dash of his foot capsized and sank his canoe; climbed up the chains...

ACRYLIC PAINT, COLORED PENCIL, INK AND MARKER ON FOUND PAPER
8.5" × 11"
09/30/09

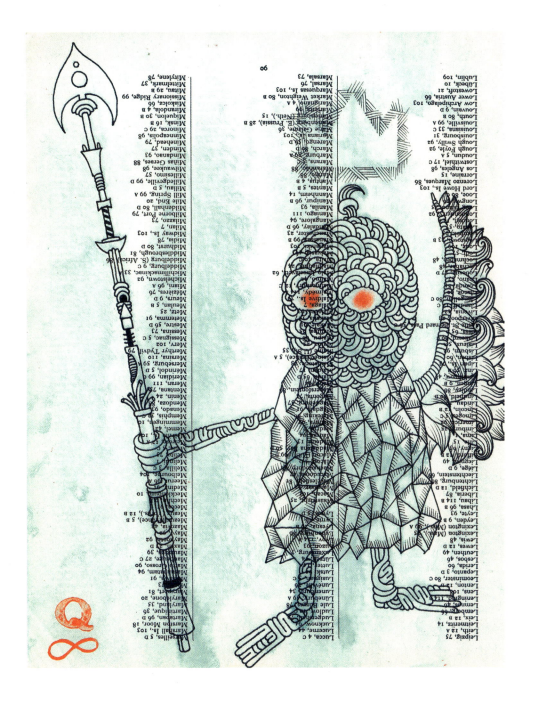

55

They had made a harpooneer of him, and that barbed iron was in lieu of a sceptre now.

COLORED PENCIL AND INK ON FOUND
PAPER
8.5″ × 11″
10/01/09

56

...he had a particular affection for his own harpoon, because it was of assured stuff, well tried in many a mortal combat, and deeply intimate with the hearts of whales.

ACRYLIC PAINT AND INK ON FOUND PAPER
7.75″ × 11″
10/02/09

when the were laid down, and some of these have survived. We should be grateful enough for these priceless materials records, but it is a pity that they do not begin a hundred or so years earlier when changes in design were more fundamental. However, they do record several interesting developments. While there was no inclination to follow the Dutch straight-sided practice, the hull form of them had altered markedly from late Elizabethan days in order to provide better sea-worthiness and a steadier platform for the much increased weight of ordnance. The strong degree of sheer which marked Matthew Baker's galleons was also much reduced. The cut up tumble-home was still there but was much less evident forward, as it was done in order to lower the maximum beam of the ship to the water line. Consequently, these ships were much more bluff in the bows. The fore castle was correspondingly reduced, and the ships of the line at the time of the last Dutch wars gave the impression of sitting or digging deep into the water.

European naval competition in the second half of the century produced a shortage of skilled men and materials comparable with that of the years before the First World War. Timber was imported in great quantities from the Baltic, and it was not so satisfactory or long-lasting as home-grown oak. England, with her great reserves of finest standing oak, was at an advantage. But even before Charles II's Act of 1677, calling for thirty new men-of-war, the increased demand on the oak reserves of the Royal forests, and wilful neglect to replant in

57

On one side, New Bedford rose in terraces of streets, their ice-covered trees all glittering in the clear, cold air...and side by side the world-wandering whale ships lay silent and safely moored at last...

BALLPOINT PEN ON FOUND PAPER
11″ × 7.75″
10/03/09

58

At the same foam-fountain, Queequeg seemed to drink and reel with me. His dusky nostrils swelled apart; he showed his filed and pointed teeth.

COLORED PENCIL, INK AND MARKER ON FOUND PAPER
7.75" x 11"
10/04/09

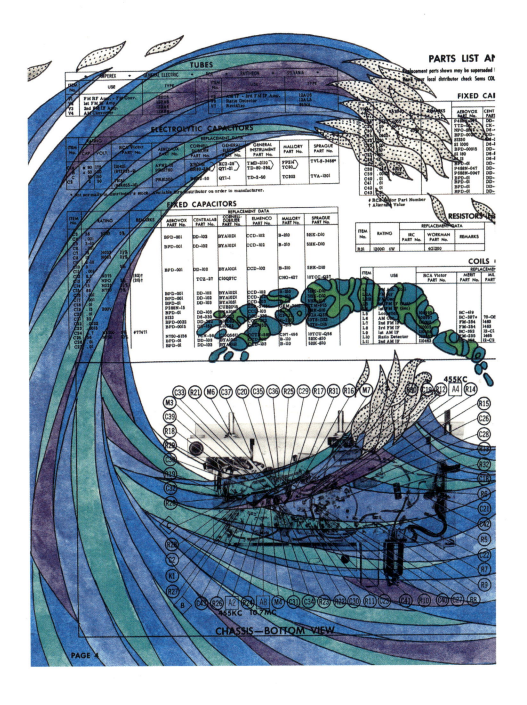

59

...Queequeg, stripped to the waist, darted from the side with a long living arc of a leap.

INK AND MARKER ON FOUND PAPER
7.75" × 11"
10/04/09

60

Thus goes the legend. In olden times an eagle swooped down upon the New England coast, and carried off an infant Indian in his talons. With loud lament the parents saw their child borne out of sight over the wide waters.

INK AND MARKER ON FOUND PAPER
7" × 10"
10/05/09

61

...and in all seasons and all oceans declared everlasting war with the mightiest animated mass that has survived the flood; most monstrous and most mountainous! That Himmalehan, salt-sea Mastodon, clothed with such portentousness of unconscious power, that his very panics are more to be dreaded than his most fearless and malicious assaults!

INK AND MARKER ON FOUND PAPER
8" × 11"
10/06/09

62

*...and moreover he had
assured us that cousin
Hosea, as he called him, was
famous for his chowders.*

INK ON FOUND PAPER
6.75" × 8.5"
10/09/09

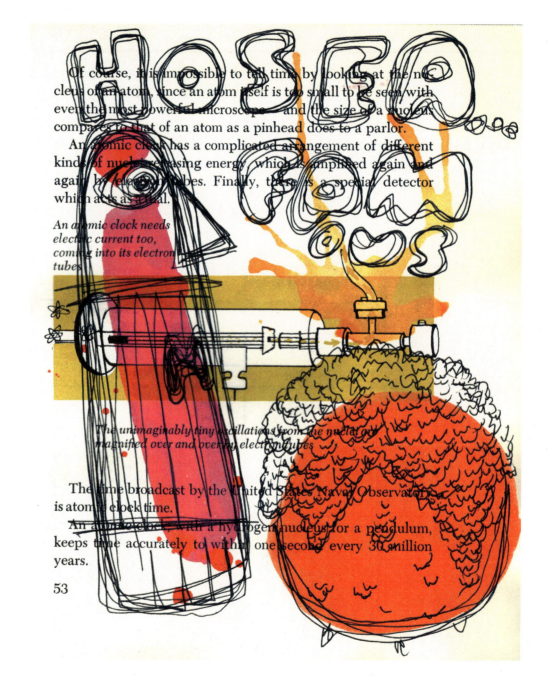

What is a day?

A day is the length of time the earth takes to turn around once on its axis. A day is 24 hours. Part of a day is light, when your section of the earth is facing the sun; and part of it is dark, when your section of the earth is turned away from the sun.

The earth spins on its axis as it moves around the sun

The 24 hours that it takes the earth to turn on its axis is called a *solar day*. Is there a *sidereal day*, too? Of course. It is about four minutes shorter than the *mean*, or "average," solar day of 24 hours.

When does a day begin? For primitive people it began at sunrise, and in some places it still does. In most of the civilized world a day begins at midnight. But midnight where? After all, the earth keeps turning, and it is always midnight somewhere.

20

63

I was called from these reflections by the sight of a freckled woman with yellow hair and a yellow gown, standing in the porch of the inn, under a dull red lamp swinging there, that looked much like an injured eye…

BALLPOINT PEN, INK AND MARKER ON FOUND PAPER
6.75" x 8.5"
10/09/09

*I saw Hosea's brindled cow
feeding on fish remnants,
and marching along the
sand with each foot in a
cod's decapitated head…*

**BALLPOINT PEN AND MARKER ON
FOUND PAPER**
11″ × 7.75″
10/15/09

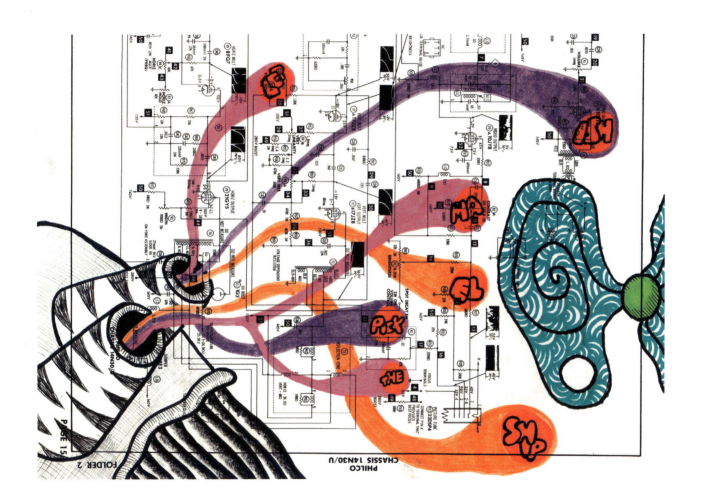

65

Queequeg now gave me to understand, that he had been diligently consulting Yojo…

BALLPOINT PEN, CHARCOAL AND
MARKER ON FOUND PAPER
11" x 7.75"
11/05/09

66

...take my word for it, you never saw such a rare old craft as this same rare old Pequod. She was a ship of the old school, rather small if anything; with an old fashioned claw-footed look about her.

BALLPOINT PEN ON FOUND PAPER
11" × 7.75"
11/05/09

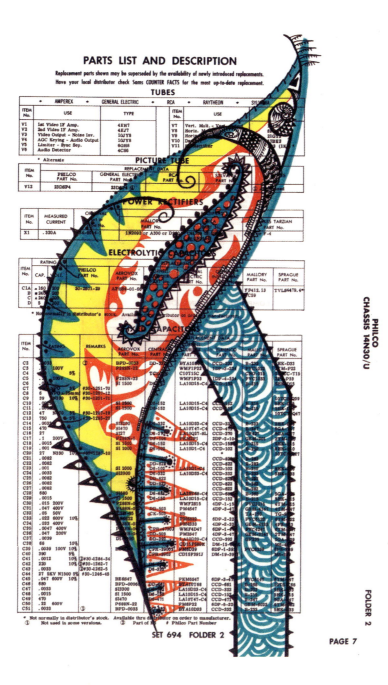

67

She was a thing of trophies. A cannibal of a craft, tricking herself forth in the chased bones of her enemies.

MARKER ON FOUND PAPER
7.75" x 11"
11/07/09

68

There was nothing so very particular, perhaps, about the appearance of the elderly man I saw; he was brown and brawny, like most old seamen, and heavily rolled up in blue pilot-cloth, cut in the Quaker style; only there was a fine and almost microscopic network of the minutest wrinkles interlacing round his eyes...

**ACRYLIC PAINT, COLORED PENCIL, INK
AND MARKER ON FOUND PAPER
7.75" × 11"
11/08/09**

"Lost by a whale! Young man, come nearer to me: it was devoured, chewed up, crunched by the monstrousest parmacetty that ever chipped a boat!—ah, ah!"

INK AND MARKER ON FOUND PAPER
7″ × 9.5″
11/09/09

Going forward and glancing over the weather bow, I perceived that the ship swinging to her anchor with the flood-tide, was now obliquely pointing towards the open ocean. The prospect was unlimited, but exceedingly monotonous and forbidding; not the slightest variety that I could see.

INK ON FOUND PAPER
11″ × 7.75″
11/10/09

71

*...who has also by the
stillness and seclusion of
many long night-watches
in the remotest waters, and
beneath constellations never
seen here at the north, been
led to think untraditionally
and independently...*

**COLORED PENCIL, INK AND MARKER
ON FOUND PAPER
7.75" × 11"
11/12/09**

72

...the sight of many unclad,
lovely island creatures,
round the Horn...

ACRYLIC PAINT AND COLLAGE ON
FOUND PAPER
8.5″ × 10.75″
11/13/09

His own person was the exact embodiment of his utilitarian character. On his long, gaunt body, he carried no spare flesh, no superfluous beard, his chin having a soft, economical nap to it, like the worn nap of his broad-brimmed hat.

ACRYLIC PAINT, COLORED PENCIL AND INK ON FOUND PAPER
7.75" × 11"
11/14/09

I was also aware that being a green hand at whaling, my own lay would not be very large; but considering that I was used to the sea, could steer a ship, splice a rope, and all that, I made no doubt that from all I had heard I should be offered at least the 275th lay—that is, the 275th part of the clear net proceeds of the voyage, whatever that might eventually amount to.

INK AND MARKER ON FOUND PAPER
11" × 7.5"
11/15/09

"Thou Bildad!" roared Peleg, starting up and clattering about the cabin. "Blast ye, Captain Bildad, if I had followed thy advice in these matters, I would afore now had a conscience to lug about that would be heavy enough to founder the largest ship that ever sailed round Cape Horn."

BALLPOINT PEN AND INK ON FOUND PAPER
7.75" × 11"
11/16/09

76

"Fiery pit! fiery pit! ye insult me, man; past all natural bearing, ye insult me. It's an all-fired outrage to tell any human creature that he's bound to hell. Flukes and flames!"

ACRYLIC PAINT AND INK ON FOUND PAPER
11" x 7.75"
11/17/09

This man is ___ ___ke charme___
He keeps his ___ ra in a basket.

19

But I had not proceeded far, when I began to bethink me that the captain with whom I was to sail yet remained unseen by me…

ACRYLIC PAINT AND INK ON FOUND PAPER
6″ × 7.75″
11/18/09

78

"Besides, my boy, he has a wife
—not three voyages wedded
—a sweet, resigned girl"

**ACRYLIC PAINT, INK AND COLLAGE ON
FOUND PAPER
7.75" × 9"
11/18/09**

? New ,

34

79

...and Heaven have mercy on us all—Presbyterians and Pagans alike—for we are all somehow dreadfully cracked about the head, and sadly need mending.

INK ON FOUND PAPER
11″ × 7.5″
11/21/09

80

Apoplexy!

**INK, MARKER AND PENCIL ON FOUND
PAPER
8" × 11"
11/21/09**

that age. He stepped up the magnification of the telescope to thirty, and he turned it on the stars, so that he really did for the first time what we think of as practical science: build the apparatus, do the experiment, publish the results. And that he did between September of 1609 and March of 1610, when he published in Venice the splendid book *Sidereus Nuncius*, *The Starry Messenger*, which gave an illustrated account of his new astronomical observations. What did it say?

[I have seen] stars in myriads, which have never been seen before, and which surpass the old, previously known, stars in number more than ten times.

But that which will excite the greatest astonishment by far, and which indeed especially moved me to call the attention of all astronomers and philosophers, is this: namely, that I have discovered four planets, neither known nor observed by any one of the astronomers before my time.

These were the satellites of Jupiter. *The Starry Messenger* also tells how he turned the telescope on the moon herself. Galileo was the first man to publish maps of the moon. We have his original water-colours.

It is a most beautiful and delightful sight to behold the body of the moon. [It] certainly does not possess a smooth and polished surface, but one rough and uneven, and, just like the face of the earth itself, is everywhere full of vast protuberances, deep chasms, and sinuosities.

The British ambassador to the Doge's court in Venice, Sir Henry Wotton, reported to his superiors in England on the day that *The Starry Messenger* came out:

The mathematical professor at Padua hath . . . discovered four new planets rolling about the sphere of Jupiter, besides many other unknown fixed stars; likewise . . . that the moon is not spherical, but endued with many prominences . . . The author runneth a fortune to be either exceeding famous or exceeding ridiculous. By the next ship your lordship shall receive from me one of the [optical] instruments, as it is bettered by this man.

The news was sensational. It made a reputation larger even than the triumph among the trading community. And yet it was not altogether welcome, because what Galileo saw in the sky, and revealed to everyone who was willing to look, was that the Ptolemaic heaven simply would not work. Copernicus's powerful guess had been right, and now stood open and revealed. And like many more recent scientific results, that did not at all please the prejudice of the establishment of his day.

...and there, good heavens! there sat Queequeg, altogether cool and self-collected; right in the middle of the room; squatting on his hams, and holding Yojo on top of his head. He looked neither one way nor the other way, but sat like a carved image with scarce a sign of active life.

COLORED PENCIL AND INK ON FOUND PAPER
6.75" x 9.5"
11/22/09

82

*But previous to turning in,
I took my heavy bearskin
jacket, and threw it over
him, as it promised to be
a very cold night…*

ACRYLIC PAINT, COLORED PENCIL AND
INK ON FOUND PAPER
8″ × 11″
11/23/09

DIAG. 14 DIAG. 15 DIAG. 16 DIAG. 17

inert mass of clay. If he builds the clay up to the shape shown in Diagram 14 and he wishes to produce a vase three times the height of the mass he has built, how should he form it ? Diagrams 15, 16, and 17 are possible solutions. It is not necessary here to agree on one of these solutions in preference to the others. It is important to realize that one of them, or rather one of many possible solutions, will be chosen. After that choice has been made, other choices will be necessary before the vase is complete ; for example the color and the surface treatment must be selected.

The artist continually makes choices from among many possibilities as he works. Once the art object has been started, some of his choices follow as a result of his initial decisions. Forms and colors in the work suggest other forms, other colors, to a painter ; the shapes and surfaces in a piece of sculpture suggest related treatments to the sculptor. The esthetic order sought by the ceramist, the sculptor, the painter, or the architect can be developed in many ways that are basic to all the visual arts. Young art students are introduced to these methods in the early phases of their training, and it will be useful for those who wish to understand the visual arts to acquaint themselves with a number of the ways employed to organize art objects. However, it should be understood that the skillful plastic organization of a work of art does not in itself ensure the production of a masterpiece, any more than the work of a skilled grammarian necessarily produces a great novel. Often the person who defies the traditional esthetic form or who creates new forms of order is the one who produces the extraordinary work of art. A slavish adherence to established principles can result in a dull, academic exercise. Despite this possibility, it is still valuable to understand certain basic organizational principles, so that even those works of art which appear to be a reaction against principles can be seen in contrast to them.

UNITY AND VARIETY

Esthetic unity is achieved when the parts of an art object ... *order.* The order, or organization, of the ... be highly complex ; it may be based ... the elements.

178
The X-rays form a regular pattern of ripples
from which the position of the obstructing
atoms can be inferred.
X-ray diffraction pattern of a crystal of DNA.

83

*"...hell is an idea first
born on an undigested
apple-dumpling..."*

**CRAYON, INK AND MARKER ON
FOUND PAPER
6.75" × 9.5"
11/24/09**

...we sallied out to board the Pequod, sauntering along, and picking our teeth with halibut bones.

COLORED PENCIL, INK, MARKER AND PENCIL ON FOUND PAPER
8.25″ × 11″
11/26/09

85

"No," said Peleg, "and he hasn't been baptized right either, or it would have washed some of that devil's blue off his face."

ACRYLIC PAINT AND COLORED PENCIL ON FOUND PAPER
7.75" × 11"
11/26/09

86

"Cap'ain, you see him small drop tar on water dere? You see him? well, spose him one whale eye, well, den!" and taking sharp aim at it, he darted the iron right over old Bildad's broad brim, clean across the ship's decks, and struck the glistening tar spot out of sight.

INK AND MARKER ON FOUND PAPER
9.25" × 6"
09/26/10

The Glory of Solomon the King, the Division into Two Kingdoms, the History of Israel and Judah, the Babylonian Captivity, and the Restoration of the Temple.

87

Quohog
his ∞ mark

COLORED PENCIL ON FOUND PAPER
11″ × 8.25″
11/27/09

88

...the above words were put to us by a stranger, who, pausing before us, levelled his massive forefinger at the vessel in question. He was but shabbily apparelled in faded jacket and patched trowsers; a rag of a black handkerchief investing his neck. A confluent small-pox had in all directions flowed over his face, and left it like the complicated ribbed bed of a torrent, when the rushing waters have been dried up.

ACRYLIC PAINT AND INK ON FOUND PAPER
6.75" x 8.5"
11/27/09

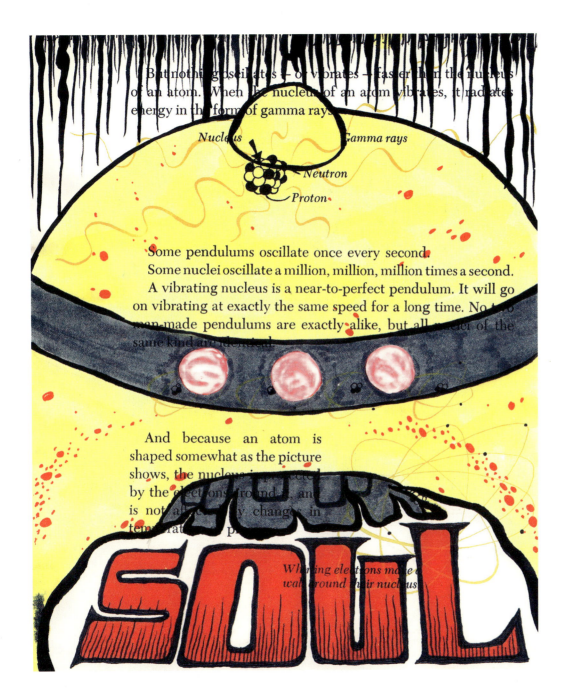

89

"Anything down there about your souls?"

ACRYLIC PAINT AND INK ON FOUND PAPER
6.75" x 8.5"
11/28/09

90

"My friend," said I, "what all this gibberish of yours is about, I don't know, and I don't much care; for it seems to me that you must be a little damaged in the head."

ACRYLIC PAINT AND INK ON FOUND PAPER
7.75" × 11"
11/29/09

91

But we had not gone perhaps above a hundred yards, when chancing to turn a corner, and looking back as I did so, who should be seen but Elijah following us, though at a distance.

INK AND MARKER ON FOUND PAPER
7.75" × 11"
11/29/09

92

*...and the men employed
in the hold and on the
rigging were working till
long after night-fall.*

**ACRYLIC PAINT, INK AND MARKER ON
FOUND PAPER**
11" × 7.75"
11/29/09

jar of
pickles

DIAG. 37

| quills | roll of flannel | oil-ladle | lance | napkins | forks |

DIAG. 38

	sauce-pans		
knives	inkwell	whet-stone	wool scarf
	boot-black		

DIAG. 39

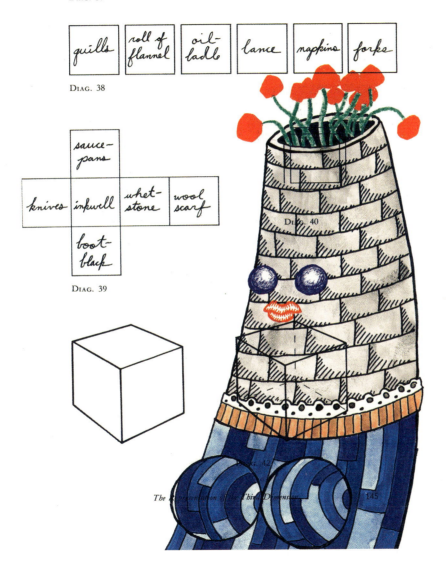

93

*And like a sister of charity
did this charitable Aunt
Charity bustle about hither
and thither, ready to turn her
hand and heart to anything
that promised to yield safety,
comfort, and consolation
to all on board a ship in
which her beloved brother
Bildad was concerned...*

**CRAYON, INK AND MARKER ON
FOUND PAPER
8″ × 11″
12/02/09**

94

*It was nearly six o'clock,
but only grey imperfect
misty dawn, when we
drew nigh the wharf.*

COLORED PENCIL ON FOUND PAPER
5.5″ x 8.25″
12/31/10

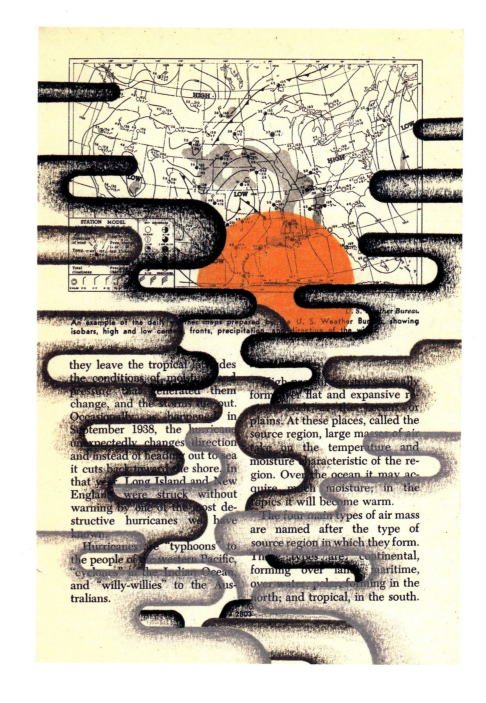

Sleeve finishes

A casing is a fabric "tunnel" through which elastic or drawstring can be passed; either will draw up sleeve fullness, creating a puffed effect. Casings are a popular sleeve finish for children's wear, blouses, and sportswear. There are basically two casing types. The first is a **self-faced casing**; in this type the tunnel is created by turning the sleeve edge to the inside. Some self-faced casings are positioned above the sleeve edge so that a gathered flounce, known as a *heading*, will hang below. To construct a self-faced casing (with or without heading), an adequate fabric allowance must be provided be-

low the hemline. The second type of casing is an **applied casing**, actually a separate bias strip that is sewed to the sleeve edge to form the tunnel. The applied type is generally used when there is not enough hem allowance for a self-faced casing or when fabric bulk makes a casing of thinner fabric desirable. Prepackaged bias tapes can be used for this purpose; select the width closest to and slightly wider than the elastic. For both types of casing, it is wise to select a narrow elastic (¼ inch to ½ inch) that is appropriate for tunneling (see illustration).

Casing with heading

1. Ma___ ___ on sleeve. Allow ___ casing width ___ hemline is equal w___ of elastic plus a scant ½".

Hemline
Elastic width

2. Along raw edges of sleeve ___ a scant ¼" to the wrong side and pre___

3. Turn casing width to wrong side along marked ___line; pin and baste ___ free edge. Stitch ___ basted line, leaving a ___ opening at sleeve se___

___ to fold ___ of sleeve. ___ few ___ elastic ___ the

5. ___ a bodkin or ___ ___ one end of ___ insert into ___ ther end to sleeve to ___ that end from s___ through. W___ around ent___ avoid twist___

6. Unpin ___ ends ___ ap ___ ___ and ___ ___ ___ ___ ___ ed

Seeing a light, we went down, and found only an old rigger there, wrapped in a tattered pea-jacket. He was thrown at whole length upon two chests, his face downwards and inclosed in his folded arms. The profoundest slumber slept upon him.

BALLPOINT PEN ON FOUND PAPER
10.5″ × 8.25″
12/06/09

96

*"Face!" said I, "call
that his face?"*

**COLORED PENCIL AND MARKER ON
FOUND PAPER
8.5" × 10.5"
12/07/09**

It was now clear sunrise.

INK ON FOUND PAPER
11" × 7.75"
12/08/09

PAGE

98

*Meantime, overseeing the
other part of the ship, Captain
Peleg ripped and swore astern
in the most frightful manner.*

**COLORED PENCIL, INK AND MARKER
ON FOUND PAPER
11" × 7.25"
12/09/09**

THE ESTHETIC EXPERIENCE

M̲AN is an image maker. From the paintings on the cave walls of paleolithic man a record of the visual arts has continued to our own time, and though the motivation these images appear to change from era to era, there is ample evidence the need of men to transform their experiences into visual symbols (Figs. this span of time buildings and monuments have risen, some to fall others to remain as evidence of the need of men to protect themselves an their heroes, their societies, and their gods.

The combination of visual symbols and architectural structure man prov illumin the past, and many of th to provide the present-day ver insights nd pleas own right without reference their historical does not lie exclusively in its function as a mirror of as a source of sensuous and intellectual satisfaction In the form of a Greek kylix (Fig. 3), the structure of a great bridge (Fig. 4) there is to practical ural and historic

For the painti th meani and it is out of erhaps it satisfie ason for creating it, it is com- pleted. Other sive audience, but the response ce can provide only a secondary lev

For the observers, neaing of art bins with the work itself. The has stopped. The meaning that the man finds on the work of art, but it is also depen ent upon the viewe and emotional condition, as well as his ility to perce e the wo

The tist produce visual stat which in turn becomes the subject matter for response o from the observer. In this sense the visual arts may be considered a lang her languages, there is a source for the

3

99

That was my first kick.

COLORED PENCIL AND MARKER ON
FOUND PAPER
8.25″ × 11″
12/10/09

100

*As for Peleg himself, he took it
more like a philosopher; but for
all his philosophy, there was a
tear twinkling in his eye, when
the lantern came too near.*

**ACRYLIC PAINT, INK AND SPRAY PAINT
ON FOUND PAPER**
8.25" × 11"
12/10/09

101

Ship and boat diverged; the cold, damp night breeze blew between; a screaming gull flew overhead; the two hulls wildly rolled; we gave three heavy-hearted cheers, and blindly plunged like fate into the lone Atlantic.

INK ON FOUND PAPER
8.5″ × 11″
12/11/09

102

*...so, better is it to perish in
that howling infinite, than be
ingloriously dashed upon the
lee, even if that were safety!*

INK ON FOUND PAPER
7.75" x 11"
12/12/09

103

...let me assure ye that many a veteran who has freely marched up to a battery, would quickly recoil at the apparition of the Sperm Whale's vast tail, fanning into eddies the air over his head.

ACRYLIC PAINT, COLORED PENCIL AND INK ON FOUND PAPER
8.5" × 11"
12/13/09

104

Why did the Dutch in De Witt's time have admirals of their whaling fleets?

COLORED PENCIL AND INK ON FOUND PAPER
7.75" × 11"
12/14/09

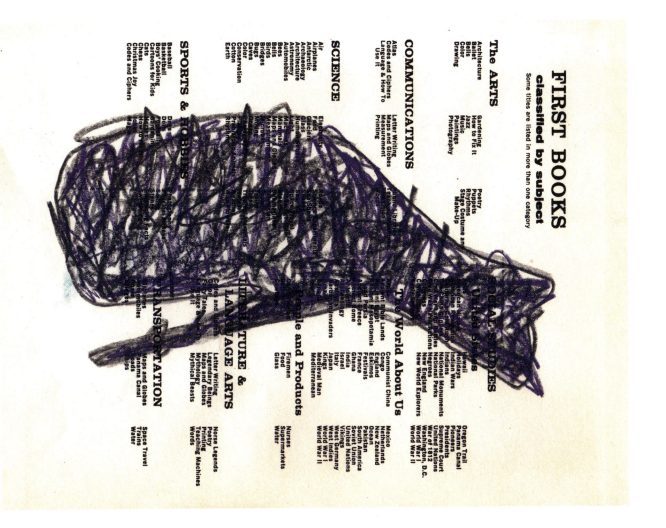

105

The whale has no famous author…

CRAYON ON FOUND PAPER
8.5" × 6.75"
12/15/09

Whaling not respectable?
Whaling is imperial! By old
English statutory law, the
whale is declared "a royal fish."

COLORED PENCIL, INK AND SPRAY
PAINT ON FOUND PAPER
6.25" × 10"
12/15/09

Cetology

to be filled in all its departments by subsequent laborers. As no better man advances to take this matter in hand, I hereupon offer my own poor endeavors. I promise nothing complete; because any human thing supposed to be complete must for that very reason infallibly be faulty. I shall not pretend to a minute anatomical description of the various species, or—in this space at least—to much of any description. My object here is simply to project the draught of a systematization of cetology. I am the architect, not the builder.

But it is a ponderous task; no ordinary letter-sorter in the Post-Office is equal to it. To grope down into the bottom of the sea after them; to have one's hands among the unspeakable foundations, ribs, and very pelvis of the world; this is a fearful thing. What am I that I should essay to hook the nose of this leviathan! The awful tauntings in Job might well appal me. "Will he (the leviathan) make a covenant with thee? Behold the hope of him is vain!" But I have swam through libraries and sailed through oceans; I have had to do with whales with these visible hands; I am in earnest; and I will try. There are some preliminaries to settle.

First: The uncertain, unsettled condition of this science of Cetology is in the very vestibule attested by the fact that in some quarters it still remains a moot point whether a whale be a fish. In his System of Nature, A.D. 1776, Linnæus declares, "I hereby separate the whales from the fish." But of my own knowledge, I know that down to the year 1850, sharks and shad, alewives and herring, against Linnæus's express edict, were still found dividing the possession of the same seas with the Leviathan.

The grounds upon which Linnæus would fain have banished the whales from the waters, he states as follows: "On account of their warm bilocular heart, their lungs, their moveable eyelids, their hollow ears, *penem intrantem feminam mammis lactantem,*" and finally, "*ex lege naturæ jure meritoque.*" I submitted all this to my friends Simeon Macey and Charley Coffin, of Nantucket, both messmates of mine in a certain voyage, and they united in the opinion that the reasons set forth were altogether insufficient. Charley profanely hinted they were humbug.

Be it known that, waiving all argument, I take the good old fashioned ground that the whale is a fish, and call upon holy Jonah to back me. This

107

*…for a whale-ship was my
Yale College and my Harvard.*

**BALLPOINT PEN AND INK ON FOUND
PAPER**
7.75" x 11"
12/16/09

108

The chief mate of the Pequod was Starbuck, a native of Nantucket, and a Quaker by descent.

ACRYLIC PAINT, INK AND MARKER ON
FOUND PAPER
8.5" × 10"
12/17/09

Machine facsimiles of hand stitches

Referred to as the blindstitch, this zigzag stitch pattern is used primarily for blind hemming by machine (see Hems). It can also be used to stitch seams, and as a seam finish (see Seams), and to produce the effect of hand-prickstitching in a machine zipper application (see Zippers).

Blind-hemming stitch (blindstitch): This stitch may be either built into the machine or produced through the insertion of a stitch-pattern cam. As a rule, the stitch pattern consists of 4 to 6 straight stitches followed by 1 zigzag, but some machines follow this

Seams 149, 151
Machine hems 294

Zippers 319, 323
Buttonholes 343-346

BUTTONHOLE STITCH
Machine stitching of buttonholes, whether automatic or manual, generally requires a zigzag stitch. (For single exception, see explanation at right.) All machine buttonholes have two straight sides with bar tacks at ends. Bar tacks are usually straight, as in buttonhole being formed here, but some machines or attachments produce round or keyhole ends.

Machine-worked buttonholes are made with a zigzag stitch (except those made with a straight-stitch machines in which an attachment joins *fabric* from side to side). Differences in how a buttonhole is formed lie in the mechanism by which buttonhole is produced (built-in or a separate attachment) and which steps are automatic. (See Machine-worked buttonholes.)

109

"I will have no man in my boat," said Starbuck, "who is not afraid of a whale."

COLORED PENCIL, INK AND MARKER ON FOUND PAPER
11" x 7.75"
12/19/09

110

Men may seem detestable as joint stock-companies and nations; knaves, fools, and murderers there may be; men may have mean and meagre faces; but man, in the ideal, is so noble and so sparkling, such a grand and glowing creature, that over any ignominious blemish in him all his fellows should run to throw their costliest robes.

COLORED PENCIL AND INK ON FOUND PAPER
8.5" x 11"
12/20/09

111

Stubb was the second mate. He was a native of Cape Cod; and hence, according to local usage, was called a Cape-Codman. A happy-go-lucky; neither craven nor valiant; taking perils as they came with an indifferent air…

ACRYLIC PAINT, COLORED PENCIL AND INK ON FOUND PAPER
8.5" × 10"
12/21/09

Buttonholes from built-in capabilities

Many sewing machines of comparatively recent design have built-in mechanisms that stitch machine-worked buttonholes automatically. There is no need to pivot, change needle position, or turn the fabric when a machine has these built-in capabilities. By manipulating a single control, each step of the buttonhole is automatically positioned and stitched. Half of the buttonhole is stitched forward, the other half is stitched backward.

Before stitching is begun, all buttonhole position and length marks must be made (see p. 331). The markings are then located under the presser foot as directed by the machine booklet. Depending upon the machine, the buttonhole is stitched in two, four, or five steps as described at the left. The instructions will vary according to the number of steps; directions in the machine booklet is followed carefully. Also check the booklet to see whether there is a presser foot designed expressly for stitching buttonholes.

An unevenness in the spacing between stitches can occur when a machine sews in reverse, causing sides of buttonhole to look mismatched. There is a special mechanism to control this problem; consult your machine booklet for instructions in its use. As a rule, if reverse stitches are too close together, the mechanism is turned to a minus setting; if they are too far apart, toward a plus setting.

The third mate was Flask, a native of Tisbury, in Martha's Vineyard. A short, stout, ruddy young fellow, very pugnacious concerning whales, who somehow seemed to think that the great Leviathans had personally and hereditarily affronted him; and therefore it was a sort of point of honor with him, to destroy them whenever encountered.

ACRYLIC PAINT, INK AND MARKER ON FOUND PAPER
8.5" × 10"
12/23/09

The parts of a pattern

113

Next was Tashtego, an unmixed Indian from Gay Head, the most westerly promontory of Martha's Vineyard, where there still exists the last remnant of a village of red men, which has long supplied the neighboring island of Nantucket with many of her most daring harpooneers.

COLORED PENCIL, INK AND MARKER ON FOUND PAPER
5.75″ × 8″
12/26/09

114

*Third among the harpooneers
was Daggoo, a gigantic, coal-
black negro-savage, with a
lion-like tread—an Ahasuerus
to behold. Suspended from
his ears were two golden
hoops, so large that the sailors
called them ring-bolts…*

**ACRYLIC PAINT, INK AND MARKER ON
FOUND PAPER
7.75" × 11"
12/27/09**

SPACELIGHT AND SHADOWS

SUNLIGHT reaching Earth is diffused by atmosphere from object to object lighting everything on all sides, softening shadows and tones even on the sunniest days.

Sunlight in space is, one imagines, of a different character: I call it spacelight. Spacelight I imagine to be harsh and raw—even eerie, something very like strong moonlight on Earth. Objects will be brilliantly lit on one side and very dark on the other. There will, of course be some light reflected to the dark sides from the other celestial bodies glittering in the dark velvet backdrop of space.

The Earth's natural satellite, the Moon, is the only space object which can be clearly seen from Earth with the naked eye: consequently makes a very good object from which to draw.

One half of the Moon is always illuminated by the Sun, the other half is always dark. We say that we see the Moon in phases; as a crescent, a half-moon etc. Drawing-wise we are looking at the same object from different positions: sometimes we see its face fully illuminated (full moon) at other times all we may see is a very edge of its illuminated face, the crescent.

Drawing Moon phases can give good experience in drawing and in shading a

le and indicate the phase by an

major axis common to that of the

he phase you intend to

ding paper. If you

tly, your Mo

d sphere.

an

115

For several days after leaving Nantucket, nothing above hatches was seen of Captain Ahab.

INK ON FOUND PAPER
5.25" × 6"
10/03/10

116

But it was especially the aspect of the three chief officers of the ship, the mates, which was most forcibly calculated to allay these colorless misgivings, and induce confidence and cheerfulness in every presentment of the voyage.

INK ON FOUND PAPER
9" × 6.25"
12/28/09

117

*Reality outran apprehension;
Captain Ahab stood
upon his quarter-deck.*

COLORED PENCIL AND INK ON FOUND
PAPER
7.75" × 11"
12/29/09

118

Upon each side of the Pequod's quarter deck, and pretty close to the mizen shrouds, there was an auger hole, bored about half an inch or so, into the plank. His bone leg steadied in that hole…

COLORED PENCIL AND INK ON FOUND PAPER
7.75" × 11"
01/05/10

119

The warmly cool, clear, ringing, perfumed, overflowing, redundant days, were as crystal goblets of Persian sherbet, heaped up—flaked up, with rose-water snow.

INK AND MARKER ON PAPER
8.5″ x 5.5″
01/06/10

120

Starting at the unforeseen concluding exclamation of the so suddenly scornful old man, Stubb was speechless a moment; then said excitedly, "I am not used to be spoken to that way, sir; I do but less than half like it, sir."

BALLPOINT PEN ON FOUND PAPER
7.75" × 11"
01/07/10

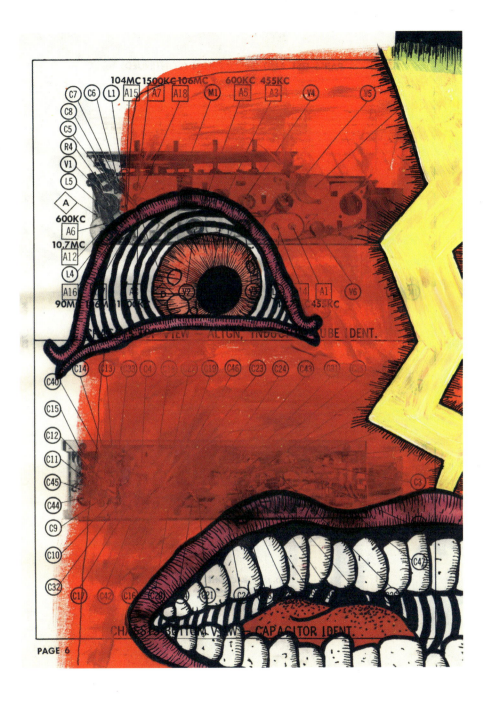

121

*As he said this, Ahab
advanced upon him with
such overbearing terrors
in his aspect, that Stubb
involuntarily retreated.*

**ACRYLIC PAINT, INK AND MARKER ON
FOUND PAPER**
7.75″ × 11″
01/09/10

For a Khan of the plank, and a king of the sea, and a great lord of Leviathans was Ahab.

**COLORED PENCIL, INK AND MARKER
ON FOUND PAPER
7″ × 7.75″
01/10/10**

Where he was, the channel was like a narrow bottle neck with the whole ocean trying to pour in at once.

That was why the fleet couldn't make any headway. The force of the seas simply swept them back . . .

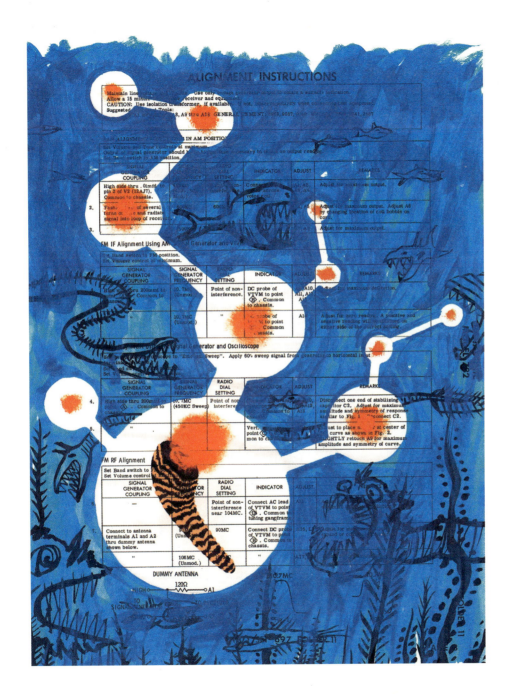

123

He tossed the still lighted pipe into the sea. The fire hissed in the waves…

ACRYLIC PAINT AND INK ON FOUND PAPER
7.75" × 11"
01/11/10

124

*...a sort of badger-haired
old merman, with a hump
on his back, takes me by the
shoulders, and slews me round.*

**INK AND MARKER ON FOUND PAPER
6.25″ × 7.75″
01/12/10**

125

"What d'ye think of that now, Flask? Ain't there a small drop of something queer about that, eh? A white whale—did ye mark that, man? Look ye—there's something special in the wind."

ACRYLIC PAINT AND BALLPOINT PEN ON NOTEBOOK PAPER AND MASKING TAPE (WITH INCIDENTAL ACRYLIC PAINT AND INK)
10.5" × 8.5"
01/13/10

126

Of the names in this list of whale authors, only those following Owen ever saw living whales; and but one of them was a real professional harpooneer and whaleman. I mean Captain Scoresby.

ACRYLIC PAINT, COLORED PENCIL,
CRAYON, INK AND MARKER ON
FOUND PAPER
8" × 11"
01/15/10

127

As yet, however, the Sperm
Whale, scientific or poetic, lives
not complete in any literature.
Far above all other hunted
whales, his is an unwritten life.

INK ON BRISTOL BOARD
8.5" x 7"
01/15/10

To be short, then, a whale is a spouting fish with a horizontal tail. *There you have him.*

COLORED PENCIL ON FOUND PAPER
5.75" × 9"
01/16/10

129

*BOOK I (Folio), Chapter I
(Sperm Whale).*

INK ON FOUND PAPER
15.75″ × 10.75″
01/16/10

130

BOOK I (Folio), CHAPTER II *(Right Whale).*

INK AND MARKER ON FOUND PAPER
15.75″ × 10.75″
01/17/10

131

The Fin-Back is not gregarious.
He seems a whale-hater, as
some men are man-haters.
Very shy; always going
solitary; unexpectedly rising
to the surface in the remotest
and most sullen waters…

INK AND MARKER ON FOUND PAPER
15.75" × 10.75"
01/17/10

132

BOOK I (Folio), Chapter IV
(Hump Back).

BALLPOINT PEN ON FOUND PAPER
15.75" × 10.75"
01/18/10

BOOK I. (folio), CHAPTER IV.
Hump Back.

~ Elephant whale
~ Castle whale

133

BOOK I (Folio), Chapter VI
(Sulphur Bottom).

**COLORED PENCIL, INK AND MARKER
ON FOUND PAPER
21″ × 10.75″
01/19/10**

BOOK II (Octavo),
CHAPTER III (Narwhale)

ACRYLIC PAINT AND INK ON FOUND PAPER
11" × 8"
01/21/10

THE REPRESENTATION OF COLOR

BOOK II (Octavo), CHAPTER III
Narwhale
~ Nostril Whale
~ Tusked Whale
~ Horned Whale
~ Unicorn Whale

135

BOOK II (Octavo),
CHAPTER V (Thrasher).

COLORED PENCIL AND INK ON FOUND PAPER
11″ × 8″
01/21/10

BOOK II (octavo), CHAPTER V

Thrasher.

ART AS COMMUNICATION

136

BOOK III (Duodecimo),
CHAPTER II (Algerine Porpoise).

ACRYLIC PAINT AND INK ON FOUND
PAPER
5.5″ × 8″
10/03/10

world's center for the whaling
industry, although England, Hol-
land, Spain, France and Norway
also sent out whalers in search
of prey.

Early in the 1800's New Lon-
don, Connecticut, became a
great whaling port. The methods
used by whalers at this time are
described in *Moby Dick*, by Her-
man Melville. These whalers
used wind-driven ships, and
once a school of whales was
spotted they pursued them in
large rowboats, called whale-
boats, and sought to kill them
with hand harpoons. The ch
often took hours; it was
ous and exciting,

lost their li search of the
huge ani he only whaling
statio
is
nor

Mod Whaling

Th volution
chang industry;
the wh was no ex-
ception elopment
of stea d the in-
ventio harpoon
gun sherman
na whaling
tely.

BOOK III (Duodecimo).
CHAPTER II
Algerine Porpoise.

137

BOOK III (Duodecimo),
CHAPTER III (Mealy-
mouthed Porpoise).

COLORED PENCIL AND INK ON FOUND
PAPER
8″ × 5.5″
10/03/10

138

...the command of a whale-ship was not wholly lodged in the person now called the captain, but was divided between him and an officer called the Specksynder. Literally this word means Fat-Cutter...

ACRYLIC PAINT, CRAYON AND INK ON FOUND PAPER
8.25″ × 11.5″
01/22/10

139

…(night watches on a whaling ground)…

ACRYLIC PAINT AND INK ON FOUND
PAPER
8″ × 11″
01/23/10

140

*That certain sultanism
of his brain…*

**ACRYLIC PAINT, COLORED PENCIL AND
INK ON FOUND PAPER**
8" × 11"
01/23/10

141

It is noon; and Dough-Boy, the steward, thrusting his pale loaf-of-bread face from the cabin-scuttle, announces dinner to his lord and master…

INK ON FOUND PAPER
9" × 11"
01/24/10

142

With one mind, their intent eyes all fastened upon the old man's knife, as he carved the chief dish before him.

INK ON FOUND PAPER
6″ x 7.5″
01/25/10

Figure 4. The Principle of Reaction

a foot-rest. Then both Newton's Third Law and common sense
tell us that whatever speed the man has given himself in jumping
to the right will be exactly equal to the speed with which the
trolley rolls off to the left.

If on the other hand the trolley weighed twice as much as the
man, its speed would be only half his, and so on for any other
ratio. The law of reaction is always just that.

It should be noticed that in this example, unlike the case of
walking, friction did not play any part in producing the thrust.
The man was able to exert the necessary "push" against some
fixed part of the trolley.

A more familiar, and certainly more striking, example of reac-
tion occurs when a gun is fired. In this case the explosion of the
charged speed of the breath provides the thrust,
very far from being equal. Yet once
if the gun weighed a thou-
sand times as much as the recoil a thousandth
of the bullet's speed.

Now, perhaps, we can consider an easy based on the above
ideas which shows very clearly the principles of rocket propul-
sion. Returning to our friend on the trolley, let us imagine that
his vehicle is carrying a load of bricks (Figure 5). He takes one
and throws it towards the right, producing a recoil as he does so.
Since the mass of the bricks is only a small fraction of that of the
trolley and its cargo, the velocity with which the vehicle moves

143

*For what he ate did not so
much relieve his hunger, as
keep it immortal in him.*

BALLPOINT PEN AND INK ON FOUND
PAPER
5″ × 8″
01/28/10

144

*...while Tashtego, knife
in hand, began laying
out the circle preliminary
to scalping him.*

**COLORED PENCIL, INK AND MARKER
ON FOUND PAPER
8" x 11"
01/29/10**

145

But, doubtless, this noble savage fed strong and drank deep of the abounding element of air…

COLORED PENCIL, INK AND MARKER
ON FOUND PAPER
8" × 5"
01/30/10

146

...so, in his inclement, howling old age, Ahab's soul, shut up in the caved trunk of his body, there fed upon the sullen paws of its gloom!

INK ON FOUND PAPER
8.5" × 10.5"
01/30/10

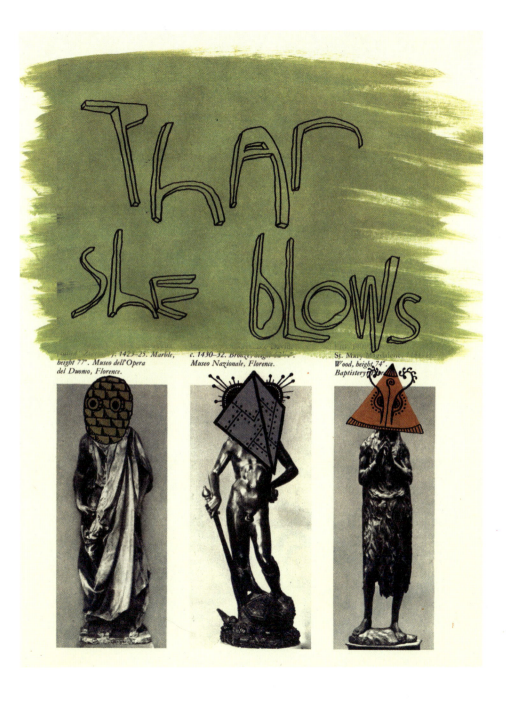

147

Of modern standers-of-mast-heads we have but a lifeless set; mere stone, iron, and bronze men; who, though well capable of facing out a stiff gale, are still entirely incompetent to the business of singing out upon discovering any strange sight.

ACRYLIC PAINT AND INK ON FOUND PAPER
8" x 11"
01/31/10

148

*There you stand, a hundred
feet above the silent decks,
striding along the deep, as
if the masts were gigantic
stilts, while beneath you
and between your legs, as
it were, swim the hugest
monsters of the sea…*

INK AND MARKER ON FOUND PAPER
6" × 7.75"
10/25/10

149

...for as the soul is glued inside of its fleshly tabernacle, and cannot freely move about in it, nor even move out of it, without running great risk of perishing...

ACRYLIC PAINT ON FOUND PAPER
4.5″ × 7.75″
10/01/10

150

*...vagrant sea unicorns
infesting those waters.*

**BALLPOINT PEN ON FOUND PAPER
8.25" × 11.75"
02/03/10**

The Mast-Head

There is no life in thee, now, except that rocking life imparted by a gentle rolling ship; by her, borrowed from the sea; by the sea, from the inscrutable tides of God. But while this sleep, this dream is on ye, move your foot or hand an inch; slip your hold at all; and your identity comes back in horror. Over Descartian vortices you hover. And perhaps, at mid-day, in the fairest weather, with one half-throttled shriek you drop through that transparent air into the summer sea, no more to rise for ever. Heed it well, ye Pantheists!

151

...yet that disadvantage is greatly counterbalanced by the widely contrasting serenity of those seductive seas in which we South fishers mostly float.

COLORED PENCIL ON FOUND PAPER
6.25″ × 10″
02/03/10

...but lulled into such an opium-like listlessness of vacant, unconscious reverie is this absent-minded youth by the blending cadence of waves with thoughts, that at last he loses his identity…

INK ON FOUND PAPER
4.25″ × 7″
02/04/10

153

Did you fixedly gaze, too, upon that ribbed and dented brow; there also, you would see still stranger foot-prints—the foot-prints of his one unsleeping, ever-pacing thought.

COLLAGE AND INK ON FOUND PAPER
11.5″ × 8.25″
02/06/10

154

"Look ye! d'ye see this Spanish ounce of gold?"—holding up a broad bright coin to the sun—"it is a sixteen dollar piece, men. D'ye see it?"

ACRYLIC PAINT AND INK ON FOUND PAPER
6" × 8"
10/01/10

155

"Captain Ahab," said Tashtego, "that white whale must be the same that some call Moby Dick."

ACRYLIC PAINT AND INK ON FOUND PAPER
7.75" × 11"
02/07/10

156

"Aye, aye! and I'll chase him round Good Hope, and round the Horn, and round the Norway Maelstrom, and round perdition's flames before I give him up."

ACRYLIC PAINT, BALLPOINT PEN, INK AND MARKER ON FOUND PAPER
11" × 7.75"
02/07/10

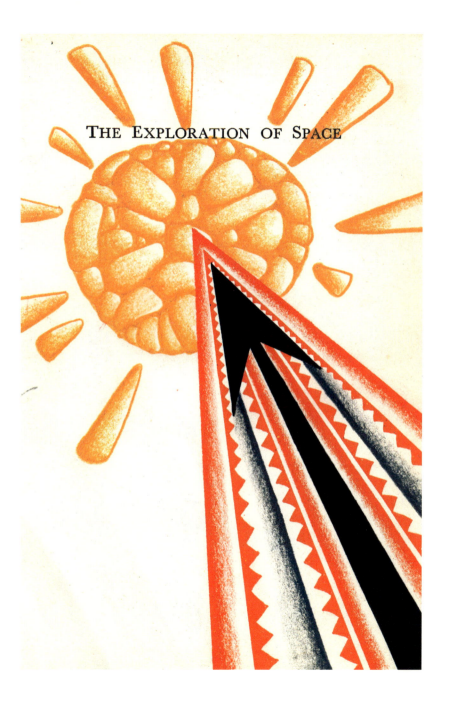

THE EXPLORATION OF SPACE

157

"...I'd strike the sun if it insulted me."

COLORED PENCIL ON FOUND PAPER
5" x 8"
02/09/10

158

"God keep me!—keep us all!"
murmured Starbuck, lowly.

ACRYLIC PAINT, INK AND MARKER ON
FOUND PAPER
9.5" × 7.75"
10/31/10

159

*"Advance, ye mates! Cross
your lances full before me."*

INK AND MARKER ON FOUND PAPER
7.75" × 11"
02/10/10

160

"Drink, ye harpooneers! drink and swear, ye men that man the deathful whaleboat's bow—Death to Moby Dick! God hunt us all, if we do not hunt Moby Dick to his death!"

MARKER ON FOUND PAPER
7.75" × 11"
02/10/10

161

"I am madness maddened!"

INK ON FOUND PAPER
8.5" × 10.5"
02/12/10

162

*The white whale is
their demigorgon.*

INK ON FOUND PAPER
7″ × 9.5″
02/13/10

THE RIDDLE OF CREATION

The theory of evolution by natural selection was put forward in
the 1850s independently by two men. One was Charles Darwin,
the other was Alfred Russel Wallace. Both men had some scien-
tific background, of course, but at heart both men were
naturalists. Darwin had been a medical student at Edinburgh
University for two years, before his father, who was a wealthy
doctor, proposed that he might become a clergyman and sent him
to Cambridge. Wallace, whose parents were poor and who had
left school at fourteen, had followed courses at Working Men's
Institutes in London and Leicester as a surveyor, apprentice and
pupil teacher.

The fact is that there are two traditions of exploration that
march side by side in the ascent of man. One is the analysis of the
physical structure of the world. The other is the study of the pro-
cesses of life: their delicacy, their diversity, the wavering cycles
from life to death in the individual and in the species. And these
traditions do not come together until the theory of evolution;
because until then there is a paradox which cannot be resolved,
which cannot be begun, about life.

The paradox of the life sciences, which makes them different in
kind from physical science, is in the detail of nature everywhere.
We see it about us in the birds, the trees, the grass, the snails, in
every living thing. It is this. The manifestations of life, its ex-
pressions, its forms, are so diverse that they must contain a large
element of the accidental. And yet the nature of life is so uniform
that it must be constrained by many necessities.

So it is not surprising that biology as we understand it begins
with naturalists in the eighteenth and nineteenth centuries:
observers of the countryside, bird-watchers, clergymen, doctors,
gentlemen of leisure in country houses. I am tempted to call
them, simply, 'gentlemen in Victorian England', because it can-
not be an accident that the theory of evolution is conceived twice
by two men living at the same time in the same culture – the
culture of Queen Victoria in England.

The paradox of the life
sciences is in the detail of
nature everywhere.
*A single jungle tree in bloom in
a forest of vegetative profusion.*

163

*Because a laugh's the
wisest, easiest answer
to all that's queer…*

ACRYLIC PAINT AND INK ON FOUND
PAPER
6.5″ × 9″
02/14/10

164

*Our captain stood
upon the deck, / A spy-
glass in his hand…*

**ACRYLIC PAINT, COLORED PENCIL AND
INK ON FOUND PAPER**
7.5" × 9"
02/15/10

*"I've the sort of mouth
for that…"*

**INK AND MARKER ON FOUND PAPER
11″ × 7.75″
02/16/10**

166

Go it, Pip! Bang it, bell-boy!
Rig it, dig it, stig it, quig
it, bell-boy! Make fire-
flies; break the jinglers!

INK AND MARKER ON FOUND PAPER
7″ × 9.5″
02/16/10

THE HIDDEN STRUCTURE

It is with fire that blacksmiths iron subdue
Unto fair form, the image of their thought :
Nor without fire hath any artist wrought
Gold to its utmost purity of hue.
Nay, nor the unmanned phoenix lives anew,
Unless she burn.

Michelangelo, *Sonnet 59*

...s accomplished by fire is alchemy, whether in the furnace or kitchen stove.
Paracelsus

...here is a special mystery and fascination a... ...n's relation ...o fire, the only one of the four Greek ele... ... no animal ...nhabits (not even the salamander). Mode... ...al science is ...much concerned with the invisible fine str... ...f matter, and ...hat is first opened by the sharp instrument... Although that ...node of analysis beg... ...eral thousandgo in practical ...ocesses (the extr... ...n ...lt and of m... ...for example) it ...urely set goin... ...the... ...of magic th... ...oils out of the fire : ...emical fee... ...ubstanc... ...n be changed in un- ...pre... ...ways... ...ous quality that seems to make fire... ...ving thing to carry us into a hidden underw... ...material world. Many ancient recipes express...

Now the substance... ...cin... ...ba... ...s... that the more it is heated, the more exquisite are its sub... ...ation... ...r will become mercury, and passing through a series ofit is again turned into cinnabar, and thus it enables man to...

This is the cla... ...h which the alchemists in the Middle Age... ...awe... ...who watched them, all the way from... ...Spain. They... ...he red pigment, cinnabar, which... ...de of mercury, a... ...ed it. The heat drives off the su... ...eaves behinde pearl of the mysteri- ous s... ...metal mer... ...ish and strike awe into the pa... ...e mercury... ...d in air it is oxidised and becom... ...recipe t... ...ght) cinnabar again, but an oxide o... ...s also red. Yet the recipe was not quite

The numinous quality
that seems to make fire a
source of life.
'Le Souffleur à la Lampe' by
Georges de la Tour.

64

167

There's naught so sweet
on earth—heaven may
not match it!—as those
swift glances of warm, wild
bosoms in the dance, when
the over-arboring arms hide
such ripe, bursting grapes.

INK ON FOUND PAPER
7.75" × 11"
02/18/10

168

*Hail, holy nakedness of
our dancing girls!*

COLLAGE ON CHIPBOARD AND FOUND
PAPER
8.5" x 11"
02/19/10

Through the telescope

"Our captain has his birth-mark; look yonder, boys, there's another in the sky—lurid-like, ye see, all else pitch black."

INK AND MARKER ON FOUND PAPER
10.75" × 7.5"
02/21/10

"Jollies? Lord help such jollies! Crish, crash! there goes the jib-stay! Blang-whang! God!"

INK AND MARKER ON FOUND PAPER
4.25" × 7"
02/21/10

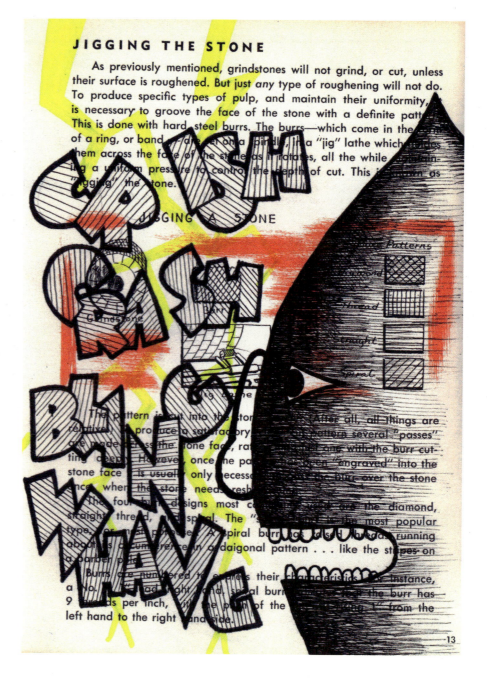

would have an almanac or "ephemeris" containing tables which gave the positions of the planets at any time, and Figure 13 shows how he could use this to locate his ship. (For simplicity, we will assume that ship and planets lie in the same plane. This would not be very far from the truth, and there is no difficulty in allowing for the error in practice.) Let us suppose that Venus and the Earth are the two most convenient planets to observe.

By means of a sextant, or whatever its equivalent device may be in astronautics, the navigator first measures the angle A between Sun and Earth. He knows, from the almanac, the position of the Earth, and hence the line Sun-Earth is fixed. Next he measures the angle B between Venus and the Sun—and since the line Sun-Venus is also known, simple geometry fixes the spaceship's position at X.

Since there would seldom be less than three, and would often be five, bright planets available for observation this is clearly a very useful method, as well as an extremely simple one.

An alternative though less accurate method of position-finding would be to measure the *apparent size* of the Sun and planets. Since their diameters are known, this would fix the *distance* of the ship from each of them, and so locate it in space. This would be particularly valuable when one was approaching a planet, and its disc was becoming fairly large. It would not give accuracy until the

Figure 13. Position-finding in Space

171

I, Ishmael, was one of that crew; my shouts had gone up with the rest; my oath had been welded with theirs; and stronger I shouted, and more did I hammer and clinch my oath, because of the dread in my soul.

COLORED PENCIL AND INK ON FOUND PAPER
5″ × 8″
02/21/10

172

*...a Sperm Whale of
uncommon magnitude and
malignity, which whale,
after doing great mischief
to his assailants, had
completely escaped them...*

**ACRYLIC PAINT, BALLPOINT PEN AND
INK ON FOUND PAPER**
7.75" × 11"
02/22/10

173

No wonder, then, that ever gathering volume from the mere transit over the widest watery spaces, the outblown rumors of the White Whale did in the end incorporate with themselves all manner of morbid hints, and half-formed foetal suggestions of supernatural agencies, which eventually invested Moby Dick with new terrors unborrowed from anything that visibly appears.

ACRYLIC, BALLPOINT PEN, INK AND PENCIL ON FOUND PAPER
11″ x 7.75″
02/23/10

174

One of the wild suggestions referred to, as at last coming to be linked with the White Whale in the minds of the superstitiously inclined, was the unearthly conceit that Moby Dick was ubiquitous; that he had actually been encountered in opposite latitudes at one and the same instant of time.

INK ON FOUND PAPER
7.75" × 11"
02/25/10

THE PERCEPTION OF THE OBSERVER

The deaf cannot ~~appreciate~~ a Brahms symphony. The blind cannot know the sensation of ~~a red color~~ opposed to a green one of equal brilliance. Between the observer ~~are~~ the limitations imposed by the ability to perceive.

Except for the blind, perception of the visual arts would seem to pose no difficult problems, but few persons of normal vision realize how limited their perception really is.

Perception, our awareness of the world around us, based on the information that comes through the senses, is too often considered a natural, matter-of-fact attribute of the human being. The assumption is made that everyone sees the same things, that the world, as we know it through our sight, hearing, touch, and ability to smell, is the same for all. This is not so.

For some time psychologists and physiologists have known that there is a considerable difference between the raw information given to the brain by the senses (sensations) and our awareness of the world based on this information (perceptions). Professor J. Z. Young, an English physiologist, describes a number of experiments performed with individuals born blind who, in their later years, were enabled to see. Under these conditions the scientist has an opportunity to study the phases of visual training normally passed through by children, because the adult, unlike the child, can describe with accuracy what is happening to him. The once-blind person, now physiologically normal, does not "see" the world immediately.

The patient on opening his eyes for the first time gets little or no enjoyment; indeed, he finds the experience painful. He reports only a spinning mass of lights and colours. He proves to be quite unable to pick out objects by sight, to recognize what they are, or to name them. He has no conception of a space with objects in it, although he knows all about objects and their names by touch. "Of course," you will say, "he must take a little time to learn to recognize them by sight." Not a *little* time, but a very, very long time, in fact, years. His brain has not been trained in the rules of seeing. We are not conscious that there are any such rules; we think that we see, as we say, "naturally." But we have in fact learned a whole set of rules during childhood.

Young goes on to say that the once-blind man can learn to "see" only by training his brain. By expending a considerable amount of effort, he can gradually understand the visual experiences of color, form, space, and textures.

These experiments suggest that the sensations we receive have no meaning for us until we know how to order them into a coherent perception. Sensation is only one part of perception. Also included in the construction of a percept is the past experience of the observer and his ability to combine sensations into a meaningful form. To perceive something requires that the observer make a selection of the numerous sensations transmitted to him at any one time. He must select those sensations which are significant for the construction of a particular experience and disregard those which are irrelevant. As Young points out, this requires training. The untrained observer cannot make sense out of what he sees before him.

Doubt and Certainty in Science, Oxford University Press, London

175

...declating Moby Dick not only ubiquitous, but immortal (for immortality is but ubiquity in time)...

COLORED PENCIL, INK AND MARKER
ON FOUND PAPER
7.75" × 11"
02/25/10

176

The rest of his body was so streaked, and spotted, and marbled with the same shrouded hue, that, in the end, he had gained his distinctive appellation of the White Whale; a name, indeed, literally justified by his vivid aspect, when seen gliding at high noon through a dark blue sea, leaving a milky-way wake of creamy foam, all spangled with golden gleamings.

INK ON FOUND PAPER
10" × 6"
02/27/10

177

All that most maddens and torments; all that stirs up the lees of things; all truth with malice in it; all that cracks the sinews and cakes the brain; all the subtle demonisms of life and thought; all evil, to crazy Ahab, were visibly personified, and made practically assailable in Moby Dick.

INK ON FOUND PAPER
7.75″ × 11″
02/28/10

178

Ahab's full lunacy subsided not,
but deepeningly contracted...

BALLPOINT PEN AND INK ON FOUND
PAPER
7.75" × 11"
02/28/10

The Solar System

The evolution of the Solar System is believed to have started with an interstellar cloud of gas and dust which fragmented and condensed (A). Nuclear fusion then began and the Sun was born (B). Astronomers also agree that the planets condensed from the gas and dust around the Sun (C). Some suggest that, as they accreted the planets were pulled into solar orbit (D). The Sun is a young star; as it ages it will expand (E) to become a red giant (F) and engulf its planetary system.

B C

erial, ranging from ... distribution of momentum and rotation that
Sun to matter ... the ... exist ... Solar System. The planets themselves
Sun's gravity ... and dust ... coh- ... could ... condensed from the gas and dust
densed into the ... planetesimals, which ... young Sun, building up from local
eventually built up ... planetary system we know ... conditions, through the planetesimal stage
today. This ... sequence would explain ... finally into the planets that we observe today.
presence of asteroids which are ... planets ... If such variables are an indication of pos-
that never accreted into ... possibly ... sible early processes within our own Solar System,
of the gravitational influence of giant ... then they could also indicate other similar embry-
Jupiter. ... onic planetary systems. The idea of a planetary
Towards ... centre ... vention ... group forming from a nebula surrounding a
French ... Pierre-Simon de Laplace ... young ... is more credible than that of an accid-
pro... ... some ... rings ... ental ... with, for example, matter being
of gas thrown off by the young ... but this the- ... dragged from a passing star. The former notion
ory would not explain ... Sun ... dispropor- ... indicates that the process of planetary formation
tionately ... tor ... in the Solar System ... happens on a fairly regular basis, that other sys-
were concentrated in the ... he suggests ... the ... tems are commonplace, and that they are the
Sun would have almost the correct amount of ... standard by-product of a young star.
moment ... which is not the case. According to ... On the other hand, the chances of any parti-
the Australian astronomer A. J. Prentice, how- ... cular star passing close enough to another to
ever, Laplace's idea would work if the solar co- ... cause a matter transfer on such a scale are very
was supposed to have condensed at a sufficiently ... remote, and would mean that our Solar System is
rapid rate to push the angular momentum ... almost unique. But stellar collisions, or near-col-
outward into the surrounding space. Prentice's ... lisions, are not the only way that a planetary sys-
modification of Laplace's original idea has gained ... tem could form accidentally; a star could pass
some popularity. ... through a nebula and draw off matter from the
nebula while doing so. This matter could accumu-
Other planetary systems ... late and condense into planets, although this, too,
Looking to other regions of the galaxy for ... would be unlikely.
answers to their questions astro... stu- ... Theories may be proposed unendingly, but
died groups of stars and in ... without actual observational proof the idea of
iable stars. T Tauri is the ... extra-solar planetary systems remains just an idea.
kind of star which vari... ... Even the world's largest telescopes are unable to
sity. This star, and o... ... detect planets orbiting other suns because the
stars in the early st... ... light from any non-luminous companions would
throwing off mass w... ... be obscured in the glare from the parent star. Such
ulosity surrounding ... objects may, however, be detected from the obser-
of this matter is not u... ... vation of gravitational effects within other
to vary in brightness as ... systems.
between the star and ours ...
matter from the star in this way ... to ... **Wobbling stars**
decrease its angular momentum. If the Sun had ... Two gravitationally-bound bodies orbit each
gone through a similar phase this ... explain ... other around their mass center – their common

179

Gnawed within and scorched without, with the infixed, unrelenting fangs of some incurable idea…

ACRYLIC PAINT ON FOUND PAPER
7.75" × 10.75"
03/01/10

180

For one, I gave myself up to the abandonment of the time and the place; but while yet all a-rush to encounter the whale, could see naught in that brute but the deadliest ill.

ACRYLIC PAINT, CHARCOAL, COLORED PENCIL AND INK ON FOUND PAPER
9.25" × 6"
03/01/10

181

It was the whiteness of the whale that above all things appalled me.

COLORED PENCIL ON FOUND PAPER
7.5″ × 10.75″
03/02/10

182

...yet for all these accumulated
associations, with whatever
is sweet, and honorable,
and sublime, there yet lurks
an elusive something in the
innermost idea of this hue,
which strikes more of panic
to the soul than that redness
which affrights in blood.

ACRYLIC PAINT AND INK ON FOUND
PAPER
7.25″ x 10.75″
03/02/10

LEARNING TO FLY

183

I remember the first albatross I ever saw.

INK ON FOUND PAPER
7.5" × 10.75"
03/03/10

184

What is it that in the Albino man so peculiarly repels and often shocks the eye, as that sometimes he is loathed by his own kith and kin!

ACRYLIC PAINT AND INK ON FOUND PAPER
8" × 10.75"
03/05/10

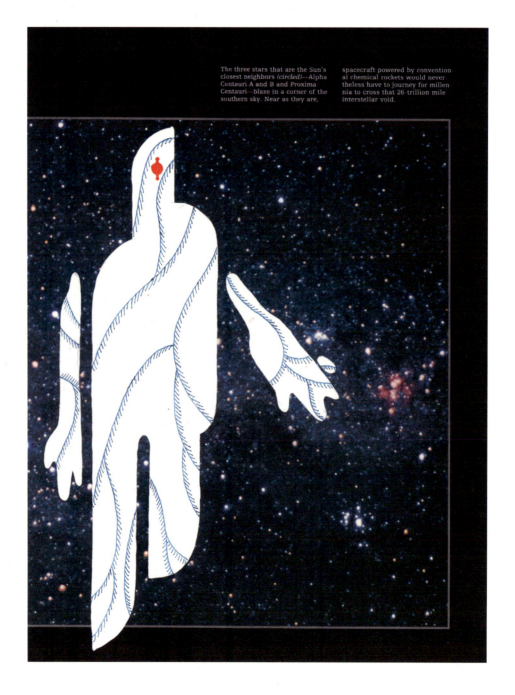

The three stars that are the Sun's closest neighbors *(circled)*—Alpha Centauri A and B and Proxima Centauri—blaze in a corner of the southern sky. Near as they are, spacecraft powered by conventional chemical rockets would nevertheless have to journey for millennia to cross that 26-trillion-mile interstellar void.

185

*Therefore, in his other moods,
symbolize whatever grand
or gracious thing he will
by whiteness, no man can
deny that in its profoundest
idealized significance
it calls up a peculiar
apparition to the soul.*

INK ON BRISTOL BOARD
7″ × 8.5″
10/01/10

186

Or why, irrespective of all latitudes and longitudes, does the name of the White Sea exert such a spectralness over the fancy…

INK AND MARKER ON WATERCOLOR PAPER
12″ × 8.25″
04/08/11

187

*Not so the sailor, beholding
the scenery of the Antarctic
seas; where at times, by some
infernal trick of legerdemain
in the powers of frost and
air, he, shivering and half
shipwrecked, instead of
rainbows speaking hope and
solace to his misery, views what
seems a boundless church-
yard grinning upon him
with its lean ice monuments
and splintered crosses.*

**ACRYLIC PAINT AND INK ON FOUND
PAPER**
8.5" x 11"
03/05/10

188

*...a colorless, all-color of
atheism from which we shrink?*

ACRYLIC PAINT ON FOUND PAPER
8″ × 9″
03/05/10

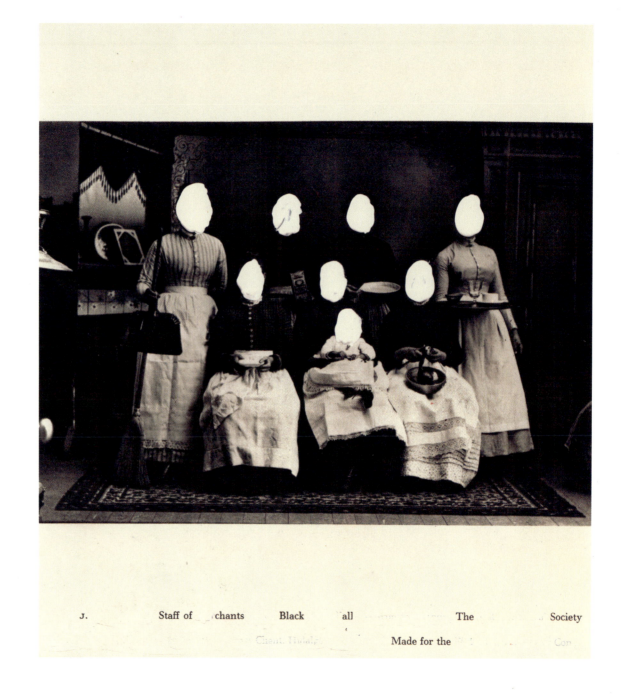

J. Staff of chants Black all The Society

Client. Holdg. Made for the Con

189

*And of all these things the
Albino Whale was the symbol.*

INK ON BRISTOL BOARD
7″ × 8.5″
03/06/10

190

While thus employed, the heavy pewter lamp suspended in chains over his head, continually rocked with the motion of the ship, and for ever threw shifting gleams and shadows of lines upon his wrinkled brow…

INK AND MARKER ON FOUND PAPER
5.75" × 10"
03/06/10

191

*...Ahab was threading a
maze of currents and eddies,
with a view to the more
certain accomplishment
of that monomaniac
thought of his soul.*

INK AND MARKER ON FOUND PAPER
8.25" × 11"
03/07/10

192

*...the Sperm Whales, guided
by some infallible instinct—
say, rather, secret intelligence
from the Deity—mostly swim
in* veins, *as they are called:
continuing their way along
a given ocean-line with such
undeviating exactitude, that
no ship ever sailed her course,
by any chart, with one tithe
of such marvellous precision.*

INK AND MARKER ON FOUND PAPER
7.5″ × 11″
03/07/10

193

...there the waves were
storied with his deeds...

INK ON FOUND PAPER
10.75″ × 8.5″
03/08/10

194

...and a chasm seemed opening in him, from which forked flames and lightnings shot up, and accursed fiends beckoned him to leap down among them…

INK AND MARKER ON FOUND PAPER
8″ × 10.75″
03/09/10

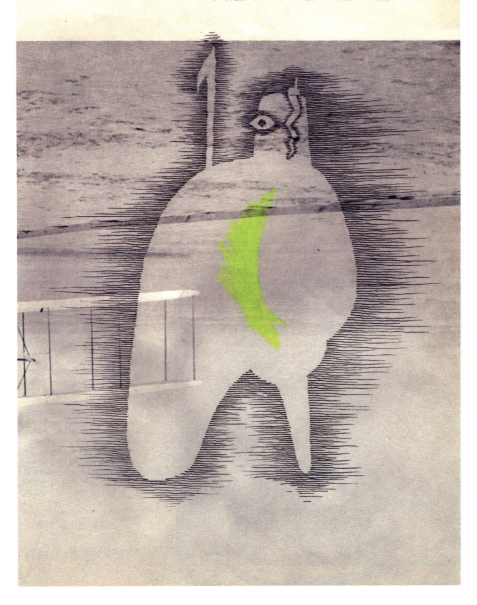

The First Powered Flight

195

Therefore, the tormented spirit that glared out of bodily eyes, when what seemed Ahab rushed from his room, was for the time but a vacated thing, a formless somnambulistic being, a ray of living light, to be sure, but without an object to color, and therefore a blankness in itself.

CRAYON AND INK ON FOUND PAPER
7.5" x 10.75"
03/10/10

196

First: I have personally known three instances where a whale, after receiving a harpoon, has effected a complete escape; and, after an interval (in one instance of three years), has been again struck by the same hand, and slain; when the two irons, both marked by the same private cypher, have been taken from the body.

ACRYLIC PAINT AND INK ON FOUND PAPER
11″ × 7.75″
03/11/10

197

*Was it not so, O Don Miguel!
thou Chilian whale, marked
like an old tortoise with mystic
hieroglyphics upon the back!*

INK AND MARKER ON FOUND PAPER
10.75″ × 13.75″
03 / 13 / 10

198

Do you suppose that that poor fellow there, who this moment perhaps caught by the whale-line off the coast of New Guinea, is being carried down to the bottom of the sea by the sounding Leviathan—do you suppose that that poor fellow's name will appear in the newspaper obituary you will read tomorrow at your breakfast?

INK ON FOUND PAPER
7.75" × 10.75"
03/14/10

199

The Sperm Whale is in some cases sufficiently powerful, knowing, and judiciously malicious, as with direct aforethought to stave in, utterly destroy, and sink a large ship; and what is more, the Sperm Whale has done it.

ACRYLIC PAINT AND INK ON FOUND PAPER
7.75" × 9.5"
03/14/10

200

I tell you, the Sperm Whale
will stand no nonsense.

ACRYLIC PAINT, COLORED PENCIL AND
INK ON FOUND PAPER
7.5" × 10.75"
03/15/10

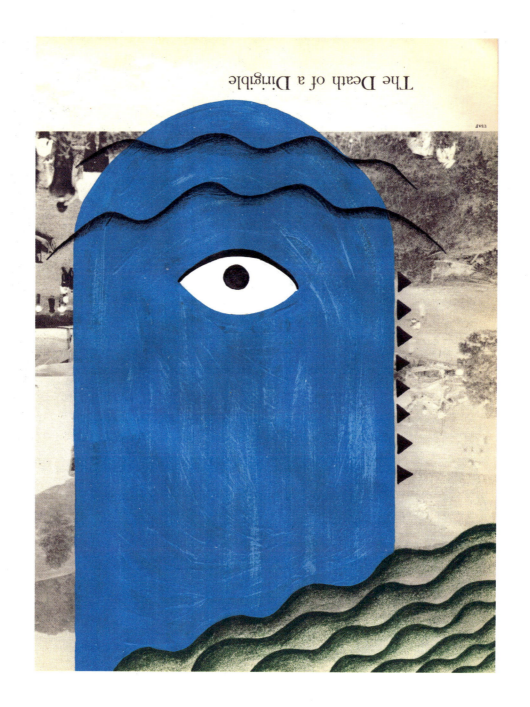

The Death of a Dirigible

201

An uncommon large whale, the body of which was larger than the ship itself, lay almost at the surface of the water, but was not perceived by any one on board till the moment when the ship, which was in full sail, was almost upon him…

COLORED PENCIL AND INK ON FOUND PAPER
7.5″ × 10.5″
03/16/10

202

...upon being attacked he will frequently open his mouth, and retain it in that dread expansion for several consecutive minutes.

INK ON FOUND PAPER
7″ × 4.25″
03/18/10

203

I am told, on good authority, that on the Barbary coast, a Commodore Davis of the British navy found the skeleton of a Sperm Whale.

ACRYLIC PAINT, CHARCOAL, COLORED
PENCIL AND INK ON FOUND PAPER
10.5″ × 8.5″
03/19/10

204

*To accomplish his object
Ahab must use tools…*

INK ON FOUND PAPER
7.5" × 10.5"
03/20/10

205

*…(for few men's courage
is proof against protracted
meditation unrelieved
by action)…*

INK ON FOUND PAPER
7.5″ × 10.5″
03/20/10

*That protection could
only consist in his own
predominating brain and
heart and hand…*

**COLORED PENCIL AND INK ON FOUND
PAPER**
6.75" × 8.5"
03/20/10

Scientists think now that the power source that regulates these living clocks is not inside them. Scientists think the clocks are regulated by the movements and magnetic forces of the sun, the moon, and the earth. There is no way for anything on earth to be disconnected from these power sources.

THE CLOCK IN YOUR BODY

Everything in your body has a rhythm. Everything keeps time.

You breathe a certain number of times a minute, and your heart beats a certain number of times. You blink and swallow as regularly as clockwork. Your body has certain regular changes in the course of a lunar month.

Even though you do not use it, because you have learned to depend on man-made clocks, you have a wonderful, built-in time sense. Most people can train themselves to use this sense.

Here's an experiment to try. Before you go to bed, tell yourself exactly what time you want to wake up. Repeat this a few times and for a few nights, and see what happens. Most people can be their own alarm clocks — but if you don't go off, it's no excuse for being late to school!

207

Thus we were weaving and weaving away when I started at a sound so strange, long drawn, and musically wild and unearthly, that the ball of free will dropped from my hand, and I stood gazing up at the clouds…

INK ON FOUND PAPER
8.5" x 11"
03/21/10

208

High aloft in the cross-trees was that mad Gay-Header, Tashtego. His body was reaching eagerly forward, his hand stretched out like a wand, and at brief sudden intervals he continued his cries.

COLORED PENCIL, INK AND MARKER
ON FOUND PAPER
7.5" x 10.5"
03/22/10

209

The figure that now stood by its bows was tall and swart, with one white tooth evilly protruding from its steel-like lips. A rumpled Chinese jacket of black cotton funereally invested him, with wide black trowsers of the same dark stuff. But strangely crowning this ebonness was a glistening white plaited turban, the living hair braided and coiled round and round upon his head.

ACRYLIC PAINT, CHARCOAL, COLORED PENCIL, CRAYON AND INK ON FOUND PAPER
7.5" × 10.75"
03/22/10

210

*Hardly had they pulled out
from under the ship's lee,
when a fourth keel, coming
from the windward side,
pulled round under the
stern, and showed the five
strangers rowing Ahab…*

INK ON PAPER
8" × 5"
03/23/10

211

He would say the most terrific things to his crew, in a tone so strangely compounded of fun and fury, and the fury seemed so calculated merely as a spice to the fun, that no oarsman could hear such queer invocations without pulling for dear life, and yet pulling for the mere joke of the thing.

INK AND MARKER ON FOUND PAPER
11″ × 7.75″
03/24/10

212

*Those tiger yellow creatures
of his seemed all steel
and whalebone…*

INK AND MARKER ON FOUND PAPER
7.75" × 11"
03/27/10

213

The whales had irregularly settled bodily down into the blue, thus giving no distantly discernible token of the movement…

INK AND MARKER ON FOUND PAPER
7.75" × 11"
03/27/10

214

*But the sight of little Flask
mounted upon gigantic
Daggoo was yet more curious;
for sustaining himself with
a cool, indifferent, easy,
unthought of, barbaric majesty,
the noble negro to every roll of
the sea harmoniously rolled his
fine form. On his broad back,
flaxen-haired Flask seemed
a snow-flake. The bearer
looked nobler than the rider.*

**ACRYLIC PAINT, INK AND MARKER ON
FOUND PAPER**
8.5″ × 11″
04/02/10

215

Seen in advance of all the other indications, the puffs of vapor they spouted, seemed their forerunning couriers and detached flying outriders.

BALLPOINT PEN, INK, MARKER AND
SPRAY PAINT ON FOUND PAPER
7.75" × 11"
04/02/10

216

...the brief suspended agony of the boat, as it would tip for an instant on the knife-like edge of the sharper waves, that almost seemed threatening to cut it in two…

INK AND MARKER ON FOUND PAPER
7.75" × 11"
04/03/10

THE ART OBJECT

WHAT IS a work of art? In gener... the ... "art" may include the products of a wide area of human sp... ... and writ... word to the us... minute size... delicate craf... The ... figure both of the an... bronze the six... gre... ... of the goddess Athe... material, are cons... works of ar... obv... and there... ... compare the Pablo (Fig... ... and a piece of sculp... produced in the ... twentieth century, ...d the di... art seen even more strikingly.

FIG. 9. Draped Warrior, Greek. 6th cent. ... Bronze, height 7¹/₂... The Wadsworth Atheneum, Hartford.

217

...with a lightning-like hurtling whisper Starbuck said: "Stand up!" and Queequeg, harpoon in hand, sprang to his feet.

**COLORED PENCIL, INK AND MARKER
ON FOUND PAPER
8.5" × 10.75"
04/04/10**

218

*Squall, whale, and harpoon
had all blended together…*

**BALLPOINT PEN AND INK ON FOUND
PAPER**
10.75″ × 15.25″
04/06/10

219

There are certain queer times and occasions in this strange mixed affair we call life when a man takes this whole universe for a vast practical joke, though the wit thereof he but dimly discerns, and more than suspects that the joke is at nobody's expense but his own.

ACRYLIC PAINT AND CRAYON ON FOUND PAPER
10.75" × 15.75"
04/07/10

220

*"Mr. Stubb," said I, turning
to that worthy, who, buttoned
up in his oil-jacket, was
now calmly smoking his
pipe in the rain…*

**ACRYLIC PAINT, INK AND PENCIL ON
SKETCHBOOK PAGE
6.75" × 10"
04/09/10**

221

I looked round me tranquilly and contentedly, like a quiet ghost with a clean conscience sitting inside the bars of a snug family vault.

INK ON FOUND PAPER
7″ × 6″
04/09/10

THE ARCH AND VAULT

Because stone is a permanent, fireproof, impressive material, it was used by builders wherever it was available. The earliest attempts at building with this material were probably no more than piles of rocks heaped one upon the other, with a small space left open within the pile. The open space was created by piling the stones about it so that the upper stones projected slightly beyond the lower ones, gradually converging from all sides until they joined at the top of the structure. This is corbeled construction (Fig. 219). Examples of this method of construction

222

...the pursuit of whales is always under great and extraordinary difficulties…

ACRYLIC PAINT, COLLAGE AND INK ON FOUND PAPER
10.75" × 15.75"
04/11/10

223

...Beelzebub himself might climb up the side and step down into the cabin to chat with the captain...

ACRYLIC PAINT AND INK ON FOUND
PAPER
10.75″ × 15.75″
04/11/10

224

Lit up by the moon, it looked celestial; seemed some plumed and glittering god uprising from the sea.

INK ON FOUND PAPER
7.75" × 10.75"
04/12/10

225

...*every reclining mariner started to his feet as if some winged spirit had lighted in the rigging, and hailed the mortal crew.* "*There she blows!*"

INK ON FOUND PAPER
17" × 11.5"
04/13/10

226

These temporary apprehensions, so vague but so awful, derived a wondrous potency from the contrasting serenity of the weather, in which, beneath all its blue blandness, some thought there lurked a devilish charm, as for days and days we voyaged along, through seas so wearily, lonesomely mild, that all space, in repugnance to our vengeful errand, seemed vacating itself of life before our urn-like prow.

ACRYLIC PAINT, COLORED PENCIL, INK
AND MARKER ON FOUND PAPER
7.5" × 10.5"
04/15/10

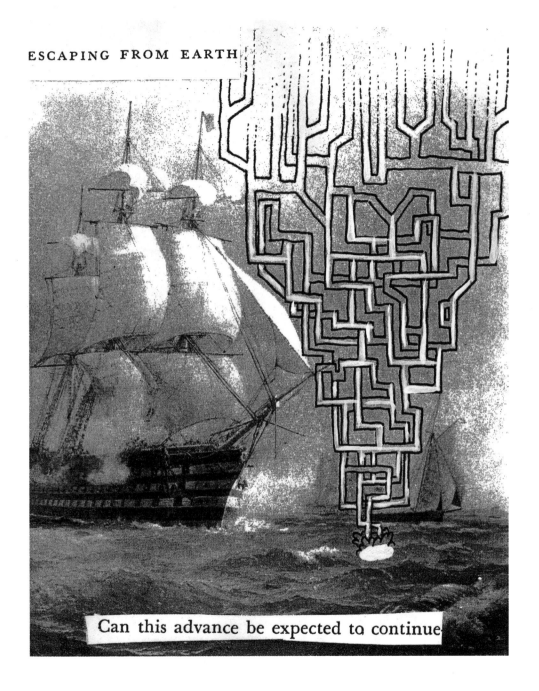

Can this advance be expected to continue

227

But calm, snow-white, and unvarying; still directing its fountain of feathers to the sky; still beckoning us on from before, the solitary jet would at times be descried.

INK ON FOUND PAPER, XEROXED
AND ENLARGED FOUR TIMES, THEN
PAINTED WITH WITE-OUT (ORIGINAL
DRAWING AND INTERVENING
XEROXES DESTROYED)
8.5" x 11"
04/15/10

228

...this craft was bleached like the skeleton of a stranded walrus. All down her sides, this spectral appearance was traced with long channels of reddened rust, while all her spars and her rigging were like the thick branches of trees furred over with hoar-frost.

INK ON FOUND PAPER
9.75" × 8"
04/27/10

229

"Swim away from me, do ye?" murmured Ahab, gazing over into the water. There seemed but little in the words, but the tone conveyed more of deep helpless sadness than the insane old man had ever before evinced.

COLORED PENCIL, INK AND MARKER
ON FOUND PAPER
7.25" × 10.75"
04/28/10

230

Were this world an endless plain, and by sailing eastward we could for ever reach new distances, and discover sights more sweet and strange than any Cyclades or Islands of King Solomon, then there was promise in the voyage.

INK AND MARKER ON WATERCOLOR PAPER
12" × 8"
05/01/10

231

Besides, the English whalers sometimes affect a kind of metropolitan superiority over the American whalers…

**COLORED PENCIL, INK AND MARKER
ON FOUND PAPER**
7.5″ × 10.75″
05/01/10

232

And as for Pirates, when they chance to cross each other's cross-bones, the first hail is—"How many skulls?"

ACRYLIC PAINT AND INK ON FOUND PAPER
10.75″ × 15.75″
05/01/10

233

And often you will notice that being conscious of the eyes of the whole visible world resting on him from the sides of the two ships, this standing captain is all alive to the importance of sustaining his dignity by maintaining his legs.

INK AND MARKER ON FOUND PAPER
6.25″ × 9.25″
10/31/10

234

It was not very long after speaking the Goney that another homeward-bound whaleman, the Town-Ho, was encountered. She was manned almost wholly by Polynesians.

ACRYLIC PAINT, INK AND MARKER ON FOUND PAPER
11" × 7.75"
05/03/10

235

For my humor's sake, I shall preserve the style in which I once narrated it at Lima, to a lounging circle of my Spanish friends, one saint's eve, smoking upon the thick-gilt tiled piazza of the Golden Inn. Of those fine cavaliers, the young Dons, Pedro and Sebastian, were on the closer terms with me...

INK AND MARKER ON FOUND PAPER
5″ × 8″
05/05/10

236

"...had it not been for the brutal overbearing of Radney, the mate…"

ACRYLIC PAINT, COLLAGE AND INK ON FOUND PAPER
7.75" × 11"
05/07/10

237

"...they are swept by Borean and dismasting blasts as direful as any that lash the salted wave..."

ACRYLIC PAINT AND BALLPOINT PEN ON FOUND PAPER
7.75" × 11"
05/07/10

238

"...at all events Steelkilt was a tall and noble animal with a head like a Roman, and a flowing golden beard like the tasseled housings of your last viceroy's snorting charger…"

ACRYLIC PAINT, COLLAGE AND INK ON FOUND PAPER
7.75" × 11"
05/08/10

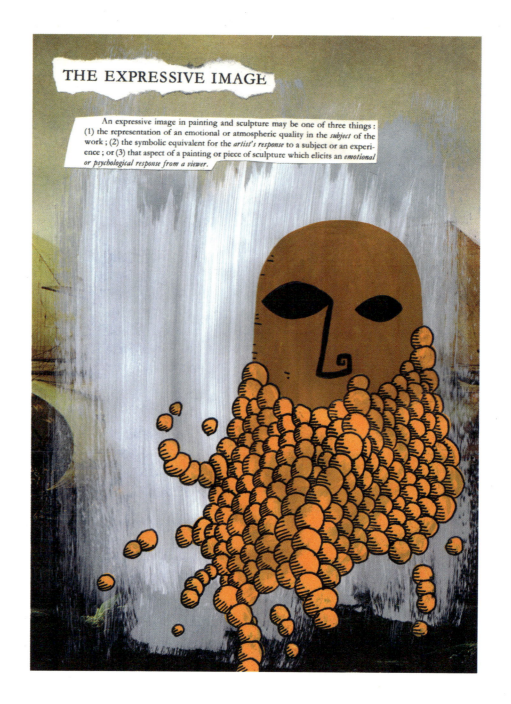

THE EXPRESSIVE IMAGE

An expressive image in painting and sculpture may be one of three things : (1) the representation of an emotional or atmospheric quality in the *subject* of the work ; (2) the symbolic equivalent for the *artist's response* to a subject or an experience ; or (3) that aspect of a painting or piece of sculpture which elicits an *emotional or psychological response from a viewer.*

239

"Quitting the pump at last, with the rest of his band, the Lakeman went forward all panting, and sat himself down on the windlass; his face fiery red, his eyes bloodshot, and wiping the profuse sweat from his brow..."

ACRYLIC PAINT, COLORED PENCIL AND
INK ON FOUND PAPER
7.75" x 11"
05/08/10

240

"Intolerably striding along the deck, the mate commanded him to get a broom and sweep down the planks, and also a shovel, and remove some offensive matters consequent upon allowing a pig to run at large."

ACRYLIC PAINT ON FOUND PAPER
7.75″ × 11″
05/09/10

241

"Immediately the hammer touched the cheek; the next instant the lower jaw of the mate was stove in his head; he fell on the hatch spouting blood like a whale."

ACRYLIC PAINT, COLLAGE AND INK ON FOUND PAPER
7.75" x 11"
05/09/10

242

*"...the holy-of-holies
of great forests..."*

**ACRYLIC PAINT AND INK ON FOUND
PAPER**
7.75" × 11"
05/09/10

243

"The brigandish guise which the Canaller so proudly sports; his slouched and gaily-ribboned hat betoken his grand features."

ACRYLIC PAINT AND INK ON FOUND PAPER
7.75" × 11"
05/11/10

244

"...while standing out of harm's way, the valiant captain danced up and down with a whale-pike, calling upon his officers to manhandle that atrocious scoundrel, and smoke him along to the quarter-deck."

ACRYLIC PAINT, CHARCOAL AND COLORED PENCIL ON FOUND PAPER
7.75" x 11"
05/12/10

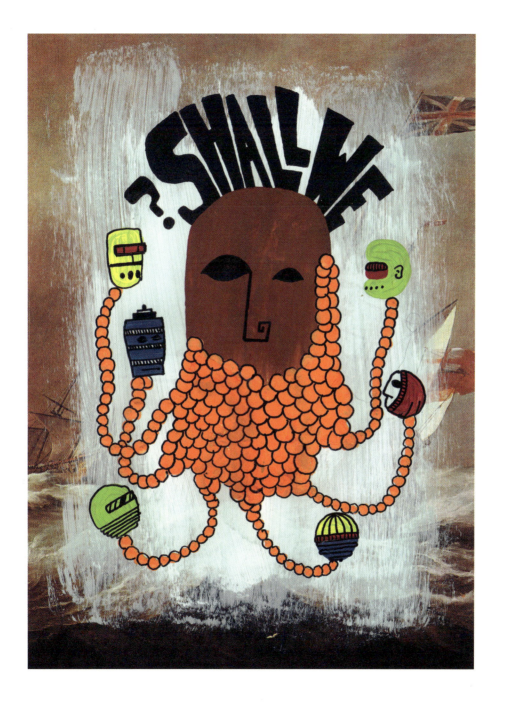

245

"'Shall we?' cried the ringleader to his men."

ACRYLIC PAINT AND INK ON FOUND PAPER
7.75" × 11"
05/14/10

246

"...it was then that Steelkilt proposed to the two Canallers, thus far apparently of one mind with him, to burst out of their hole at the next summoning of the garrison; and armed with their keen mincing knives (long, crescentic, heavy implements with a handle at each end) run amuck from the bowsprit to the taffrail..."

ACRYLIC PAINT, BALLPOINT PEN, COLLAGE AND INK ON FOUND PAPER
7.75" × 11"
05/15/10

247

"But all these were collared, and dragged along the deck like dead cattle; and, side by side, were seized up into the mizen rigging, like three quarters of meat, and there they hung till morning."

ACRYLIC PAINT AND INK ON FOUND PAPER
7.75" × 11"
05/15/10

248

*"Steelkilt here hissed out
something, inaudible to all
but the captain; who, to the
amazement of all hands,
started back, paced the deck
rapidly two or three times,
and then suddenly throwing
down his rope, said, 'I won't
do it—let him go—cut
him down: d'ye hear?'"*

**ACRYLIC PAINT, COLORED PENCIL AND
INK ON FOUND PAPER
7.75" × 11"
05/15/10**

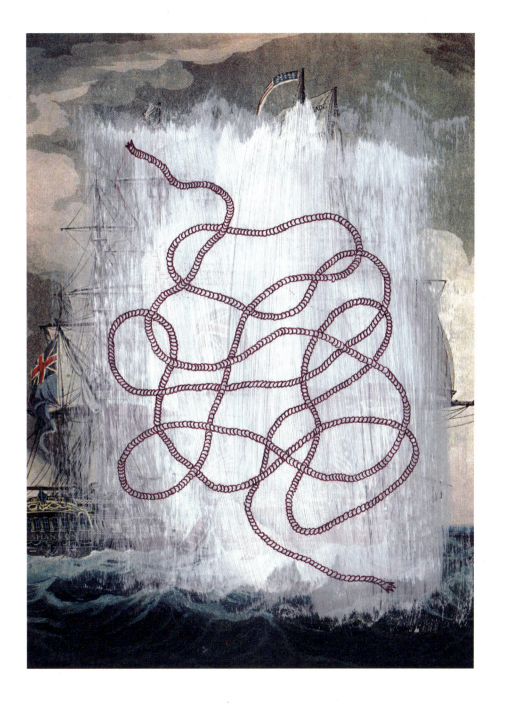

249

"'Shipmate, I haven't enough twine,—have you any?'"

ACRYLIC PAINT AND INK ON FOUND PAPER
7.75" × 11"
05/16/10

250

"For by a mysterious fatality, Heaven itself seemed to step in to take out of his hands into its own the damning thing he would have done."

ACRYLIC PAINT AND INK ON FOUND PAPER
7.75" × 11"
05/16/10

251

"...while the dogged crew eyed askance, and with curses, the appalling beauty of the vast milky mass, that lit up by a horizontal spangling sun, shifted and glistened like a living opal in the blue morning sea."

ACRYLIC PAINT, BALLPOINT PEN AND INK ON FOUND PAPER
11" x 7.75"
05/17/10

252

"But, at some distance, Moby Dick rose again, with some tatters of Radney's red woolen shirt, caught in the teeth [that] had destroyed him."

ACRYLIC PAINT AND INK ON FOUND PAPER
7.75" x 11"
05/18/10

253

"...but upon the island of Nantucket, the widow of Radney still turns to the sea which refuses to give up its dead; still in dreams sees the awful White Whale that destroyed him."

ACRYLIC PAINT AND INK ON FOUND PAPER
11" x 7.75"
05/19/10

254

It may be worth while, therefore, previously to advert to those curious imaginary portraits of him which even down to the present day confidently challenge the faith of the landsman. It is time to set the world right in this matter, by proving such pictures of the whale all wrong.

INK ON FOUND PAPER
10" x 7.75"
05/21/10

255

The Hindoo whale referred to, occurs in a separate department of the wall, depicting the incarnation of Vishnu in the form of Leviathan, learnedly known as the Matse Avatar.

ACRYLIC PAINT, BALLPOINT PEN, COLORED PENCIL, INK AND MARKER ON FOUND PAPER
7.75" × 11"
05/23/10

256

*In the vignettes and other
embellishments of some
ancient books you will at
times meet with very curious
touches at the whale, where
all manner of spouts, jets
d'eau, hot springs and cold,
Saratoga and Baden-Baden,
come bubbling up from
his unexhausted brain.*

INK AND MARKER ON FOUND PAPER
10.75″ × 7.75″
05/23/10

257

But the placing of the cap-sheaf to all this blundering business was reserved for the scientific Frederick Cuvier, brother to the famous Baron. In 1836, he published a Natural History of Whales, in which he gives what he calls a picture of the Sperm Whale. Before showing that picture to any Nantucketer, you had best provide for your summary retreat from Nantucket. In a word, Frederick Cuvier's Sperm Whale is not a Sperm Whale, but a squash.

ACRYLIC PAINT AND INK ON FOUND PAPER
8″ × 10.75″
05/25/10

←

258

*The living whale, in his full
majesty and significance,
is only to be seen at sea in
unfathomable waters; and
afloat the vast bulk of him is
out of sight, like a launched
line-of-battle ship…*

**COLLAGE, INK AND PENCIL ON FOUND
PAPER**
29.75″ × 10.75″
05/26/10

259

For all these reasons, then, any way you may look at it, you must needs conclude that the great Leviathan is that one creature in the world which must remain unpainted to the last. True, one portrait may hit the mark much nearer than another, but none can hit it with any very considerable degree of exactness. So there is no earthly way of finding out precisely what the whale really looks like.

MARKER ON FOUND PAPER
9" × 12"
05/26/10

260

*His jets are erect, full,
and black like soot…*

INK AND MARKER ON FOUND PAPER
5″ × 7.75″
05/27/10

261

And all the while the thick-lipped Leviathan is rushing through the deep, leaving tons of tumultuous white curds in his wake…

ACRYLIC PAINT, CHARCOAL, COLORED PENCIL, INK AND PENCIL ON FOUND PAPER
8.5" × 11"
05/28/10

262

It is a quiet noon-scene among the isles of the Pacific; a French whaler anchored, inshore, in a calm, and lazily taking water on board…

WATERCOLOR ON WATERCOLOR PAPER
8″ × 6″
05/30/10

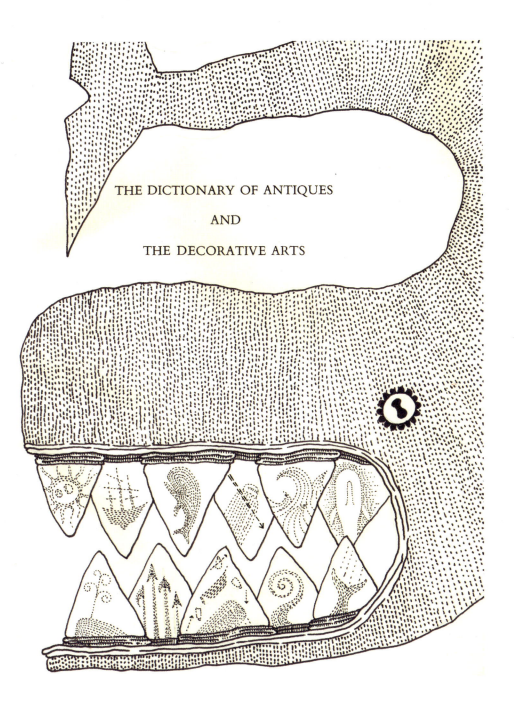

THE DICTIONARY OF ANTIQUES

AND

THE DECORATIVE ARTS

263

Throughout the Pacific, and also in Nantucket, and New Bedford, and Sag Harbor, you will come across lively sketches of whales and whaling-scenes, graven by the fishermen themselves on Sperm Whale-teeth…

INK AND MARKER ON FOUND PAPER
8″ x 10.5″
05/30/10

264

*In bony, ribby regions of the
earth, where at the base of
high broken cliffs masses of
rock lie strewn in fantastic
groupings upon the plain,
you will often discover images
as of the petrified forms of
the Leviathan partly merged
in grass, which of a windy
day breaks against them
in a surf of green surges.*

ACRYLIC PAINT, CHARCOAL, COLORED
PENCIL, INK AND PENCIL ON FOUND
PAPER
7.25" × 10.25"
05/31/10

265

Nor when expandingly lifted by your subject, can you fail to trace out great whales in the starry heavens...

INK AND MARKER ON FOUND PAPER
11.25″ × 8.25″
05/31/10

266

As morning mowers, who side by side slowly and seethingly advance their scythes through the long wet grass of marshy meads; even so these monsters swam, making a strange, grassy, cutting sound; and leaving behind them endless swaths of blue upon the yellow sea.

INK AND MARKER ON FOUND PAPER
10.75″ × 7.75″
06/02/10

Waves of the Sea

In this chapter we shall talk [...]
group of waves—the waves tha[...]
surface of the sea. Compared [...]
speed seismic waves and the so[...]
out by the echo-sounder, the [...]
travel quite slowly. Ocean [...]
ever kind, have a great deal [...]
other wave forms, but the[...]
portant differences. For o[...]
they travel comparativ[...]
visible to the naked [...]
about them just by [...]

You will find [...]
a puddle, bec[...]
water surf[...]
watch the [...]
dropped i[...]
ri[...]
t[...]

267

Yea; foolish mortals,
Noah's flood is not yet
subsided; two thirds of the
fair world it yet covers.

ACRYLIC PAINT ON FOUND PAPER
7.25″ × 10.25″
06/03/10

268

In the distance, a great white mass lazily rose, and rising higher and higher, and disentangling itself from the azure, at last gleamed before our prow like a snow-slide, new slid from the hills. Thus glistening for a moment, as slowly it subsided, and sank. Then once more arose, and silently gleamed.

ACRYLIC PAINT AND INK ON FOUND PAPER
15.5″ × 10.75″
06/03/10

269

The four boats were soon on the water; Ahab's in advance, and all swiftly pulling towards their prey. Soon it went down, and while, with oars suspended, we were awaiting its reappearance, lo! in the same spot where it sank, once more it slowly rose. Almost forgetting for the moment all thoughts of Moby Dick, we now gazed at the most wondrous phenomenon which the secret seas have hitherto revealed to mankind. A vast pulpy mass, furlongs in length and breadth, of a glancing cream-color, lay floating on the water, innumerable long arms radiating from its centre, and curling and twisting like a nest of anacondas, as if blindly to clutch at any hapless object within reach. No perceptible face or front did it have; no conceivable token of either sensation or instinct; but undulated there on the billows an unearthly, formless, chance-like apparition of life.

ACRYLIC PAINT AND INK ON FOUND PAPER
12" × 9"
06/05/10

270

*For though other species of
whales find their food above
water, and may be seen by
man in the act of feeding,
the spermaceti whale obtains
his whole food in unknown
zones below the surface; and
only by inference is it that
any one can tell of what,
precisely, that food consists.*

INK AND MARKER ON FOUND PAPER
7" × 15.5"
06/06/10

271

Hemp is a dusky, dark fellow, a sort of Indian; but Manilla is as a golden-haired Circassian to behold.

ACRYLIC PAINT, COLORED PENCIL AND INK ON FOUND PAPER
7.75" × 10.75"
06/07/10

272

As the least tangle or kink in the coiling would, in running out, infallibly take somebody's arm, leg, or entire body off…

ACRYLIC PAINT ON FOUND PAPER
10.75" × 7.75"
06/07/10

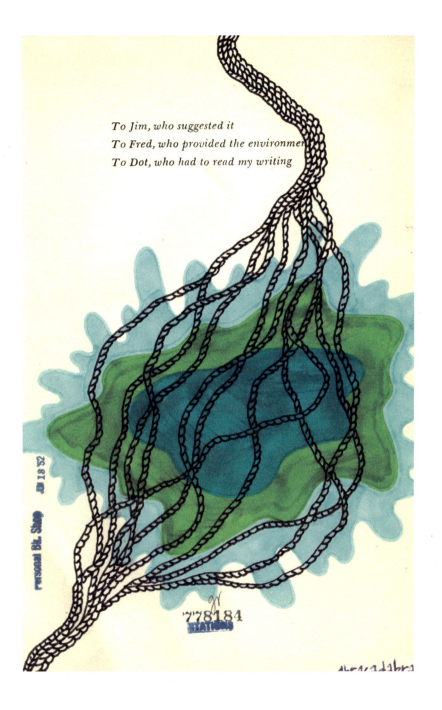

To Jim, who suggested it
To Fred, who provided the environmen[
To Dot, who had to read my writing

273

*...previous to that connexion,
the short-warp goes through
sundry mystifications
too tedious to detail.*

INK AND MARKER ON FOUND PAPER
4.75" × 8"
06 / 07 / 10

274

"When you see him 'quid,"
said the savage, honing his
harpoon in the bow of his
hoisted boat, "then you quick
see him 'parm whale."

COLORED PENCIL, INK AND MARKER
ON FOUND PAPER
10.75" × 7.75"
06/08/10

275

*The waves, too, nodded
their indolent crests; and
across the wide trance of
the sea, east nodded to west,
and the sun over all.*

**INK, MARKER AND WATERCOLOR ON
WATERCOLOR PAPER
12" × 8"
06/11/10**

276

*Yes, a mighty change had
come over the fish. All alive
to his jeopardy, he was going
"head out;" that part obliquely
projecting from the mad
yeast which he brewed.*

**ACRYLIC PAINT, COLLAGE, INK,
MARKER AND PENCIL ON FOUND
PAPER
9" × 12"
06/12/10**

Headwork

others have worked out a table that showsus g...
would meet in reaching interplanetary rocket speeds.

FORCES PRODUCED	LENGTH OF TIME g FORCE WOULD LAST
	9 minutes 31 seconds
	6 minutes 21 seconds
	4 minutes 45 seconds
	3 minutes 48 seconds
	3 minutes 10 seconds
	minutes 6 seconds

...cal Laboratory at W. A. D. C. (Wright ... placed in the transverse g position and subjected ... ads for the times shown. In every case their vision ... clear. They were mentally alert. They responded well to flashing lights and coded sounds. They were able to move their hands, wrists, and ankles ... and they were able to talk in monosyllables. (They could say "yes," "no," and other short ...

As if positive, negative and tra... ... weren't enough for a pilot to contend with, there are still oth... g forces. These are the mixed g's that grip a pilot when he ejects from a crippled airplane. Before his parachute opens he is likely to find himself tumbling head over heels through the air andound and ground. Both motions produce positive and negative g's...

Imagine for a moment that you have just bailed out of a jet and find yourself tumbling rapidlyif you are tumbling in such a way that your stomach is the center of gravity, all the blood below your stomach is forced down toward your feet (positive g). At the same time all the blood above your stomach is forced up toward your brain (negative g). Depending on your tumbling speed, you may be in serious trouble. If you were tumbling at the rate of 170 turns a minute, at the end of thirty seconds you would lose consciousness. Then your heart would no longer be able to control the circulation of your blood. If you were tumbling in such a way that your heart were the center of gravity you would be in more serious trouble. If you were tumbling at ...

turns a minute you would lose consciousness after thirty secon...

61

277

Like desperadoes they tugged and they strained, till the welcome cry was heard—"Stand up, Tashtego!—give it to him!" The harpoon was hurled.

ACRYLIC PAINT, INK AND MARKER ON FOUND PAPER
18" × 11.5"
06/12/10

278

*The red tide now poured
from all sides of the monster
like brooks down a hill.
His tormented body rolled
not in brine but in blood,
which bubbled and seethed
for furlongs behind in their
wake. The slanting sun
playing upon this crimson
pond in the sea, sent back
its reflection into every face,
so that they all glowed to
each other like red men.*

ACRYLIC PAINT, BALLPOINT PEN,
COLORED PENCIL AND INK ON FOUND
PAPER
7.75" × 10.75"
06/13/10

279

At last, gush after gush of clotted red gore, as if it had been the purple lees of red wine, shot into the frighted air; and falling back again, ran dripping down his motionless flanks into the sea. His heart had burst!

INK ON FOUND PAPER
7.75" × 10.75"
06/13/10

280

But however prolonged and exhausting the chase, the harpooneer is expected to pull his oar meanwhile to the uttermost; indeed, he is expected to set an example of superhuman activity to the rest, not only by incredible rowing, but by repeated loud and intrepid exclamations...

**COLORED PENCIL, INK AND MARKER
ON FOUND PAPER
6.75" × 8.5"
06/13/10**

THE HARPOON →

THE CROTCH →

THE GUNWALE →

WHALE BOAT ←

281

The crotch alluded to on a previous page deserves independent mention. It is a notched stick of a peculiar form, some two feet in length, which is perpendicularly inserted into the starboard gunwale near the bow, for the purpose of furnishing a rest for the wooden extremity of the harpoon, whose other naked, barbed end slopingly projects from the prow. Thereby the weapon is instantly at hand to its hurler, who snatches it up as readily from its rest as a backwoodsman swings his rifle from the wall.

ACRYLIC PAINT ON FOUND PAPER
11" × 8"
06/14/10

282

Stubb's whale had been killed some distance from the ship. It was a calm; so, forming a tandem of three boats, we commenced the slow business of towing the trophy to the Pequod.

BALLPOINT PEN AND INK ON FOUND PAPER
7.75" × 10.75"
06/17/10

283

Though, in overseeing the pursuit of this whale, Captain Ahab had evinced his customary activity, to call it so; yet now that the creature was dead, some vague dissatisfaction, or impatience, or despair, seemed working in him; as if the sight of that dead body reminded him that Moby Dick was yet to be slain; and though a thousand other whales were brought to his ship, all that would not one jot advance his grand, monomaniac object.

ACRYLIC PAINT, BALLPOINT PEN AND
INK ON FOUND PAPER
8.5" x 10.5"
06/18/10

284

Nor was that Stubb the only banqueter on whale's flesh that night. Mingling their mumblings with his own mastications, thousands on thousands of sharks, swarming round the dead Leviathan, smackingly feasted on its fatness.

INK AND MARKER ON FOUND PAPER
7.75″ × 10.75″
06/19/10

WILL TIME EVER END?

Time has many different faces.

When a person is worried or ⬚⬚⬚⬚ can seem like ⬚⬚⬚⬚⬚⬚⬚⬚⬚⬚⬚⬚, a ⬚⬚⬚⬚⬚⬚⬚⬚⬚⬚⬚⬚ And ⬚⬚⬚⬚⬚⬚⬚⬚⬚⬚⬚ seem to ⬚⬚⬚⬚⬚⬚⬚

Time means different things in mathematics, in physics, in biology, in history, and in our minds. ⬚⬚⬚⬚⬚⬚ the living things on earth only people can travel backward and forward in time. We can turn to the past in our memories and we can go into the future in our imaginations.

Do you know the word eternity?

For some people it means infinity in time, there ever is or was time without beginning or end—time going on forever.

285

...this old Fleece, as they called him, came shuffling and limping along...

ACRYLIC PAINT, INK AND MARKER ON FOUND PAPER
6.75″ × 8.5″
06/20/10

286

Sullenly taking the offered lantern, old Fleece limped across the deck to the bulwarks; and then, with one hand dropping his light low over the sea, so as to get a good view of his congregation, with the other hand he solemnly flourished his tongs, and leaning far over the side in a mumbling voice began addressing the sharks...

BALLPOINT PEN, INK AND MARKER ON FOUND PAPER
5" × 7.75"
06/22/10

To my Mother and Father
With fondest love

87 06701

287

"You is sharks, sartin; but if you gobern de shark in you, why den you be angel; for all angel is not'ing more dan de shark well goberned."

INK AND MARKER ON FOUND PAPER
5" × 7.75"
06/23/10

288

*Faintly smacking his withered
lips over it for a moment,
the old negro muttered,
"Best cooked 'teak I eber
taste; joosy, berry joosy."*

**ACRYLIC PAINT, BALLPOINT PEN AND
MARKER ON FOUND PAPER**
5" x 7.75"
06/24/10

289

*"Up dere," said Fleece,
holding his tongs straight
over his head, and keeping
it there very solemnly.*

ACRYLIC PAINT, BALLPOINT PEN, INK
AND MARKER ON FOUND PAPER
5" x 7.75"
06/25/10

290

It is upon record, that three centuries ago the tongue of the Right Whale was esteemed a great delicacy in France, and commanded large prices there.

INK ON FOUND PAPER
7.75″ × 5″
06/25/10

291

But no doubt the first man that ever murdered an ox was regarded as a murderer…

ACRYLIC PAINT, INK AND MARKER ON FOUND PAPER
6.75" × 8.5"
06/26/10

292

*But Stubb, he eats the whale
by its own light, does he?*

INK AND MARKER ON FOUND PAPER
7.25" × 10.75"
06/27/10

When a blood count is taken, a small amount of blood is drawn into a pipette, diluted with a special fluid, and released on a counting chamber. The counting chamber has a grid on it. When looked at through a microscope, the number of blood cells on the grid can easily be counted.

They viciously snapped, not only at each other's disembowelments, but like flexible bows, bent round, and bit their own; till those entrails seemed swallowed over and over again by the same mouth, to be oppositely voided by the gaping wound.

BALLPOINT PEN ON FOUND PAPER
8″ x 7.5″
06/28/10

More about the Blood

MEN may have learned fairly early in history about bandaging, and how necessary it is to stop the flow of blood from a cut or a wound. However, the human race wouldn't have lasted long enough to learn even this if nature hadn't given the body its own way of stopping bleeding.

If blood did not have the power to clot, the slightest cut would mean continual bleeding until the body was emptied. Although bandages are often helpful and sometimes necessary, there are many times when they are not needed. In a short time, most cuts and abrasions form a dark red scab, or clot, that stops the bleeding.

The next time you scrape your flesh enough for it to bleed a little, watch for a while to see what happens. The flow stops as the blood forms a soft cap over the wound. As this cap dries and hardens, you may notice a yellowish or white fluid around the edges. This is the serum being squeezed out as the clot hardens.

Clotting is a complicated process involving four substances: calcium, and three proteins called fibrinogen, prothrombin, and thromboplastin.

Clotting is begun when a blood vessel is injured. Blood comes into contact with the tissue around the injury, and the prothrombin in the tissue unites with the calcium and thromboplastin in the bloodstream. The prothrombin is changed into another substance, called thrombin, which unites with the fibrinogen to form a network of a threadlike substance called fibrin that traps red and white cells in its meshes.

The red cells give the color to a clot, although white cells are trapped, too. The clot, in addition to acting like a plug in a leaking dike, forms the foundation on which the new tissue will be built to heal the wound.

The way the blood clots is so complicated and involves so many factors that it can easily go wrong if one or another of the various ingredients

294

...to this block the great blubber hook, weighing some one hundred pounds, was attached.

BALLPOINT PEN ON FOUND PAPER
7.25" × 10"
06/29/10

Leonardo turned again to the proportional formulas of classical and medieval science. In a number of these cases the formulas possessed immaculate accuracy, at least in the theoretical terms of a frictionless universe. The basic law of balances as deduced by Euclid and Archimedes had been reconfirmed many times, for example by Jordanus in the thirteenth century: 'If the arms of a balance are proportional to the weights suspended in such a manner that the heavier weight is suspended from the shorter arm, the weights will have equal positional gravity.' This law was accurately restated by Leonardo (*gesto*) and provided the basis for numerous variations of simple and compound equilibrium, using the formula that W_1 x L_1 = W_2 x L_2 (Figures 3 – 9). His sources included Pelacani's *De ponderibus*, and almost certainly the treatise of the same title by Jordanus. A

Fig.3. *Studies of Balances*

A and B based on Madrid I, 129v
C based on Madrid I, 157r
D based on Madrid I, 167v
E based on C.A.86rb

Fig. 35 *Pulley System with a Ratio of 1 : 33*, based on Madrid I, 36v

Fig. 37 *System of Pulleys for Lignum...* based on ...A.321ra

Fig. 36 *Systems of Pulleys for Raising a Load*, based on I.58r and 114r

295

Now as the blubber envelops the whale precisely as the rind does an orange, so is it stripped off from the body precisely as an orange is sometimes stripped by spiralizing it. For the strain constantly kept up by the windlass continually keeps the whale rolling over and over in the water, and as the blubber in one strip uniformly peels off along the line called the "scarf," simultaneously cut by the spades of Starbuck and Stubb, the mates; and just as fast as it is thus peeled off, and indeed by the very act itself, it is all the time being hoisted higher and higher aloft till its upper end grazes the main-top...

ACRYLIC PAINT, BALLPOINT PEN AND INK ON FOUND PAPER
7.5" × 10.5"
07/01/10

296

Already you know what his blubber is. That blubber is something of the consistence of firm, close-grained beef, but tougher, more elastic and compact, and ranges from eight or ten to twelve and fifteen inches in thickness.

INK AND MARKER ON FOUND PAPER
10.75" × 7.75"
07/02/10

Sea

Monsters

297

In life, the visible surface of the Sperm Whale is not the least among the many marvels he presents. Almost invariably it is all over obliquely crossed and re-crossed with numberless straight marks in thick array, something like those in the finest Italian line engravings.

INK ON FOUND PAPER
5.5" × 8.5"
07 / 03 / 10

298

...when seamen fall overboard, they are sometimes found, months afterwards, perpendicularly frozen into the hearts of fields of ice, as a fly is found glued in amber.

ACRYLIC PAINT, BALLPOINT PEN AND
INK ON FOUND PAPER
8.75" x 9.5"
07/04/10

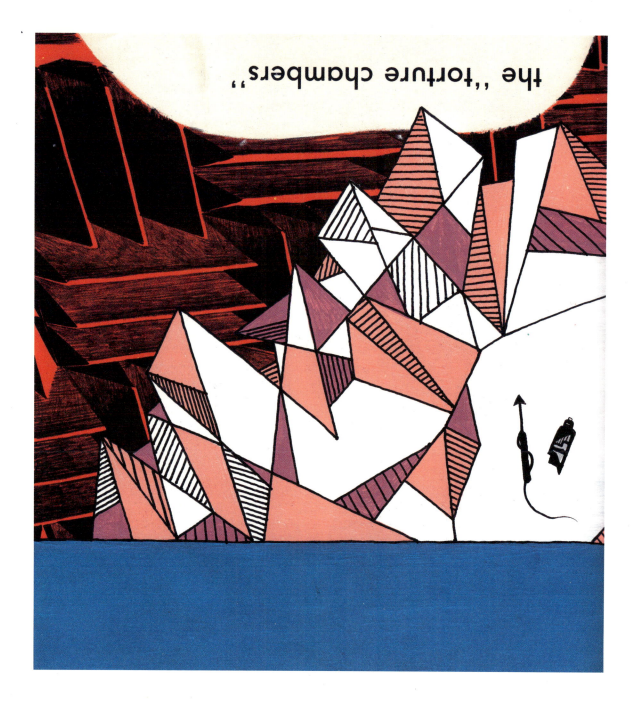

\longrightarrow

299

*Beneath the unclouded and
mild azure sky, upon the fair
face of the pleasant sea, wafted
by the joyous breezes, the great
mass of death floats on and on,
till lost in infinite perspectives.*

**ACRYLIC PAINT, COLORED PENCIL AND
INK ON FOUND PAPER
30″ × 10.75″
07/05/10**

SYLVANIA MODELS SC576CH,
SC581W (Ch. 370-2, 804-1)

300

Thus, while in life the great whale's body may have been a real terror to his foes, in his death his ghost becomes a powerless panic to a world.

**ACRYLIC PAINT, CHARCOAL AND INK
ON FOUND PAPER
10.75" × 7.75"
07/07/10**

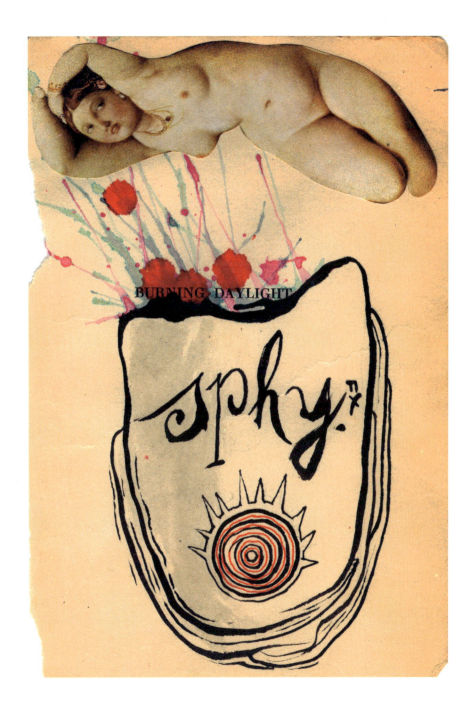

301

...there, that blood-dripping head hung to the Pequod's waist like the giant Holofernes's from the girdle of Judith.

COLLAGE AND INK ON FOUND PAPER
5" × 8"
07/08/10

302

It was a black and hooded head; and hanging there in the midst of so intense a calm, it seemed the Sphynx's in the desert.

ACRYLIC PAINT AND INK ON FOUND PAPER
5.5″ × 8″
07/09/10

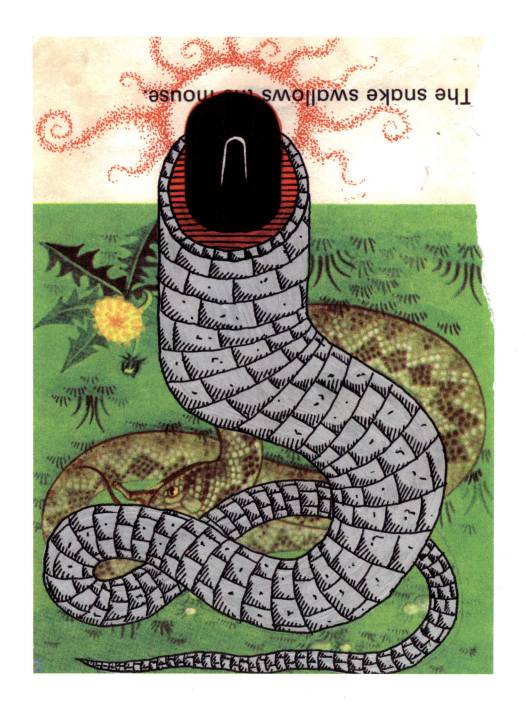

The snake swallows the mouse.

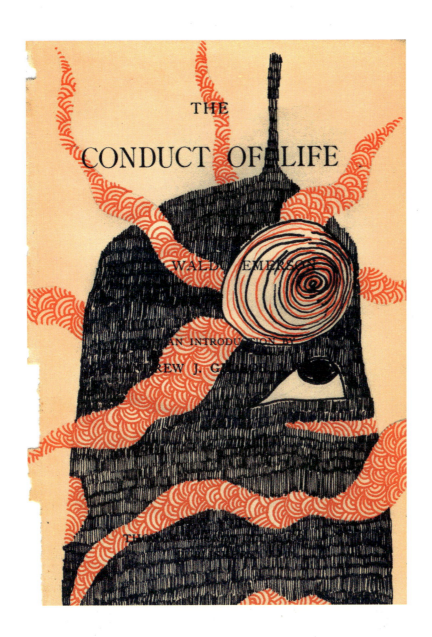

303

"...not the smallest atom stirs or lives on matter, but has its cunning duplicate in mind."

INK ON FOUND PAPER
3.75" x 6"
07/09/10

Pulling an oar in the Jeroboam's boat, was a man of a singular appearance, even in that wild whaling life where individual notabilities make up all totalities. He was a small, short, youngish man, sprinkled all over his face with freckles, and wearing redundant yellow hair. A long-skirted, cabalistically-cut coat of a faded walnut tinge enveloped him; the overlapping sleeves of which were rolled up on his wrists. A deep, settled, fanatic delirium was in his eyes.

ACRYLIC PAINT, COLORED PENCIL AND INK ON FOUND PAPER
6.75" × 8.5"
07/11/10

305

He announced himself as the archangel Gabriel, and commanded the captain to jump overboard.

ACRYLIC PAINT, BALLPOINT PEN,
COLORED PENCIL, INK AND MARKER
ON FOUND PAPER
6.75″ × 8.5″
07/11/10

306

"Beware of the horrible tail!"

**ACRYLIC PAINT AND INK ON FOUND
PAPER**
10.75" × 15.5"
07/11/10

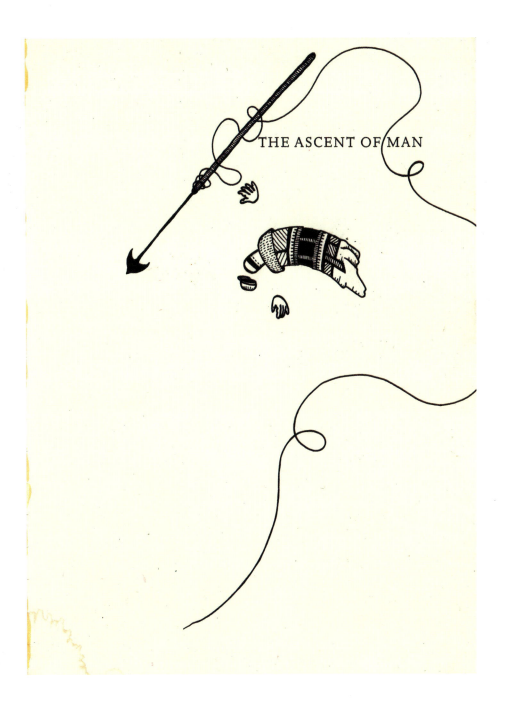

THE ASCENT OF MAN

307

Next instant, the luckless mate, so full of furious life, was smitten bodily into the air, and making a long arc in his descent, fell into the sea at a distance of about fifty yards. Not a chip of the boat was harmed, nor a hair of any oarsman's head; but the mate for ever sank.

INK ON FOUND PAPER
7″ × 9.5″
07/11/10

308

He clutched it in an instant, seized the boat-knife, and impaling the letter on it, sent it thus loaded back into the ship. It fell at Ahab's feet.

ACRYLIC PAINT, BALLPOINT PEN,
COLORED PENCIL AND INK ON FOUND
PAPER
6.75" × 8.5"
07/11/10

309

On the occasion in question, Queequeg figured in the Highland costume—a shirt and socks—in which to my eyes, at least, he appeared to uncommon advantage; and no one had a better chance to observe him, as will presently be seen.

COLORED PENCIL, INK AND MARKER
ON FOUND PAPER
7.75" x 10.75"
07/13/10

310

So strongly and metaphysically did I conceive of my situation then, that while earnestly watching his motions, I seemed distinctly to perceive that my own individuality was now merged in a joint stock company of two...

COLORED PENCIL, INK, MARKER AND WATERCOLOR ON WATERCOLOR PAPER
8" × 12"
07/14/10

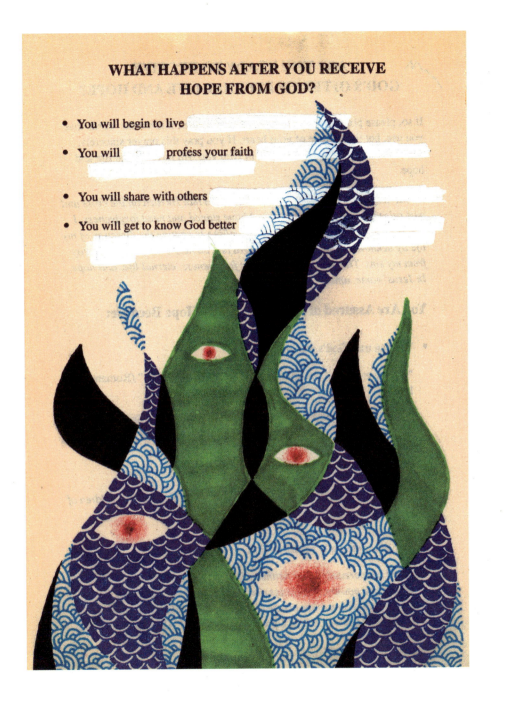

311

...poor Queequeg, I suppose,
only prayed to his Yojo,
and gave up his life into
the hands of his gods.

COLORED PENCIL, INK, MARKER AND
WITE-OUT ON FOUND PAPER
5" x 7.5"
07/15/10

312

"It was not me," cried Dough-Boy…

INK ON FOUND PAPER
9″ × 11″
07/17/10

313

Now, during the past night and forenoon, the Pequod had gradually drifted into a sea, which, by its occasional patches of yellow brit, gave unusual tokens of the vicinity of Right Whales, a species of the Leviathan that but few supposed to be at this particular time lurking anywhere near.

ACRYLIC PAINT, INK AND WATERCOLOR ON FOUND PAPER
9.75″ × 7.75″
07/18/10

314

So close did the monster come to the hull, that at first it seemed as if he meant it malice…

INK AND MARKER ON FOUND PAPER
10.75" × 7.75"
07/18/10

Baalat... and... god... connected prob-
ably wi... responsi... ty fo products valued by
the Egyp... is w... *Hathor*. Her name means
... and she is clearly the feminine counter-
part to *Baal*. In her role as Baalat Gebal 'mistress
of Byblos' she protects the cedar-wood trade
between the Lebanon and Egypt which goes back

Baal wielding thunderbolt.
Stela from Ugarit, Syria, c.
1700–1500 BC, Louvre
Museum

BAALAT

315

"Flask, I take that Fedallah
to be the devil in disguise."

ACRYLIC PAINT, CHARCOAL, INK AND
MARKER ON FOUND PAPER
7.75" x 5"
07/18/10

316

"I don't know, Flask, but the devil is a curious chap, and a wicked one, I tell ye."

INK AND MARKER ON FOUND PAPER
6" × 8"
07/19/10

DEVILS AND DEMONS

"Well," you may be saying, "Who the devil [careful!] can tell who the Devil really is and what he looks like? He slips shapes on and off as easily as we change clothes?" The Russian writer Nikolai Gogol had the answer. According to a story he wrote, if you want to see the Devil's true shape, you must wait till St. John's Eve (June 21). Find yourself a mustard seed and keep it near you on that night. At midnight, the Devil will appear in his true shape.

What he'll do then, of course, is another matter entirely!

317

"How old do you suppose Fedallah is, Stubb?"

"Do you see that mainmast there?" pointing to the ship; "well, that's the figure one; now take all the hoops in the Pequod's hold, and string 'em along in a row with that mast, for oughts, do you see; well, that wouldn't begin to be Fedallah's age. Nor all the coopers in creation couldn't show hoops enough to make oughts enough."

INK AND MARKER ON FOUND PAPER
10.75" × 7.75"
07/20/10

318

*And Ahab chanced so to stand,
that the Parsee occupied his
shadow; while, if the Parsee's
shadow was there at all it
seemed only to blend with,
and lengthen Ahab's.*

INK ON FOUND PAPER
10.25″ × 7.25″
07/21/10

THE LAND AND

319

There is more character in the Sperm Whale's head.

INK ON FOUND PAPER
6" × 8"
07/22/10

320

Far back on the side of the head, and low down, near the angle of either whale's jaw, if you narrowly search, you will at last see a lashless eye, which you would fancy to be a young colt's eye; so out of all proportion is it to the magnitude of the head.

INK ON PAPER
11" × 8.5"
07/23/10

321

But if you now come to separate these two objects, and surround each by a circle of profound darkness; then, in order to see one of them, in such a manner as to bring your mind to bear on it, the other will be utterly excluded from your contemporary consciousness.

INK, MARKER AND PENCIL ON FOUND PAPER
10.75" × 7.75"
07/23/10

322

But far more terrible is it to behold, when fathoms down in the sea, you see some sulky whale, floating there suspended, with his prodigious jaw, some fifteen feet long, hanging straight down at right-angles with his body, for all the world like a ship's jib-boom.

INK ON CONSTRUCTION PAPER
9″ × 12″
07/24/10

323

Crossing the deck, let us now have a good long look at the Right Whale's head.

INK ON FOUND PAPER
11″ × 8.5″
07/25/10

324

...in which case you will take great interest in thinking how this mighty monster is actually a diademed king of the sea, whose green crown has been put together for him in this marvellous manner.

INK AND MARKER ON CONSTRUCTION PAPER
9" x 12"
07/25/10

325

*Ere this, you must have plainly
seen the truth of what I started
with—that the Sperm Whale
and the Right Whale have
almost entirely different heads.*

INK ON FOUND PAPER
6.25″ x 9″
07/27/10

326

*You observe that in the
ordinary swimming position
of the Sperm Whale, the front
of his head presents an almost
wholly vertical plane to the
water; you observe that the
lower part of that front slopes
considerably backwards, so as
to furnish more of a retreat for
the long socket which receives
the boom-like lower jaw; you
observe that the mouth is
entirely under the head, much
in the same way, indeed, as
though your own mouth were
entirely under your chin.*

INK AND MARKER ON FOUND PAPER
7.75" × 11"
07/27/10

327

Wherefore, you must now have perceived that the front of the Sperm Whale's head is a dead, blind wall, without a single organ or tender prominence of any sort whatsoever.

COLORED PENCIL, CRAYON, INK AND MARKER ON FOUND PAPER
6″ × 8.5″
07/29/10

←

328

*Now, mark. Unerringly
impelling this dead,
impregnable, uninjurable wall,
and this most buoyant thing
within; there swims behind it
all a mass of tremendous life…*

**ACRYLIC PAINT, COLORED PENCIL, INK
AND PENCIL ON FOUND PAPER
22″ × 10.75″
07/30/10**

329

...so the whale's vast plaited forehead forms innumerable strange devices for the emblematical adornment of his wondrous tun.

BALLPOINT PEN ON FOUND PAPER
3″ × 5″
07/30/10

330

Nimble as a cat, Tashtego mounts aloft; and without altering his erect posture, runs straight out upon the overhanging main-yard-arm, to the part where it exactly projects over the hoisted Tun.

ACRYLIC PAINT AND INK ON FOUND PAPER
7.75" × 10.75"
08/01/10

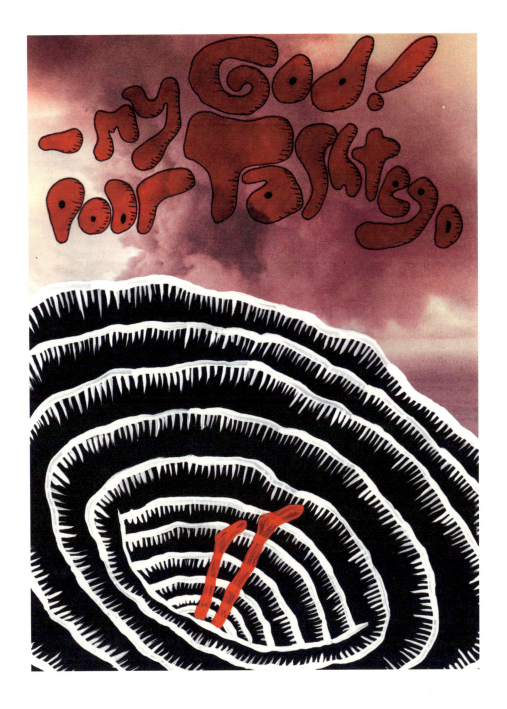

331

*...but, on a sudden, as the
eightieth or ninetieth bucket
came suckingly up—my
God! poor Tashtego—like
the twin reciprocating bucket
in a veritable well, dropped
head-foremost down into this
great Tun of Heidelburgh, and
with a horrible oily gurgling,
went clean out of sight!*

**ACRYLIC PAINT, INK AND MARKER ON
FOUND PAPER**
7.25″ x 10.25″
08/01/10

332

But hardly had the blinding vapor cleared away, when a naked figure with a boarding-sword in its hand, was for one swift moment seen hovering over the bulwarks. The next, a loud splash announced that my brave Queequeg had dived to the rescue.

ACRYLIC PAINT, COLORED PENCIL, INK AND MARKER ON FOUND PAPER
7.75" × 10.75"
08/01/10

333

Now, how had this noble rescue been accomplished? Why, diving after the slowly descending head, Queequeg with his keen sword had made side lunges near its bottom, so as to scuttle a large hole there; then dropping his sword, had thrust his long arm far inwards and upwards, and so hauled out our poor Tash by the head.

COLORED PENCIL, INK AND MARKER
ON WATERCOLOR PAPER
5.25" x 8.75"
08/03/10

334

*To scan the lines of his
face, or feel the bumps on
the head of this Leviathan;
this is a thing which no
Physiognomist or Phrenologist
has as yet undertaken.*

**CHARCOAL, INK AND MARKER ON
FOUND PAPER**
10.75" × 7.75"
08/05/10

335

In some particulars, perhaps the most imposing physiognomical view to be had of the Sperm Whale, is that of the full front of his head. This aspect is sublime.

ACRYLIC PAINT, CHARCOAL, COLLAGE AND INK ON FOUND PAPER
7.75" × 10.75"
08/05/10

336

For you see no one point precisely; not one distinct feature is revealed; no nose, eyes, ears, or mouth; no face; he has none, proper; nothing but that one broad firmament of a forehead, pleated with riddles; dumbly lowering with the doom of boats, and ships, and men.

ACRYLIC PAINT AND CHARCOAL ON FOUND PAPER
7.75″ × 10.75″
08/06/10

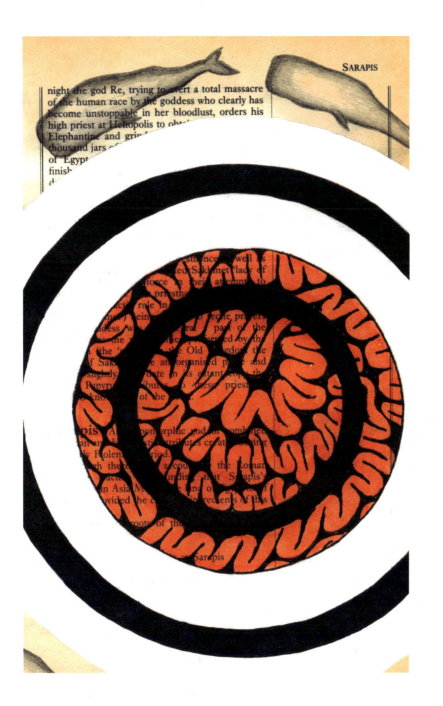

337

If the Sperm Whale be physiognomically a Sphinx, to the phrenologist his brain seems that geometrical circle which it is impossible to square.

ACRYLIC PAINT, INK, MARKER AND
PENCIL ON FOUND PAPER
4.75" × 7.75"
08/06/10

338

*If you unload his skull of
its spermy heaps …*

**ACRYLIC PAINT AND CHARCOAL ON
FOUND PAPER**
11″ × 8″
08/06/10

339

The predestinated day arrived, and we duly met the ship Jungfrau, Derick De Deer, master, of Bremen.

INK AND MARKER ON FOUND PAPER
9.5" × 8"
08/06/10

340

*"Go along with you," cried
Flask, "it's a lamp-feeder and
an oil-can. He's out of oil,
and has come a-begging."*

**ACRYLIC PAINT AND INK ON FOUND
PAPER**
7.75" × 10.75"
08/07/10

341

Full in this rapid wake, and many fathoms in the rear, swam a huge, humped old bull, which by his comparatively slow progress, as well as by the unusual yellowish incrustations overgrowing him, seemed afflicted with the jaundice, or some other infirmity.

ACRYLIC PAINT AND INK ON FOUND
PAPER
10.75" × 7.75"
08/08/10

342

At this juncture, the Pequod's keels had shot by the three German boats last lowered; but from the great start he had had, Derick's boat still led the chase, though every moment neared by his foreign rivals.

ACRYLIC PAINT AND INK ON FOUND PAPER
7.75" × 10.75"
08/08/10

343

"I say, pull like god-dam,"
—cried the Indian.

INK AND MARKER ON FOUND PAPER
8″ × 5.5″
08 / 08 / 10

344

But no sooner did his harpooneer stand up for the stroke, than all three tigers—Queequeg, Tashtego, Daggoo—instinctively sprang to their feet, and standing in a diagonal row, simultaneously pointed their barbs; and darted over the head of the German harpooneer, their three Nantucket irons entered the whale.

INK ON FOUND PAPER
6.5" × 5.25"
08/10/10

345

As the three boats lay there on that gently rolling sea, gazing down into its eternal blue noon; and as not a single groan or cry of any sort, nay, not so much as a ripple or a bubble came up from its depths; what landsman would have thought, that beneath all that silence and placidity, the utmost monster of the seas was writhing and wrenching in agony!

INK ON FOUND PAPER
7.75" × 10.75"
08/10/10

346

In most land animals there are certain valves or flood-gates in many of their veins, whereby when wounded, the blood is in some degree at least instantly shut off in certain directions. Not so with the whale; one of whose peculiarities it is, to have an entire non-valvular structure of the blood-vessels, so that when pierced even by so small a point as a harpoon, a deadly drain is at once begun upon his whole arterial system...

ACRYLIC PAINT ON FOUND PAPER
11″ × 8″
08/10/10

347

*At the instant of the dart
an ulcerous jet shot from
this cruel wound…*

**ACRYLIC PAINT AND INK ON FOUND
PAPER**
11" × 8"
08/12/10

348

It so chanced that almost upon first cutting into him with the spade, the entire length of a corroded harpoon was found imbedded in his flesh, on the lower part of the bunch before described.

INK AND MARKER ON PAPER
8.5" × 11"
08/12/10

349

But the reason of this is obvious. Gases are generated in him; he swells to a prodigious magnitude; becomes a sort of animal balloon.

COLORED PENCIL ON FOUND PAPER
10.75″ × 8″
08/13/10

350

There are some enterprises in which a careful disorderliness is the true method.

INK AND MARKER ON FOUND PAPER
4″ × 6.75″
08/14/10

351

...Perseus, the prince of whalemen, intrepidly advancing, harpooned the monster...

INK ON WATERCOLOR PAPER
10″ × 6.25″
08/15/10

352

In fact, placed before the strict and piercing truth, this whole story will fare like that fish, flesh, and fowl idol of the Philistines, Dagon by name…

BALLPOINT PEN, COLORED PENCIL
AND INK ON FOUND PAPER
5" × 7.75"
08/15/10

353

One old Sag-Harbor whaleman's chief reason for questioning the Hebrew story was this: — He had one of those quaint old-fashioned Bibles, embellished with curious, unscientific plates; one of which represented Jonah's whale with two spouts in his head…

INK AND PENCIL ON BRISTOL BOARD
7" × 8.5"
08/24/10

354

...Jonah was swallowed by the whale in the Mediterranean Sea, and after three days he was vomited up somewhere within three days' journey of Nineveh, a city on the Tigris...

ACRYLIC PAINT, BALLPOINT PEN,
COLLAGE AND INK ON FOUND PAPER
8.5" × 11"
08/25/10

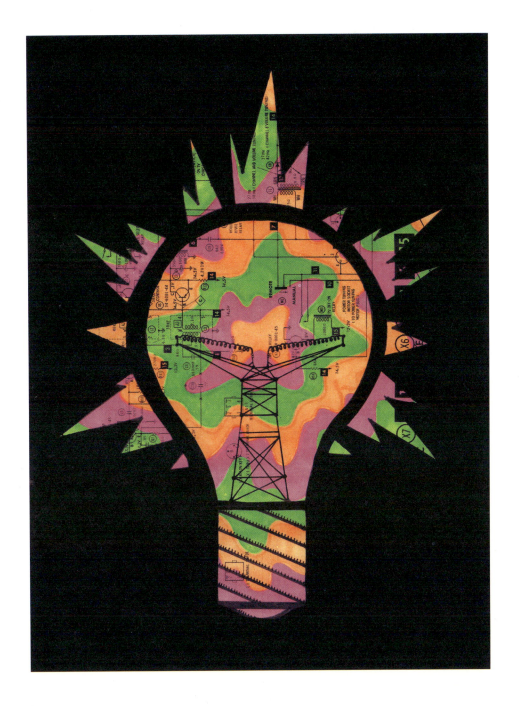

355

And some three centuries ago, an English traveller in old Harris's Voyages, speaks of a Turkish Mosque built in honor of Jonah, in which mosque was a miraculous lamp that burnt without any oil.

INK AND MARKER ON FOUND PAPER
7.75" × 11"
08/26/10

356

Steel and wood included, the entire spear is some ten or twelve feet in length; the staff is much slighter than that of the harpoon, and also of a lighter material—pine.

INK ON FOUND PAPER
6.25″ × 8.75″
08/28/10

357

Instead of sparkling water,
he now spouts red blood.

ACRYLIC PAINT, INK AND MARKER ON
FOUND PAPER
10.75" × 7.75"
08/29/10

...and what is still more, his windpipe has no connexion with his mouth. No, he breathes through his spiracle alone; and this is on the top of his head.

INK AND MARKER ON FOUND PAPER
8.5" × 7"
08/29/10

Spermaceti case

Blow hole

Cross section of head of a sperm whale

Air

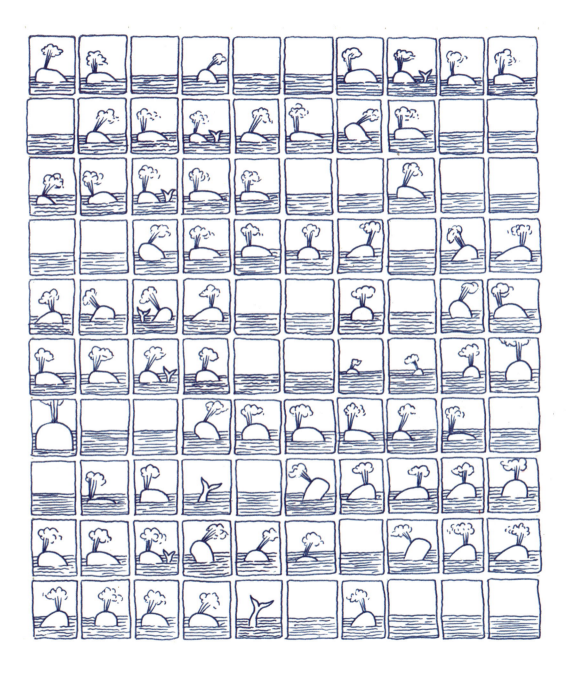

359

This is what I mean. If unmolested, upon rising to the surface, the Sperm Whale will continue there for a period of time exactly uniform with all his other unmolested risings. Say he stays eleven minutes, and jets seventy times, that is, respires seventy breaths; then whenever he rises again, he will be sure to have his seventy breaths over again, to a minute. Now, if after he fetches a few breaths you alarm him, that he sounds, he will be always dodging up again to make good his regular allowance of air. And not till those seventy breaths are told, will he finally go down to stay out his full term below.

INK ON BRISTOL BOARD
7″ × 8.5″
08/29/10

360

Now, the spouting canal of the Sperm Whale, chiefly intended as it is for the conveyance of air, and for several feet laid along, horizontally, just beneath the upper surface of his head, and a little to one side; this curious canal is very much like a gas-pipe laid down in a city on one side of a street.

INK AND MARKER ON FOUND PAPER
10.75" × 7.25"
08/29/10

Breaching

Breaching, where cetaceans launch their entire body to playfully give passengers in boats unexpected showers.

Lobtailing humpback whale

A social world

361

*And as for this whale spout,
you might almost stand in
it, and yet be undecided
as to what it is precisely.*

BALLPOINT PEN ON FOUND PAPER
5.25″ x 9.25″
08/30/10

362

He is both ponderous
and profound.

ACRYLIC PAINT ON FOUND PAPER
7.75" × 10.75"
08/31/10

363

At the crotch or junction, these flukes slightly overlap, then sideways recede from each other like wings, leaving a wide vacancy between. In no living thing are the lines of beauty more exquisitely defined than in the crescentic borders of these flukes.

INK ON FOUND PAPER
7.75" × 10.75"
09/01/10

364

*Five great motions are
peculiar to it. First, when
used as a fin for progression;
Second, when used as a
mace in battle; Third, in
sweeping; Fourth, in lobtailing;
Fifth, in peaking flukes.*

MARKER ON FOUND PAPER
7.75" × 10.75"
09/01/10

365

So in dreams, have I seen majestic Satan thrusting forth his tormented colossal claw from the flame Baltic of Hell.

INK AND MARKER ON FOUND PAPER
6" × 9"
09/03/10

366

Standing at the mast-head of my ship during a sunrise that crimsoned sky and sea, I once saw a large herd of whales in the east, all heading towards the sun, and for a moment vibrating in concert with peaked flukes. As it seemed to me at the time, such a grand embodiment of adoration of the gods was never beheld...

INK AND MARKER ON FOUND PAPER
8.75" × 8.75"
09/04/10

367

Dissect him how I may, then, I but go skin deep; I know him not, and never will. But if I know not even the tail of this whale, how understand his head? much more, how comprehend his face, when face he has none? Thou shalt see my back parts, my tail, he seems to say, but my face shall not be seen. But I cannot completely make out his back parts; and hint what he will about his face, I say again he has no face.

ACRYLIC PAINT AND CHARCOAL ON FOUND PAPER
7.75″ × 10.75″
09/05/10

368

For a long time, now, the circus-running sun has raced within his fiery ring, and needs no sustenance but what's in himself. So Ahab. Mark this, too, in the whaler.

ACRYLIC PAINT, INK AND MARKER ON FOUND PAPER
9" × 12"
09/05/10

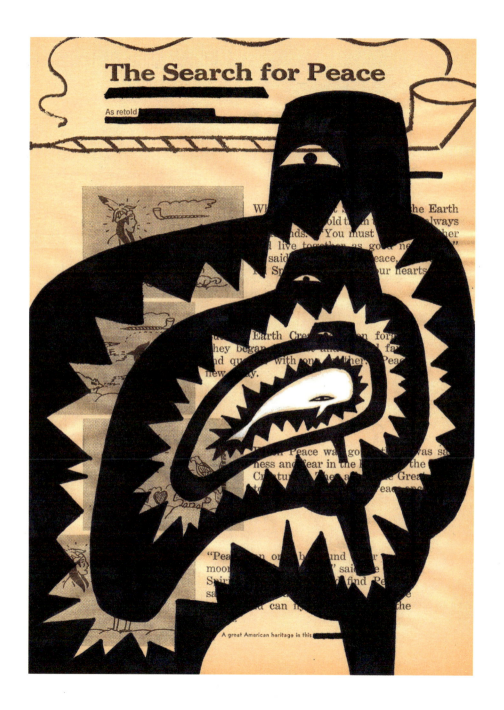

369

Hence it is, that, while other ships may have gone to China from New York, and back again, touching at a score of ports, the whale-ship, in all that interval, may not have sighted one grain of soil; her crew having seen no man but floating seamen like themselves. So that did you carry them the news that another flood had come; they would only answer—"Well, boys, here's the ark!"

ACRYLIC PAINT AND INK ON FOUND PAPER
15.5" x 10.75"
09/06/10

...a continuous chain of whale-jets were up-playing and sparkling in the noon-day air.

INK AND MARKER ON FOUND PAPER
8" × 7"
09/07/10

There Leviathan,
Hugest of living creatures, in the deep
Stretched like a promontory, sleeps or swims,
And seems a moving land, and at his gills
Draws in, and at his breath spouts out a sea. *Paradise Lost*

3. Cachalot at Sea

Thus, three centuries ago, did the great English poet John Milton describe a whale. It is a dramatic description, but the poet is inaccurate when he mentions "gills." Obviously he did not know that whales are lung breathers and do not have gills. But he is quite right in other details: "Stretched like a promontory . . . And seems a moving land. . ." A full-grown bull cachalot is indeed a small isle in the sea, and the hump-like ridge on his back could be likened to a mountain or a promontory on that isle.

Sperm whales have few enemies besides the giant squid. Man is the worst foe, since encounters with him usually lead to death. Other enemies include packs of killer whales, and, for the males, each other, when cows are involved.

Male sperm whales do not take a single mate but select a number of females, as many as twenty or thirty. Such a harem is acquired by force, with the bulls ramming heads and exchanging vicious bites to gain their mates.

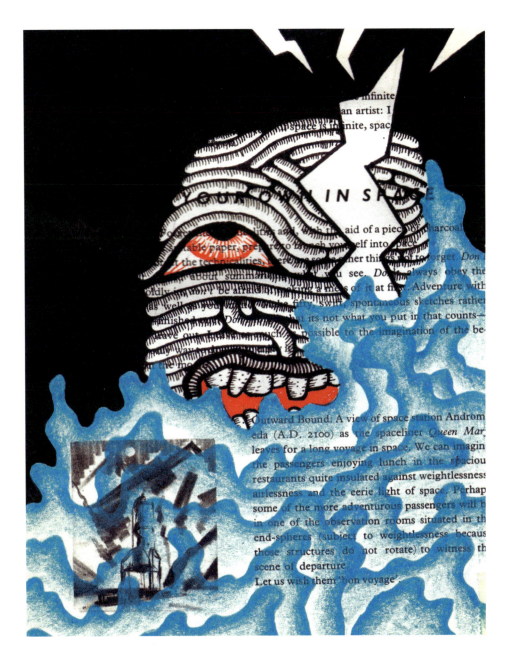

371

...when all these conceits had passed through his brain, Ahab's brow was left gaunt and ribbed, like the black sand beach after some stormy tide has been gnawing it, without being able to drag the firm thing from its place.

COLORED PENCIL AND INK ON FOUND PAPER
5" × 6.5"
09/08/10

372

The compact martial columns in which they had been hitherto rapidly and steadily swimming, were now broken up in one measureless rout; and like King Porus' elephants in the Indian battle with Alexander, they seemed going mad with consternation. In all directions expanding in vast irregular circles, and aimlessly swimming hither and thither, by their short thick spoutings, they plainly betrayed their distraction of panic.

ACRYLIC PAINT AND INK ON FOUND PAPER
7″ × 10.25″
09 / 09 / 10

373

...as we thus tore a white gash in the sea, on all sides menaced as we flew, by the crazed creatures to and fro rushing about us...

ACRYLIC PAINT AND INK ON FOUND PAPER
8″ × 7″
09/12/10

*...then, with the tapering force
of his parting momentum,
we glided between two
whales into the innermost
heart of the shoal…*

**ACRYLIC PAINT AND INK ON FOUND
PAPER
8″ × 7″
09/13/10**

375

But far beneath this wondrous world upon the surface, another and still stranger world met our eyes as we gazed over the side. For, suspended in those watery vaults, floated the forms of the nursing mothers of the whales, and those that by their enormous girth seemed shortly to become mothers.

INK AND MARKER ON WATERCOLOR
PAPER
8.25" x 12"
09/14/10

376

*As when the stricken whale,
that from the tub has reeled
out hundreds of fathoms of
rope; as, after deep sounding,
he floats up again, and
shows the slackened curling
line buoyantly rising and
spiralling toward the air;
so now, Starbuck saw long
coils of the umbilical cord
of Madame Leviathan, by
which the young cub seemed
still tethered to its dam.*

**COLORED PENCIL ON FOUND PAPER
5.25″ × 8″
09/15/10**

Do you see something strange?

The embryos look alike.

When the animals are bigger,

they will look very different.

But in the beginning,

the embryos look the same.

33

377

But at length we perceived that by one of the unimaginable accidents of the fishery, this whale had become entangled in the harpoon-line that he towed; he had also run away with the cutting-spade in him; and while the free end of the rope attached to that weapon, had permanently caught in the coils of the harpoon-line round his tail, the cutting-spade itself had worked loose from his flesh. So that tormented to madness, he was now churning through the water, violently flailing with his flexible tail, and tossing the keen spade about him, wounding and murdering his own comrades.

ACRYLIC PAINT AND INK ON FOUND PAPER
7.75″ × 10.75″
09/15/10

378

The waif is a pennoned pole, two or three of which are carried by every boat; and which, when additional game is at hand, are inserted upright into the floating body of a dead whale, both to mark its place on the sea, and also as token of prior possession, should the boats of any other ship draw near.

ACRYLIC PAINT, INK AND PENCIL ON FOUND PAPER
7.25" × 10.75"
09/16/10

379

In cavalier attendance upon the school of females, you invariably see a male of full grown magnitude, but not old; who, upon any alarm, evinces his gallantry by falling in the rear and covering the flight of his ladies. In truth, this gentleman is a luxurious Ottoman, swimming about over the watery world...

ACRYLIC PAINT AND INK ON FOUND PAPER
7.75" × 10.75"
09/17/10

380

*...he leaves his anonymous
babies all over the world;
every baby an exotic.*

INK AND MARKER ON FOUND PAPER
7.75" × 10.75"
09/18/10

381

*Almost universally, a
lone whale—as a solitary
Leviathan is called—
proves an ancient one.*

**ACRYLIC PAINT, INK AND COLORED
PENCIL ON BRISTOL BOARD
8.5" × 7"
09/19/10**

Thus the most vexatious and violent disputes would often arise between the fishermen…

COLLAGE AND INK ON FOUND PAPER
9.25" × 6"
09/20/10

383

I. A Fast-Fish belongs to the party fast to it.

II. A Loose-Fish is fair game for anybody who can soonest catch it.

ACRYLIC PAINT, COLLAGE AND INK ON FOUND PAPER
8.5" × 7"
09/21/10

384

...though the gentleman had originally harpooned the lady, and had once had her fast, and only by reason of the great stress of her plunging viciousness, had at last abandoned her; yet abandon her he did, so that she became a loose-fish…

COLLAGE ON WALLPAPER SAMPLE AND CHIPBOARD
8" x 11"
09/23/10

385

*What all men's minds and
opinions but Loose-Fish?*

**INK AND WATERCOLOR ON
WATERCOLOR PAPER**
8.25" × 12"
09/24/10

386

"De balena vero sufficit,
si rex habeat caput, et
regina caudam."

Bracton, l. 3, c. 3.

Latin from the books of the
Laws of England, which taken
along with the context, means,
that of all whales captured by
anybody on the coast of that
land, the King, as Honorary
Grand Harpooner, must have
the head, and the Queen be
respectfully presented with
the tail. A division which,
in the whale, is much like
halving an apple; there is no
intermediate remainder.

ACRYLIC PAINT, COLLAGE AND INK ON
CONSTRUCTION PAPER
12″ × 7″
09/24/10

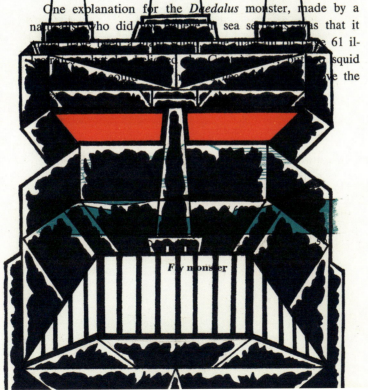

The sea monster controversy in England was reopened. This story, after all, was but a legend of some vague creature from the misty fjords of Norway or a possible Yankee hoax. This was a detailed report of a responsible British naval post Captain and his officers of a meeting with a sea serpent in a new area, the South Atlantic.

The arguments for and against recognizing the monster raged but came to nothing. Various naturalists insisted that Captain M'Quhae couldn't have seen what he said he saw, while the Captain refused to take back a syllable of his report.

One explanation for the *Dædalus* monster, made by a naturalist who did not believe in sea serpents, was that it was a squid

Fly monster

387

"Please, sir, who is the Lord Warden?"

"The Duke."

"But the Duke had nothing to do with taking this fish?"

"It is his."

"We have been at great trouble, and peril, and some expense, and is all that to go to the Duke's benefit; we getting nothing at all for our pains but our blisters?"

"It is his."

"Is the Duke so very poor as to be forced to this desperate mode of getting a livelihood?"

"It is his."

"I thought to relieve my old bed-ridden mother by part of my share of this whale."

"It is his."

"Won't the Duke be content with a quarter or a half?"
"It is his."

INK AND MARKER ON FOUND PAPER
6″ × 8.5″
09/25/10

388

But is the Queen a mermaid, to be presented with a tail? An allegorical meaning may lurk here.

COLLAGE ON CONSTRUCTION PAPER AND CHIPBOARD
9″ × 12″
09/26/10

389

*Presently, the vapors in
advance slid aside; and there
in the distance lay a ship,
whose furled sails betokened
that some sort of whale must
be alongside. As we glided
nearer, the stranger showed
French colors from his peak;
and by the eddying cloud of
vulture sea-fowl that circled,
and hovered, and swooped
around him, it was plain that
the whale alongside must be
what the fishermen called a
blasted whale, that is, a whale
that has died unmolested
on the sea, and so floated
an unappropriated corpse.*

**ACRYLIC PAINT, INK AND MARKER ON
FOUND PAPER**
10.75" × 7.75"
09/27/10

390

Coming still nearer with the expiring breeze, we saw that the Frenchman had a second whale alongside; and this second whale seemed even more of a nosegay than the first. In truth, it turned out to be one of those problematical whales that seem to dry up and die with a sort of prodigious dyspepsia, or indigestion; leaving their defunct bodies almost entirely bankrupt of anything like oil.

INK ON FOUND PAPER
5.25″ × 6.5″
09/27/10

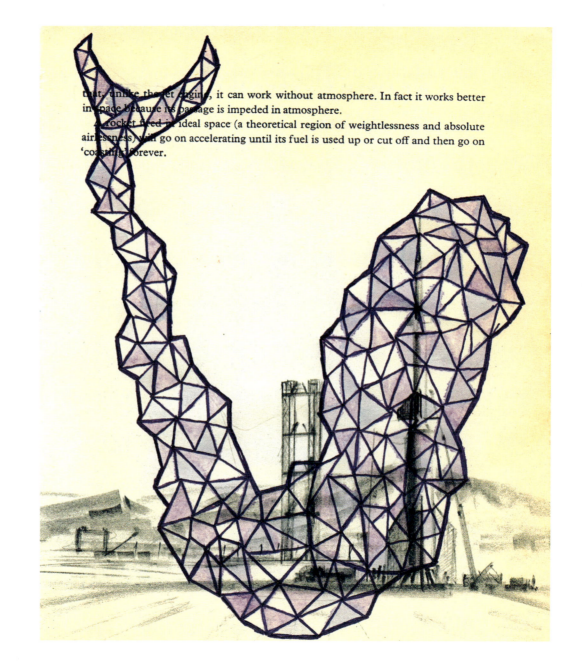

that, unlike the jet engine, it can work without atmosphere. In fact it works better in space because its passage is impeded in atmosphere.

A rocket fired in ideal space (a theoretical region of weightlessness and absolute airlessness) will go on accelerating until its fuel is used up or cut off and then go on 'coasting' forever.

Pruning roses

Though there are different schools of thought on rose pruning, here is one bit of advice to remember: in addition to the major once-a-year [pruning], prune a little all year long, [cutting] off spent flowers and trim[ming] back branches that cross and [rub. Light]-to-moderate pruning [will give] the best possible

How to prune hybrid [te]as, grandifloras & fl[orib]undas

Wrong

Cuts [for removal] should be flush. A stub [left] [cut] back into the union, becom[es an entryway] for disease. Paint with pruning co[mpo]und.

1) Ready fo[r pruning, a] [dorm]ant bush is leafless or n[early so]. [Ti]me the pruning of most ros[es is fr]om January (mildest clim[ates) to Ap]ril (30 days befo[re ...] [ki]lling frost in cold[er ... gr]owing buds are ...

2) Remove all dead wood and all weak, twiggy branches. Cut old canes that produced no strong growth, branches that cross through bush's center, and weak stems. Shorten th[e] remaining branches (see next two s[teps] for directions).

Prun[ing a] climbing hyb[rid]

[When ... for pr]uning [re]move only the [previou]sly unproductive [wood ... t]he [lateral]s that bore [la]st [year ...] [two] or three

4) Where freezing damages rose bushes, remove all dead and injured wood. This may leave shrub only half to a third the size it was in fall. Use protective coverings, mulches in winter (see page 84 for examples).

Accent is on [sy]mmetry when pruning tree (standard) roses. Remove stems extending beyond generally dome-shaped outline. Keep the top open.

[... healthy growth ... than ... pruning ... s,]

[... ng, Pin]ching & Tying

391

Drawing across her bow, he perceived that in accordance with the fanciful French taste, the upper part of her stem-piece was carved in the likeness of a huge drooping stalk, was painted green, and for thorns had copper spikes projecting from it here and there; the whole terminating in a symmetrical folded bulb of a bright red color.

ACRYLIC PAINT ON FOUND PAPER
8″ × 10.75″
09/28/10

392

Others having broken the stems of their pipes almost short off at the bowl, were vigorously puffing tobacco-smoke, so that it constantly filled their olfactories.

ACRYLIC PAINT AND INK ON FOUND PAPER
7.75″ × 10.75″
09/29/10

393

By this time their destined victim appeared from his cabin. He was a small and dark, but rather delicate looking man for a sea-captain, with large whiskers and moustache, however; and wore a red cotton velvet vest with watch-seals at his side.

ACRYLIC PAINT AND INK ON FOUND PAPER
6″ × 12″
09/30/10

394

*"Why, let me see; yes, you may
as well tell him now that—that
—in fact, tell him I've diddled
him, and (aside to himself)
perhaps somebody else."*

**ACRYLIC PAINT AND INK ON FOUND
PAPER**
6″ × 9.25″
09/30/10

of light: the spacing of the fringes is inversely proportional to the distance between the holes in the diaphragm in front of the objective. If a double star is observed, each one of the pair will produce its own system of interference fringes and it is clear that by suitably adjusting the spacing and positions of the holes, it may be possible to superpose the two systems in such a way that the bright fringes of one fall on the dark fringes of the other, cancelling them out and producing a uniform patch. The position angle of the two stars can be deduced from the orientation and the method is particularly suitable for stars which are barely separable and could hardly in practice, each giving the same width, the line joining the centres ing power of the of the system also pattern

395

Dropping his spade, he thrust both hands in, and drew out handfuls of something that looked like ripe Windsor soap, or rich mottled old cheese; very unctuous and savory withal. You might easily dent it with your thumb; it is of a hue between yellow and ash color. And this, good friends, is ambergris, worth a gold guinea an ounce to any druggist.

ACRYLIC PAINT ON FOUND PAPER
8.5″ x 11.25″
09/30/10

The above table gives the results of measurements and the corresponding actual in units of that of the Sun. It is noticeable that all the diameters are very large, which is to be expected from a method which can only give results for large stars of the giant or supergiant class. The diameter of Betelgeuse (α Orionis) is variable.

the main sequence, belong to all spectral types and are comparable to the Sun in diameter. The giants, belonging to spectral classes

396

Bethink thee of that saying of St. Paul in Corinthians, about corruption and incorruption; how that we are sown in dishonor, but raised in glory.

INK AND MARKER ON FOUND PAPER
7″ × 10.75″
10/01/10

The Sense of Smell

THE FLESHY part of the nose is, of course, only an outside cover... of the nose that actually de... the face, below the level ... region are the fine nerves, the ... branches of the first cranial ... which leads to the brain.

You ca... smell anything if the lining of your nose is d... Certain... made that they really belong to ... outward, and the... ase of the nerve cells... under... only the inside of the no... the layer of fluid called mucus. Air ... oil odors re... them a... articles of ... or gas... molecules, ... nose... are... by the mucus... smells...

... oxygen with too ... you have t... smelling... travel into the nos... nerve cells.

Much of ... taste in your mouth is ... each swallow, the back of ... back of the throat ... the nose at...

Odors come in... or gas. They are dis-
solved in a layer of fluid... special cells that
carry the sensation of smell to the brain. The olfactory
center or center for smell in... dog's brain is more sensi-
tive than that found in a human.

brain center for sense of smell (olfactory center)

sense organ for odors

section of lining of nose magnified

nerve to olfactory center

397

...which latter name is the one used by the learned Fogo Von Slack, in his great work on Smells, a textbook on that subject.

**ACRYLIC PAINT, CHARCOAL AND
PENCIL ON FOUND PAPER
8" × 11"
10/02/10**

398

It was but some few days after encountering the Frenchman, that a most significant event befell the most insignificant of the Pequod's crew; an event most lamentable; and which ended in providing the sometimes madly merry and predestinated craft with a living and ever accompanying prophecy of whatever shattered sequel might prove her own.

INK AND MARKER ON FOUND PAPER
7.75" × 11"
10/03/10

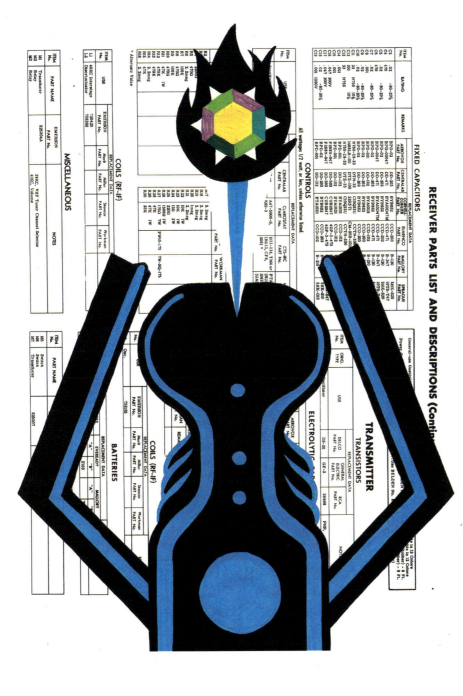

399

Then come out those fiery effulgences, infernally superb; then the evil-blazing diamond, once the divinest symbol of the crystal skies, looks like some crown-jewel stolen from the King of Hell.

ACRYLIC PAINT ON FOUND PAPER
7.75″ × 10.75″
10/04/10

400

Tashtego stood in the bows. He was full of the fire of the hunt.

ACRYLIC PAINT ON FOUND PAPER
8" × 5.5"
10/05/10

401

The sea had jeeringly kept his finite body up, but drowned the infinite of his soul.

ACRYLIC PAINT ON FOUND PAPER
7.25″ × 10.25″
10/09/10

402

*Not drowned entirely,
though. Rather carried down
alive to wondrous depths,
where strange shapes of the
unwarped primal world
glided to and fro before his
passive eyes; and the miser-
merman, Wisdom, revealed
his hoarded heaps; and
among the joyous, heartless,
ever-juvenile eternities, Pip
saw the multitudinous, God-
omnipresent, coral insects,
that out of the firmament of
waters heaved the colossal orbs.*

INK ON PAPER
9.5" × 6"
10/10/10

403

*Squeeze! squeeze! squeeze!
all the morning long; I
squeezed that sperm till I
myself almost melted into
it; I squeezed that sperm till
a strange sort of insanity
came over me; and I found
myself unwittingly squeezing
my co-laborers' hands in it,
mistaking their hands for
the gentle globules. Such an
abounding, affectionate,
friendly, loving feeling did this
avocation beget; that at last
I was continually squeezing
their hands, and looking up
into their eyes sentimentally...*

**ACRYLIC PAINT, INK AND PENCIL ON
FOUND PAPER
6.25" x 9.25"
10/10/10**

404

There is another substance, and a very singular one, which turns up in the course of this business, but which I feel it to be very puzzling adequately to describe. It is called slobgollion; an appellation original with the whalemen, and even so is the nature of the substance. It is an ineffably oozy, stringy affair, most frequently found in the tubs of sperm, after a prolonged squeezing, and subsequent decanting.

**ACRYLIC PAINT AND CHARCOAL ON
FOUND PAPER
6.25″ x 9.25″
10/10/10**

405

Had you stepped on board the Pequod at a certain juncture of this post-mortemizing of the whale; and had you strolled forward nigh the windlass, pretty sure am I that you would have scanned with no small curiosity a very strange, enigmatical object, which you would have seen there, lying along lengthwise in the lee scuppers.

ACRYLIC PAINT AND INK ON FOUND PAPER
7.75″ × 10.75″
10/11/10

406

*Arrayed in decent black;
occupying a conspicuous
pulpit; intent on bible leaves;
what a candidate for an
archbishopric, what a lad for
a Pope were this mincer!*

INK ON CONSTRUCTION PAPER
6.25" × 9.75"
10/12/10

A model of a fifteenth-century
Flemish carrack

The seal of Southampton

situation. What was the 'mesan' of
With an overall length of some 2
in need of a second mast. But
mast, or a French *misaine* or
whole, the trend of availal
mast, long established in
instance as the "mesan",
of a fifteenth-century f
two vessels, both squar
and foremast.'⁵

Pictorial evidence o
been discovered in a
masted ship is clearly
There can be no doub
sea-going vessels const
and the Mediterranea
advantages now recogn
went ahead apace, and

407

*While employed in
polishing them—one
man in each pot, side by
side—many confidential
communications are carried
on, over the iron lips.*

**ACRYLIC PAINT AND PENCIL ON
FOUND PAPER**
11" × 7.75"
10/14/10

408

It smells like the left wing of the day of judgment; it is an argument for the pit.

ACRYLIC PAINT AND INK ON FOUND PAPER
15.5" × 10.75"
10/14/10

409

...as the wind howled on, and the sea leaped, and the ship groaned and dived, and yet steadfastly shot her red hell further and further into the blackness of the sea and the night, and scornfully champed the white bone in her mouth, and viciously spat round her on all sides; then the rushing Pequod, freighted with savages, and laden with fire, and burning a corpse, and plunging into that blackness of darkness, seemed the material counterpart of her monomaniac commander's soul.

ACRYLIC PAINT AND INK ON FOUND PAPER
9″ x 7.5″
10/17/10

410

A stark, bewildered feeling,
as of death, came over me.

ACRYLIC PAINT ON FOUND PAPER
8.5" × 9.75"
10/17/10

The Skeleton Re-animated, title page, Blair's THE GRAVE, etching, 1805–08.

When the dread trumpet sounds, the slumb'ring dust,
(Not unattentive to the call) shall wake
The Grave, lines 750–752.

411

*And there is a Catskill eagle
in some souls that can alike
dive down into the blackest
gorges, and soar out of them
again and become invisible
in the sunny spaces.*

INK AND MARKER ON FOUND PAPER
6″ × 9.25″
10/17/10

412

*But the whaleman, as
he seeks the food of light,
so he lives in light.*

**ACRYLIC PAINT AND INK ON FOUND
PAPER**
7.75″ × 10.25″
10/17/10

413

The unmanufactured sperm oil possesses a singularly cleansing virtue.

ACRYLIC PAINT AND INK ON FOUND
PAPER
7.75″ × 10.75″
10/17/10

*But mark: aloft there, at
the three mast-heads, stand
three men intent on spying
out more whales…*

**ACRYLIC PAINT AND INK ON FOUND
PAPER**
11.5″ × 8.25″
10/19/10

Fig. 7-3
Two drawings of a
modern telescope
showing the prime
focus and Cassegrain
focus (which lies
below the primary
mirror) in (a), and
the fixed coudé focus
(b).

secondary mirror

main mirror

coudé focus

subsidiary mirrors

(b)

primary mirror

Cassegrain focus

(a)

spherical primary mirror

Schmidt corrector

curved film plane

Fig. 7-5 The optical layout of a Schmidt telescope. The
sharp surface of the Schmidt corrector is exaggerated here
for the sake of clarity.

auxiliary mirrors M1 M2 M3

telescope secondary mirror

M2

M4

M3

M1

(a)

primary mirror

(b)

eyepiece

small flat mirror

primary mirror

Fig. 7-4 The Newtonian focus as used in an amateur
reflecting telescope.

Mount Wilson in the 1920's shows the arrangement of
the 'beam' interferometer fitted to the top of the tube of the
2.5 m reflector, which shows the resulting interference
pattern.

415

But one morning, turning
to pass the doubloon, he
seemed to be newly attracted
by the strange figures and
inscriptions stamped on it, as
though now for the first time
beginning to interpret for
himself in some monomaniac
way whatever significance
might lurk in them.

**ACRYLIC PAINT, INK AND PENCIL ON
FOUND PAPER**
8.5" × 11"
10/19/10

416

"The firm tower, that is Ahab; the volcano, that is Ahab; the courageous, the undaunted, and victorious fowl, that, too, is Ahab; all are Ahab; and this round gold is but the image of the rounder globe, which, like a magician's glass, to each and every man in turn but mirrors back his own mysterious self."

ACRYLIC PAINT, CHARCOAL, COLORED PENCIL AND INK ON FOUND PAPER
7.75" × 10.75"
10/21/10

417

"*So in this vale of Death, God girds us round; and over all our gloom, the sun of Righteousness still shines a beacon and a hope. If we bend down our eyes, the dark vale shows her mouldy soil; but if we lift them, the bright sun meets our glance half way, to cheer.*"

ACRYLIC PAINT, INK AND MARKER ON FOUND PAPER
7.75" × 10.75"
10/21/10

418

*"Well; the sun he wheels
among 'em. Aye, here on
the coin he's just crossing
the threshold between
two of twelve sitting-
rooms all in a ring."*

**ACRYLIC PAINT, INK AND MARKER ON
FOUND PAPER**
7.75" × 10.75"
10/23/10

419

"I see nothing here, but a round thing made of gold, and whoever raises a certain whale, this round thing belongs to him. So what's all this staring been about?"

ACRYLIC PAINT, BALLPOINT PEN, CHARCOAL AND INK ON FOUND PAPER
7.75" × 10.75"
10/23/10

420

"Here's the ship's navel, this doubloon here, and they are all on fire to unscrew it. But, unscrew your navel, and what's the consequence? Then again, if it stays here, that is ugly, too, for when aught's nailed to the mast it's a sign that things grow desperate. Ha, ha! old Ahab! the White Whale; he'll nail ye!"

ACRYLIC PAINT AND INK ON FOUND PAPER
7.75" x 10.75"
10/24/10

...patch duties also performed by
th... ...st and a yard with a single
... ...opsail. In its developed and
... ...sh cutter of 150 tons carried
... ...nd one or two swivel guns.

...origin – a fast, two-masted
... ...inmast somewhat taller than
th... ...square topsails on both masts.
Wh... British seized New Amst...am from the Dutch in 1664 (and
cha... ...its ...me to New York aft... King Charles II's brother), most
of th...n. Among them were many who
hadability for ship design and ship-
build...was a Dutch speciality, and from
these... The story goes that the first
genu...eadsail was built at Gloucester,
Mass...ving the stocks and entering the
water'Oh, how she scoons!' Over-
heari...hen, a scooner let her be.'

421

*He was a darkly-tanned,
burly, good-natured, fine-
looking man, of sixty or
thereabouts, dressed in a
spacious roundabout, that
hung round him in festoons of
blue pilot-cloth; and one empty
arm of this jacket streamed
behind him like the broidered
arm of a huzzar's surcoat.*

**ACRYLIC PAINT AND INK ON FOUND
PAPER
8″ × 11″
10/24/10**

422

With his ivory arm frankly thrust forth in welcome, the other captain advanced, and Ahab, putting out his ivory leg, and crossing the ivory arm (like two sword-fish blades) cried out in his walrus way, "Aye, aye, hearty! let us shake bones together!—an arm and a leg!—an arm that never can shrink, d'ye see; and a leg that never can run."

**ACRYLIC PAINT, CHARCOAL AND INK
ON FOUND PAPER
10.75" x 7.75"
10/24/10**

423

"Presently up breaches from the bottom of the sea a bouncing great whale, with a milky-white head and hump, all crows' feet and wrinkles."

ACRYLIC PAINT AND INK ON FOUND PAPER
10.75″ × 15.5″
10/25/10

424

"...the whale's tail looming straight up out of it, perpendicular in the air, like a marble steeple."

ACRYLIC PAINT AND PENCIL ON FOUND PAPER
10.75" × 15.5"
10/26/10

425

"Samuel Enderby is the name of my ship," interrupted the one-armed captain, addressing Ahab…

ACRYLIC PAINT AND BALLPOINT PEN ON FOUND PAPER
10.75" × 7.75"
10/28/10

426

"...Moby Dick doesn't bite so much as he swallows."

ACRYLIC PAINT ON FOUND PAPER
8.5" x 7"
10/29/10

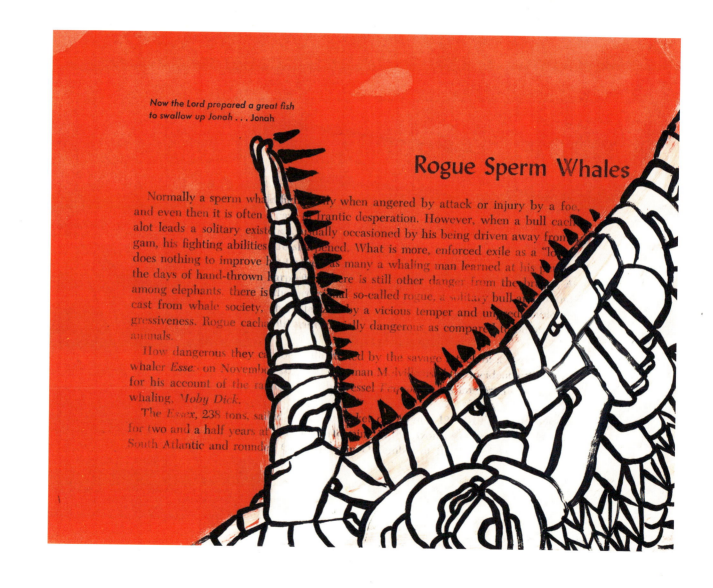

Now the Lord prepared a great fish
to swallow up Jonah . . . Jonah

Rogue Sperm Whales

Normally a sperm wha... ...ly when angered by attack or injury by a foe, and even then it is oftenrantic desperation. However, when a bull cac... alot leads a solitary existe... ...ually occasioned by his being driven away from gam, his fighting abilitiesened. What is more, enforced exile as a "lo... does nothing to improve h... ...as many a whaling man learned at his ... the days of hand-thrown l... ...re is still other danger from the b... among elephants, there isal so-called rogue, a solitary bull ... cast from whale society,y a vicious temper and un... gressiveness. Rogue cacha... ...lly dangerous as compared ... animals.

How dangerous they ca... ...d by the savage whaler *Esse...* on Novemb... ...nan M...vil... for his account of the ra... ...essel 7... whaling, *Moby Dick*.

The *Essex*, 238 tons, sa... ...for two and a half years a... South Atlantic and round...

427

"But he will still be hunted, for all that. What is best let alone, that accursed thing is not always what least allures. He's all a magnet!"

ACRYLIC PAINT AND INK ON FOUND PAPER
8.25" x 11"
10/29/10

428

In 1778, a fine ship, the Amelia, fitted out for the express purpose, and at the sole charge of the vigorous Enderbys, boldly rounded Cape Horn, and was the first among the nations to lower a whale-boat of any sort in the great South Sea.

ACRYLIC PAINT, INK, MARKER AND WATERCOLOR ON FOUND PAPER
10.75″ × 7.75″
10/30/10

429

...the British government was induced to send the sloop-of-war Rattler on a whaling voyage of discovery into the South Sea. Commanded by a naval post-captain, the Rattler made a rattling voyage of it, and did some service…

INK AND MARKER ON FOUND PAPER
10.75" × 7.75"
10/31/10

430

During my researches in the Leviathanic histories, I stumbled upon an ancient Dutch volume, which, by the musty whaling smell of it, I knew must be about whalers. The title was, "Dan Coopman", wherefore I concluded that this must be the invaluable memoirs of some Amsterdam cooper in the fishery, as every whale ship must carry its cooper. I was reinforced in this opinion by seeing that it was the production of one "Fitz Swackhammer."

INK ON OLD BOOK COVER
5.25″ x 7.5″
10/31/10

431

But my friend Dr. Snodhead, a very learned man, professor of Low Dutch and High German in the college of Santa Claus and St. Pott's, to whom I handed the work for translation, giving him a box of sperm candles for his trouble —this same Dr. Snodhead, as soon as he spied the book, assured me that "Dan Coopman" did not mean "The Cooper," but "The Merchant."

ACRYLIC PAINT, COLLAGE AND INK ON
WALLPAPER SAMPLE AND CHIPBOARD
7.5″ × 7.5″
11/01/10

432

*...if you can get nothing better
out of the world, get a good
dinner out of it, at least.*

INK ON FOUND PAPER
7.75" × 10.75"
11/02/10

433

And as for my exact knowledge of the bones of the Leviathan in their gigantic, full grown development, for that rare knowledge I am indebted to my late royal friend Tranquo, king of Tranque, one of the Arsacides.

INK ON FOUND PAPER
7.75" x 10"
11/03/10

434

*...in the skull, the priests
kept up an unextinguished
aromatic flame, so that
the mystic head again sent
forth its vapory spout...*

**ACRYLIC PAINT AND INK ON FOUND
PAPER
8.5" × 7"
11/04/10**

Skeleton of large
sperm whale

rooms by means of a beautiful curtain called the "veil." The curtain was made of blue, purple and crimson cloth. The inside room was called the Most Holy Place, because the Ark of the Covenant was to be kept there.

The walls on the inside of the Most Holy Place were covered with wood that had been carved to represent cherubim (angels), and palm trees, and flowers. These Solomon had covered with gold, and the floor as well. Two cherubim, each fifteen feet high, were carved out of olive wood, and Solomon had them covered with gold also. They stood facing each other, with their wings outspread and stretching from one wall to the other.

The altar of the Temple was made of brass. It was four times as large as the altar Moses had made for the tabernacle.

All of the other things that had been in the tabernacle were included in the equipment for the Temple. There were the golden candlesticks, the lavers or basins for water in which the priests must wash themselves before entering to offer sacrifices, the tables for the loaves of unleavened bread, and the censers in which the priests burned incense.

From the time the building of the Temple was started until it was finally completed, the people worked for more than seven years.

When the Temple was finished, there were ceremonies to dedicate it to the Lord. Solomon called all the elders and the chief men of Israel to Jerusalem to be present when the Ark was taken into the Temple. Only priests were permitted to touch the Ark, so the priests carried it into the Temple and placed it under the wings of the two cherubim, covered with gold, in the Most Holy Place.

The Lord When the priests had left them in the Most Holy Place **comes in** and had come out of the building, a great cloud filled the **a cloud** Temple. The cloud was the glory of God.

Then Solomon stood the people, and gave thanks to the Lord to build their Temple.

He asked the Lord to accept it as Solomon spoke aloud, praying to the Lord within the hearing assembled before the temple.

"Please, Lord, hear and answer the prayers of Israel make in this house," said Solomon that the Lord would give their enemies sin and be punished by drought and their

435

Now, amid the green, life-restless loom of that Arsacidean wood, the great, white, worshipped skeleton lay lounging—a gigantic idler! Yet, as the ever-woven verdant warp and woof intermixed and hummed around him, the mighty idler seemed the cunning weaver; himself all woven over with the vines; every month assuming greener, fresher verdure; but himself a skeleton. Life folded Death; Death trellised Life...

ACRYLIC PAINT AND INK ON FOUND
PAPER
6″ × 9″
11/05/10

436

*The skeleton dimensions
I shall now proceed to set
down are copied verbatim
from my right arm, where
I had them tattooed; as in
my wild wanderings at that
period, there was no other
secure way of preserving
such valuable statistics.*

BALLPOINT PEN ON PAPER
8.5″ x 5.5″
11/05/10

whale
85 ft length
40 ft round
90 tons wt

skeleto
72 ft l
skull ar
50 ft b
10 ribs

Warrior Whale

Warrior Whale

The Third Word of the Octopus and Squid

Your First Book of Salt Water Fishing

437

...according to my careful calculation, I say, a Sperm Whale of the largest magnitude, between eighty-five and ninety feet in length, and something less than forty feet in its fullest circumference, such a whale will weigh at least ninety tons; so that, reckoning thirteen men to a ton, he would considerably outweigh the combined population of a whole village of one thousand one hundred inhabitants.

INK ON FOUND PAPER
8.5" × 7"
11/06/10

438

*Only in the heart of quickest
perils; only when within
the eddyings of his angry
flukes; only on the profound
unbounded sea, can the
fully invested whale be truly
and livingly found out.*

**ACRYLIC PAINT, COLORED PENCIL AND
INK ON FOUND PAPER**
7" × 8.5"
11/06/10

do a special job. The heart, the stomach, and the lungs are organs.

ORGANISM Any living thing.

OVUM A female egg cell.

PAPILLAE Tiny projections, as on the tongue. The taste buds lie within the papillae of the tongue.

PARATHYROID GLAND Any of four small glands behind the thyroid gland. They regulate the calcium content of the blood.

PANCREAS A digestive gland that secretes pancreatic juice into the intestine and the hormone insulin into the bloodstream.

PELVIS The firm girdle of bones at the lower end of the trunk by which the legs are attached to the body; also, the upper end of the ureter as it leaves the kidney.

PERILYMPH A fluid in the cochlea of the inner ear.

PERISTALSIS The progressive squeezing of the muscles of the intestinal tube, which moves food or fluid along.

PHAGOCYTE A white blood cell which engulfs foreign particles such as bacteria.

PHARYNX The upper part of the throat, between the mouth and the esophagus.

PIGMENT Coloring matter.

PITUITARY GLAND A pea-sized endocrine gland located at the base of the brain. It regulates activities of other endocrine glands and controls body growth.

PLANKTON Tiny swimming or floating animal or plant life of the sea.

PLASMA The fluid part of the blood.

PLATELET A tiny platelike particle in the blood that aids in clotting.

PONS A bridge, as in the bridge of nervous tissue that connects parts of the brain.

PREMOLAR See BICUSPID.

PROTEIN One of the three main classes of food essential to man. Meat, milk, and eggs are rich in proteins.

PROTHROMBIN A substance that aids in blood clotting.

PROTOPLASM The complex substance that makes up living tissue.

PROTOZOON (plural protozoa) Any one-celled animal.

PULP The soft, sensitive tissue filling the central part of a tooth.

PUPIL The adjustable opening in the eye through which light passes.

PYLORUS The narrow passage at the lower end of the stomach connecting with the duodenum, or upper part of the small intestine.

RED BLOOD CELL Any of the cells that give blood its color and transport oxygen.

REFLEX An automatic movement or activity in response to a stimulus, as when we pull our hand away after touching something hot.

RETINA The light-sensitive tissue at the back of the eye.

ROD Any of the cells in the retina that distinguish between light and dark and enable us to see in dim light.

SAC A baglike body part, as the air sacs of the lungs.

SACCULE A small sac in the inner ear.

SACRUM The part of the backbone that joins with the pelvis.

SALIVARY GLAND Any of the glands that secrete saliva into the mouth. Saliva begins the breakdown of food and helps it move down the throat.

SEBACEOUS Like or related to fatty matter, as the sebaceous glands of the skin, which secrete fatty matter.

138

SEMICIRCULAR CANAL Any of three loop-shaped tubes in the inner ear that help the body maintain balance.

SERUM The liquid left after blood clots.

SINUS A cavity or hollow. The sinuses of the nose are air-filled cavities in the skull that open into the nose.

SMALL INTESTINE A long tube extending from the stomach to the colon which is the main site of the digestion and absorption of food.

SPERM A male reproductive cell.

SPINAL CORD A cord of nerve tissue extending from the brain down the back in the spinal column. It sends messages to and from the brain and controls reflex actions.

SPLEEN A small organ near the stomach which makes certain white blood cells, destroys worn-out red blood cells, and stores blood.

STIRRUP See HAMMER.

STOMACH The muscular pouch in which the early phases of digestion take place.

SYSTEM All of the organs involved in an important body process, such as digestion.

TAILBONE See COCCYX.

TARSUS Seven bones in the arch of the foot. They correspond to the wrist, or carpus, of the hand.

TENDON A tough, non-stretchable cord of tissue connecting a muscle to a bone.

THROMBOPLASTIN A substance that aids in blood clotting.

THYMUS A gland of the lower neck and upper chest, large in infants but shrunken to a mere trace in adults.

THYROID GLAND An H-shaped gland in the front of the neck. It secretes a hormone that helps control the speed at which body cells work.

TISSUE A group of similar specialized cells that form a body structure. Skin, muscle, and bone are tissues.

TRACHEA The main tube through which air passes to and from the lungs. Also called the windpipe.

TUBULE A small body tube.

URETER Either of two long tubes, each of which carries liquid wastes from one of the kidneys to the bladder.

URETHRA A tube that carries urine from the bladder to the outside of the body.

UTRICLE A small sac in the inner ear.

VALVE A structure that temporarily closes a passage or opening, or permits a fluid to flow in one direction only.

VEIN Any of the blood vessels that carry blood back to the heart.

VENTRICLE A cavity or space in an internal organ, such as either one of the two lower chambers of the heart.

VERTEBRA (plural vertebrae) Any of thirty-three separate bones that make up the backbone.

VESSEL A tube or canal through which a fluid moves, such as a blood vessel.

VILLUS (plural villi) One of millions of tiny hairlike projections, as those in the small intestine that help absorb food.

VITAMIN Any of a number of substances in food that are essential to life. Only minute quantities are needed by the body.

VITREOUS BODY (or HUMOR) The transparent syrupy fluid that fills the main chamber of the eye.

WHITE BLOOD CELL Any of the colorless cells that protect the body against disease. Most of them move about freely in the bloodstream.

WINDPIPE See TRACHEA.

439

...only think of the gigantic involutions of his intestines, where they lie in him like great cables and hawsers coiled away in the subterranean orlop-deck of a line-of-battle-ship.

INK ON FOUND PAPER
7.75" × 11"
11/07/10

440

To produce a mighty book, you must choose a mighty theme.

INK ON FOUND PAPER
6.25" x 10"
11/07/10

441

But by far the most wonderful of all cetacean relics was the almost complete vast skeleton of an extinct monster, found in the year 1842, on the plantation of Judge Creagh, in Alabama. The awe-stricken credulous slaves in the vicinity took it for the bones of one of the fallen angels.

ACRYLIC PAINT AND INK ON FOUND PAPER
8.25" × 8"
11/08/10

442

I am horror-struck at this antemosaic, unsourced existence of the unspeakable terrors of the whale, which, having been before all time, must needs exist after all humane ages are over.

ACRYLIC PAINT AND INK ON FOUND PAPER
10″ × 6.25″
11/09/10

TUBE PLACEMENT CHART

443

For Pliny tells us of whales that embraced acres of living bulk, and Aldrovandus of others which measured eight hundred feet in length…

ACRYLIC PAINT AND INK ON FOUND
PAPER
15.5″ × 10.75″
11/10/10

444

But will any whaleman believe these stories? No. The whale of to-day is as big as his ancestors in Pliny's time. And if ever I go where Pliny is, I, a whaleman (more than he was), will make bold to tell him so.

INK AND MARKER ON FOUND PAPER
7.75" × 10.75"
11/11/10

445

*Forty men in one ship
hunting the Sperm Whale
for forty-eight months…*

ACRYLIC PAINT AND CHARCOAL ON
FOUND PAPER
11" × 7.75"
11/11/10

446

...so, hunted from the savannas and glades of the middle seas, the whale-bone whales can at last resort to their Polar citadels, and diving under the ultimate glassy barriers and walls there, come up among icy fields and floes; and in a charmed circle of everlasting December, bid defiance to all pursuit from man.

INK AND MARKER ON BRISTOL BOARD
8.5″ × 7″
11/13/10

447

In Noah's flood he despised Noah's Ark; and if ever the world is to be again flooded, like the Netherlands, to kill off its rats, then the eternal whale will still survive, and rearing upon the topmost crest of the equatorial flood, spout his frothed defiance to the skies.

ACRYLIC PAINT AND PENCIL ON FOUND PAPER
10.75" x 15.5"
11/13/10

448

With many other particulars concerning Ahab, always had it remained a mystery to some, why it was, that for a certain period, both before and after the sailing of the Pequod, he had hidden himself away with such Grand-Lama-like exclusiveness and, for that one interval, sought speechless refuge, as it were, among the marble senate of the dead.

ACRYLIC PAINT ON FOUND PAPER
6″ × 9″
11/14/10

449

...take high abstracted man alone; and he seems a wonder, a grandeur, and a woe.

INK AND MARKER ON FOUND PAPER
7.75" × 10.75"
11/14/10

450

But most humble though he was, and far from furnishing an example of the high, humane abstraction; the Pequod's carpenter was no duplicate; hence, he now comes in person on this stage.

INK AND PENCIL ON FOUND PAPER
8.5" × 11"
11/15/10

CAVALIER OBLIQUE

When the receding angle is 45°:

TH = H +
TW = W + (D

The following formulas are used for centering cabinet pictorial drawings when the receding angle is 30°:

$$TH = H + \frac{(D \times .5)}{2}$$

$$TW = W + \frac{(D \times .866)}{2}$$

When the receding angle is 45°:

$$\frac{(D \times .707)}{2}$$

$$TW = W + \frac{(D \times .707)}{2}$$

451

For nothing was this man more remarkable, than for a certain impersonal stolidity as it were; impersonal, I say; for it so shaded off into the surrounding infinite of things, that it seemed one with the general stolidity discernible in the whole visible world...

ACRYLIC PAINT AND INK ON FOUND PAPER
8.5" × 11"
11/16/10

452

Yet, as previously hinted, this omnitooled, open-and-shut carpenter, was, after all, no mere machine of an automaton. If he did not have a common soul in him, he had a subtle something that somehow anomalously did its duty.

ACRYLIC PAINT AND INK ON FOUND
PAPER
8.5" x 11"
11/16/10

453

...for what's made in fire must properly belong to fire...

ACRYLIC PAINT AND INK ON FOUND PAPER
15.5" x 10.75"
11/18/10

454

*Hold; while Prometheus is
about it, I'll order a complete
man after a desirable pattern.
Imprimis, fifty feet high in his
socks; then, chest modelled
after the Thames Tunnel;
then, legs with roots to 'em,
to stay in one place; then,
arms three feet through the
wrist; no heart at all, brass
forehead, and about a quarter
of an acre of fine brains; and
let me see—shall I order eyes
to see outwards? No, but put
a sky-light on top of his head
to illuminate inwards. There,
take the order, and away.*

INK AND MARKER ON FOUND PAPER
5.75" × 7.75"
11/19/10

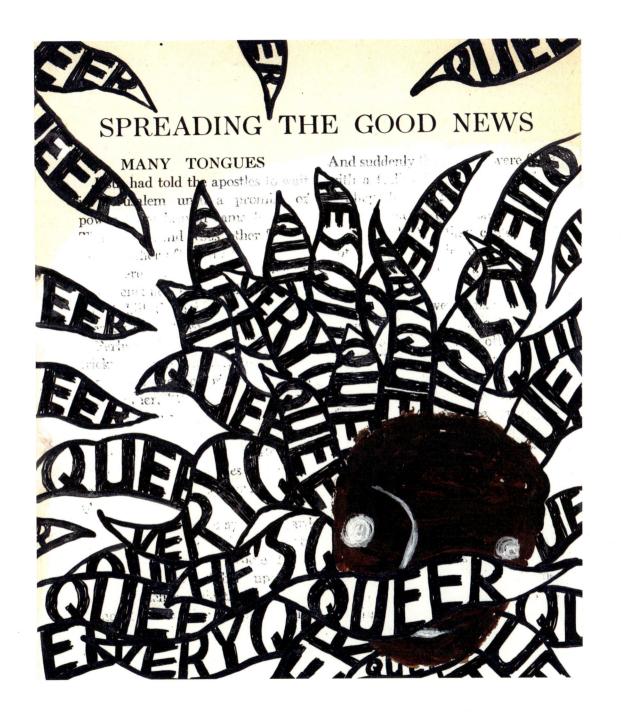

455

Well, well, well! Stubb knows him best of all, and Stubb always says he's queer; says nothing but that one sufficient little word queer; he's queer, says Stubb; he's queer—queer, queer; and keeps dinning it into Mr. Starbuck all the time—queer, Sir—queer, queer, very queer.

ACRYLIC PAINT AND INK ON FOUND PAPER
7.5" × 9.5"
11/20/10

456

...let's finish it before the resurrection fellow comes a-calling with his horn for all legs, true or false, as brewery-men go round collecting old beer barrels, to fill 'em up again.

INK ON BRISTOL BOARD
7" x 8.5"
11/20/10

457

"What we come twenty thousand miles to get is worth saving, Sir."

"So it is, so it is; if we get it."

ACRYLIC PAINT ON FOUND PAPER
15.5" × 10.75"
11/21/10

458

Ahab seized a loaded musket from the rack (forming part of most South-Sea-men's cabin furniture), and pointing it towards Starbuck, exclaimed: "There is one God that is Lord over the earth, and one Captain that is lord over the Pequod.—On deck!"

INK ON FOUND PAPER
10.75" × 7.75"
11/21/10

459

Now, at this time it was that my poor pagan companion, and fast bosom-friend, Queequeg, was seized with a fever, which brought him nigh to his endless end.

ACRYLIC PAINT, COLORED PENCIL AND
INK ON FOUND PAPER
8″ × 11″
11/22/10

460

*But as all else in him thinned,
and his cheekbones grew
sharper, his eyes, nevertheless,
seemed growing fuller and
fuller; they became of a strange
softness of lustre; and mildly
but deeply looked out at you
there from his sickness, a
wondrous testimony to that
immortal health in him which
could not die, or be weakened.
And like circles on the water,
which, as they grow fainter,
expand; so his eyes seemed
rounding and rounding,
like the rings of Eternity.*

ACRYLIC PAINT ON FOUND PAPER
7.75" × 10.75"
11/24/10

461

...for not only do they believe that the stars are isles, but that far beyond all visible horizons, their own mild, uncontinented seas, interflow with the blue heavens; and so form the white breakers of the milky way.

ACRYLIC PAINT AND INK ON FOUND PAPER
7.5″ × 9.5″
11/25/10

462

...there lay Queequeg in his coffin with little but his composed countenance in view. "Rarmai" (it will do; it is easy), he murmured at last...

ACRYLIC PAINT AND INK ON FOUND PAPER
8" × 11"
11/25/10

463

"...but base little Pip, he died a coward; died all a'shiver;— out upon Pip! Hark ye; if ye find Pip, tell all the Antilles he's a runaway; a coward, a coward, a coward! Tell them he jumped from a whale-boat! I'd never beat my tambourine over base Pip, and hail him General, if he were once more dying here. No, no! shame upon all cowards—shame upon them! Let 'em go drown like Pip, that jumped from a whale-boat. Shame! shame!"

INK ON WATERCOLOR PAPER
6" x 9"
11/26/10

464

*So, in good time my Queequeg
gained strength; and at length
after sitting on the windlass
for a few indolent days
(but eating with a vigorous
appetite) he suddenly leaped
to his feet, threw out arms
and legs, gave himself a good
stretching, yawned a little bit,
and then springing into the
head of his hoisted boat, and
poising a harpoon, pronounced
himself fit for a fight.*

**ACRYLIC PAINT, COLORED PENCIL AND
INK ON FOUND PAPER**
7.75" × 10.75"
11/26/10

10 The Future

What are likely to be the most important fields of oceanographic work in the future? We live in an age when only a few sh... fact, and ev... dictions ... event ...

Power from the Sea

465

His firm lips met like the lips of a vice; the delta of his forehead's veins swelled like overladen brooks; in his very sleep, his ringing cry ran through the vaulted hull, "Stern all! the White Whale spouts thick blood!"

ACRYLIC PAINT AND INK ON FOUND PAPER
7.25″ × 10.25″
11/27/10

466

Availing himself of the mild, summer-cool weather that now reigned in these latitudes, and in preparation for the peculiarly active pursuits shortly to be anticipated, Perth, the begrimed, blistered old blacksmith, had not removed his portable forge to the hold again, after concluding his contributory work for Ahab's leg, but still retained it on deck, fast lashed to ringbolts by the foremast...

ACRYLIC PAINT, CHARCOAL, COLORED
PENCIL AND INK ON FOUND PAPER
8.25" × 11"
11/27/10

467

*It was the Bottle Conjuror!
Upon the opening of that
fatal cork, forth flew the fiend,
and shrivelled up his home.*

INK ON BRISTOL BOARD
7" × 8.5"
11/28/10

468

Hearkening to these voices,
East and West, by early
sun-rise, and by fall of
eve, the blacksmith's soul
responded, Aye, I come! And
so Perth went a-whaling.

ACRYLIC PAINT, CHARCOAL, INK AND
MARKER ON FOUND PAPER
7" × 8.5"
11/28/10

469

"...look ye here—here—can ye
smooth out a seam like this,
blacksmith," sweeping one
hand across his ribbed brows;
"if thou could'st, blacksmith,
glad enough I lay my head
upon thy anvil, and feel thy
heaviest hammer between
my eyes. Answer! Can'st
thou smooth this seam?"

INK ON FOUND PAPER
6.25" × 9"
11/29/10

470

At last the shank, in one complete rod, received its final heat; and as Perth, to temper it, plunged it all hissing into the cask of water near by, the scalding steam shot up into Ahab's bent face.

ACRYLIC PAINT AND INK ON FOUND PAPER
6.25" × 9.75"
11/30/10

471

"Ego non baptizo te in nomine patris, sed in nomine diaboli!" deliriously howled Ahab, as the malignant iron scorchingly devoured the baptismal blood.

ACRYLIC PAINT AND INK ON FOUND PAPER
7.75" × 10.75"
11/30/10

472

At such times, under an abated sun; afloat all day upon smooth, slow heaving swells; seated in his boat, light as a birch canoe; and so sociably mixing with the soft waves themselves, that like hearth-stone cats they purr against the gunwale; these are the times of dreamy quietude, when beholding the tranquil beauty and brilliancy of the ocean's skin, one forgets the tiger heart that pants beneath it; and would not willingly remember, that this velvet paw but conceals a remorseless fang.

INK AND MARKER ON FOUND PAPER
7.25" × 10.25"
12/01/10

Positions of the main oceanic trenches are shown on the map above. The profile of the Challenger Deep (below map) shows how even the largest trenches slope quite gradually to their maximum depths.

depth of nearly six miles—about twice the average depth of the ocean floor. The deepest known trenches run southward along the east of Japan and the Mariana Islands, then running west toward the Philippine Islands. There are others south of the equator next to the Kermadec and Tonga islands. The relatively narrow width of these trenches, if considered in relation to the Earth's circumference of 25,000 miles, shows that they are merely folds in the Earth's crust. As you sail over one of these deep trenches, with the echo-sounder recorder going all the time, you find that the slope of the sea floor is fairly gentle at first. Then quite gradually the side of the underwater valley becomes steeper, sloping like a mountainous road. In some places there are steep cliffs, and in other places it is almost flat. But the average slope brings us down to nearly 5000 fathoms, where the valley rounds off at the bottom. The Challenger Deep in the Mariana Trench is not called after the famous ship of that name. In 1951 a new survey vessel, H.M.S. Challenger, working at about 11° south of the equator, was the first to record 5940 fathoms. Since then, this

depth has been confirmed by the Russian research ship *Vityaz* and by United States expeditions. On board an oceanographic ship you would realize the great depth if you watched the echo-sounder: It takes $14\frac{1}{2}$ seconds for the signal to travel to the bottom of the valley and back again. To verify the echo-sounder reading, oceanographers on board the *Challenger* lowered a piece of iron weighing 140 pounds on a steel wire until it touched bottom. It took an hour and a half!

What forces within the Earth cause the trenches? They are probably formed because the crust of the Earth is being squeezed constantly—just as folds appear in the carpet when you push it from one end with your foot. But another kind of deep-ocean valley has been discovered recently, and it seems to have been formed in just the opposite way—by a tearing-apart of the earth's crust. Thus sometimes the Earth's crust is pushed and folded, and at other times it is split apart.

All down the middle of the Mid-Atlantic Ridge—that great underwater mountain range that forms a wall in the center of the Atlantic Ocean—there is a steep-sided valley. This valley has been tracked by continually

473

...Our souls are like those orphans whose unwedded mothers die in bearing them: the secret of our paternity lies in their grave, and we must there to learn it.

ACRYLIC PAINT AND INK ON FOUND PAPER
7.5″ × 9″
12/02/10

474

It was a Nantucket ship, the
Bachelor, which had just
wedged in her last cask of
oil, and bolted down her
bursting hatches; and now,
in glad holiday apparel, was
joyously, though somewhat
vain-gloriously, sailing round
among the widely-separated
ships on the ground, previous
to pointing her prow for home.

The three men at her mast-
head wore long streamers
of narrow red bunting at
their hats; from the stern, a
whale-boat was suspended,
bottom down; and hanging
captive from the bowsprit was
seen the long lower jaw of
the last whale they had slain.
Signals, ensigns, and jacks
of all colors were flying from
her rigging, on every side.

**ACRYLIC PAINT, BALLPOINT PEN, INK
AND MARKER ON FOUND PAPER
10.75" × 7.75"
12/02/10**

475

*On the quarter-deck, the mates
and harpooneers were dancing
with the olive-hued girls
who had eloped with them
from the Polynesian Isles…*

CHARCOAL AND INK ON WALLPAPER
SAMPLE
8.25" × 11"
12/04/10

476

*It was far down the afternoon;
and when all the spearings
of the crimson fight were
done: and floating in
the lovely sunset sea and
sky, sun and whale both
stilly died together…*

INK AND MARKER ON FOUND PAPER
10.25" × 7.25"
12/04/10

477

For that strange spectacle observable in all Sperm Whales dying—the turning sunwards of the head, and so expiring—that strange spectacle, beheld of such a placid evening, somehow to Ahab conveyed a wondrousness unknown before.

ACRYLIC PAINT, INK AND MARKER ON
FOUND PAPER
7.25" × 9"
12/04/10

478

The waif-pole was thrust upright into the dead whale's spout-hole; and the lantern hanging from its top, cast a troubled flickering glare upon the black, glossy back, and far out upon the midnight waves, which gently chafed the whale's broad flank, like soft surf upon a beach.

INK ON FOUND PAPER
9.75″ × 8.5″
12/05/10

479

"Take another pledge, old man," said the Parsee, as his eyes lighted up like fire-flies in the gloom…

ACRYLIC PAINT AND INK ON BRISTOL
BOARD
7″ × 8.5″
12/05/10

480

The sky looks lacquered; clouds there are none; the horizon floats; and this nakedness of unrelieved radiance is as the insufferable splendors of God's throne.

ACRYLIC PAINT AND INK ON FOUND PAPER
10.75" × 7.75"
12/06/10

Imitate the Birds

In The Empire of the Air, pub-
... 1881, the French pioneer
... Mouillard urged experiment-
... of soaring. His
... up by others, were
... time to final success with
...wered machines.

...hold that in the flight of the soaring
... (the vultures, the eagles, and
... which fly without flap-

...Benea...

Mouillard, watching bi... in Egypt

LIBRARY OF CONGRESS

projecting prow. Be...
built hull which...
stores, tools, a...
sorts, including...
There were th...
compartments...
for the crew o...
The bow conta...
quarters for the cr...
stern were an engine...
saloon, above which...
house for the helmsman,...
ed the vessel . . . Benea...
was an arrangement...
springs to soften the jolt o...
though this was hardly...
skilled was the engineer...
the movements of his...

Above the deck r...
vertical axes, fiftee...
and seven, more...
ter. One could...
Albatross wa...
seven mast...
mast bor...
. . . W...
speeds...
denth...
turn...
its a...
the...
pell...
zon...
we...
set...

R...
powe...
nor c...
gases,...
which...
He cho...
one day...
trial wor...
no electro...
tricity, but...
age cells. W...
these batteries,...
them?—only Ro...
secret was the construction of the
storage cells. What made up the
negative and positive plates? No one
knows. The engineer was careful—
and quite sensibly, too—not to pat-
ent his invention.

employed, but all forms of apparatus
however dissimilar, must be based
upon this idea.

"A Matter of Practice"

In 1893 Otto Lilienthal, the grea...
German glider pilot, described hi...
early experiments—and summed u...
his optimistic hopes for the future—
in a paper titled "The Carrying Ca...
pacity of Arched Surfaces in Sailin,...
..." from which the followin,...
...been taken.

I have now reached the close of...
series of experiments during which...
...d set myself a definite task. Thi...
...construct an apparatus wit...
...arrying surfaces whic...
...me to sail through th...
...m high points an...
...sible—that is t...
...he least obtainable inclina...
...to do this with stability an...
...winds of medium...

...that wit...
...rces ar...
...ing to b...
...that is far fron...
...flying...
The success...ization...
of this impo...n in ai...
resistance is g...o der...a con...
siderable amou...f inge...y. . . .
I had come...the conclusion tha...
a particular class of difficulties wa...
next to be overcome. In trials wit...
movable wings in the building c...
steam air ships, in experiments wit...
mechanical birds of all kinds I ha...
found out how hard it is to maintai...
a stable equilibrium in the air and t...
counteract the "whims" of the wind...

For this reason I gave up for th...
...me being motor mechanisms alto...
...ther, and limited myself to th...
...mplest form of flight, namely, glid...
...g downward in an inclined direc...
...on. . . .

There can be no doubt, in m...
op...ion, that by perfecting our pre...
...ent...pparatus, and by acquirin...
...greater...skill in using it, we sha...

481

...these passed over the
mute, motionless Parsee's
face. Unobserved he rose
and glided away...

ACRYLIC PAINT AND INK ON FOUND
PAPER
7.75" × 10.75"
12/07/10

482

So, too, it is, that in these resplendent Japanese seas the mariner encounters the direst of all storms, the Typhoon. It will sometimes burst from out that cloudless sky, like an exploding bomb upon a dazed and sleepy town.

ACRYLIC PAINT, INK AND MARKER ON FOUND PAPER
8.25" x 7.75"
12/08/10

able agility despite his bulk, made him very dangerous to small, open boats. The greatest peril came from some of the older bulls, which put up a fierce resistance when harpooned and were even known to jump clear of the water, hitting the sea a thunderous slap with their tails. The enormous power and huge flukes of those tails could smash a whaleboat and her men with the ease of a fly swatter crushing a mosquito. There also was the danger of being rammed by an infuriated bull.

After 1846, American whaling skidded downhill. Some speed was lent to the decline by discovery of gold at Sutter's Mill, California, in 1849. Suddenly everyone developed "gold fever." Lured by the promise of fabulous wealth, thousands of men began a trek westward. With them went ~~sailors~~ ~~~~. There were no transcontinental railroads yet ~~and no Panama~~ ~~~~ to the Pacific Coast by ship, braving storms and often hardships in months ~~long voyages~~ around Cape Horn and ~~up~~ the western coast of South America. Transporting gold seekers became a profitable business, a~~nd a number of w~~ ~~~~s converted to passenger vessels to cash in ~~the bonanza.~~

~~~~ ~~ing in 1861~~ was an especially severe blow to American whal- ~~~~ ~~industry for~~ ~~~~ ~~th~~ the Union forces. Ships were ~~~~ ~~~~ ~~~~rs fell ~~victim to~~ Southern warships and ~~~~ ~~~~ with the South in that conflict ~~~~ ~~~~

**483**

"*But I am not a brave man; never said I was a brave man; I am a coward…*"

**ACRYLIC PAINT, COLORED PENCIL, INK AND PENCIL ON FOUND PAPER**
**8.5" × 7"**
**12/08/10**

## 484

*"Look aloft!" cried Starbuck. "The St. Elmo's Lights (corpus sancti) corposants! the corposants!"*

*All the yard-arms were tipped with a pallid fire; and touched at each tri-pointed lightning-rod-end with three tapering white flames, each of the three tall masts was silently burning in that sulphurous air, like three gigantic wax tapers before an altar.*

**ACRYLIC PAINT AND BALLPOINT PEN ON FOUND PAPER**
**7.5″ × 11″**
**12/08/10**

## 485

*...while lit up by the preternatural light, Queequeg's tattooing burned like Satanic blue flames on his body.*

**ACRYLIC PAINT ON FOUND PAPER**
**10.75″ × 7.75″**
**12/09/10**

**486**

*"Aye, aye, men!" cried Ahab.
"Look up at it; mark it well;
the white flame but lights the
way to the White Whale!"*

**ACRYLIC PAINT, BALLPOINT PEN AND
INK ON FOUND PAPER
15.5" × 10.75"
12/09/10**

**487**

*...from the keen steel barb there now came a levelled flame of pale, forked fire.*

**ACRYLIC PAINT AND INK ON FOUND PAPER**
**7" × 8.5"**
**12/10/10**

## 488

*But dashing the rattling*
*lightning links to the deck,*
*and snatching the burning*
*harpoon, Ahab waved it like a*
*torch among them; swearing to*
*transfix with it the first sailor*
*that but cast loose a rope's*
*end. Petrified by this aspect,*
*and still more shrinking from*
*the fiery dart that he held,*
*the men fell back in dismay,*
*and Ahab again spoke:*

*"All your oaths to hunt*
*the White Whale are as*
*binding as mine; and heart,*
*soul, and body, lungs and*
*life, old Ahab is bound."*

**INK AND MARKER ON FOUND PAPER**
**7.75" x 10.75"**
**12/11/10**

**489**

*"Didn't you once say that whatever ship Ahab sails in, that ship should pay something extra on its insurance policy, just as though it were loaded with powder barrels aft and boxes of lucifers forward?"*

**ACRYLIC PAINT, BALLPOINT PEN AND INK ON FOUND PAPER**
**10.5" × 7.75"**
**12/11/10**

## 490

*"...when a fellow's soaked through, it's hard to be sensible, that's a fact."*

**INK ON FOUND PAPER**
7.75" × 10.75"
12/12/10

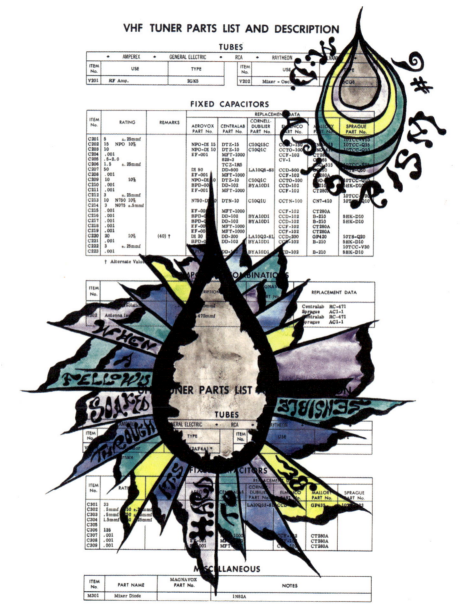

**491**

*"Um, um, um. Stop that thunder! Plenty too much thunder up here. What's the use of thunder? Um, um, um. We don't want thunder; we want rum; give us a glass of rum. Um, um, um!"*

**COLORED PENCIL ON FOUND PAPER**
**8" × 5.5"**
**12 / 12 / 10**

**492**

*...like the feathers of an albatross, which sometimes are cast to the winds when that storm-tossed bird is on the wing.*

**INK ON FOUND PAPER**
**7.75″ × 10.75″**
**12 / 13 / 10**

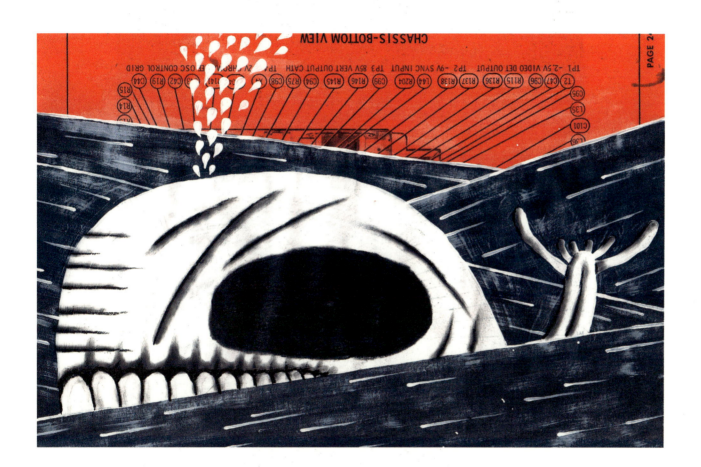

## 493

*"Fair for death and doom,—*
that's *fair for Moby Dick."*

**ACRYLIC PAINT AND CHARCOAL ON
FOUND PAPER**
**10.75" × 7.25"**
**12/15/10**

## 494

*"A touch, and Starbuck may survive to hug his wife and child again.—Oh, Mary! Mary!—boy! boy! boy!—But if I wake thee not to death, old man, who can tell to what unsounded deeps Starbuck's body this day week may sink, with all the crew! Great God, where art thou? Shall I? shall I?"*

**ACRYLIC PAINT AND INK ON FOUND PAPER**
**7.75″ × 10.75″**
**12/16/10**

**495**

*The sea was as a crucible of molten gold, that bubblingly leaps with light and heat.*

**INK AND MARKER ON FOUND PAPER**
**10.75" × 7.75"**
**12/17/10**

## 496

*Deliberately standing before the binnacle, and eyeing the transpointed compasses, the old man, with the sharp of his extended hand, now took the precise bearing of the sun…*

**INK AND WATERCOLOR ON WATERCOLOR PAPER**
**11.5" × 8"**
**12/17/10**

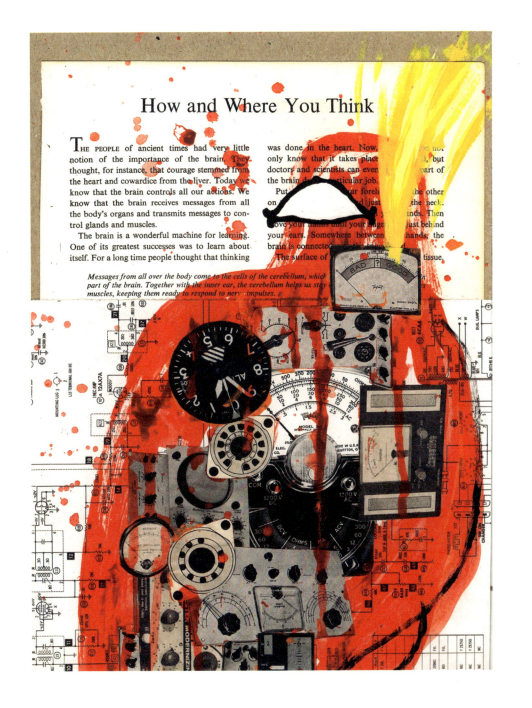

How and Where You Think

THE PEOPLE of ancient times had very little notion of the importance of the brain. They thought, for instance, that courage stemmed from the heart and cowardice from the liver. Today we know that the brain controls all our actions. We know that the brain receives messages from all the body's organs and transmits messages to control glands and muscles.

The brain is a wonderful machine for learning. One of its greatest successes was to learn about itself. For a long time people thought that thinking

was done in the heart. Now, [...] not only know that it takes place [...] but doctors and scientists can even [...] part of the brain do [...] particular job.

Put [...] your foreh[...] the other on [...] d just [...] the neck. [...] ove your [...] until your [...] just behind your ears. Somewhere between [...] hands, the brain is connected [...]

The surface of [...] tissue.

*Messages from all over the body come to the cells of the cerebellum, which [...] part of the brain. Together with the inner ear, the cerebellum helps us stay [...] muscles, keeping them ready to respond to nerv [...] impulses.*

**497**

*"Men," said he, steadily turning upon the crew, as the mate handed him the things he had demanded, "my men, the thunder turned old Ahab's needles…"*

**ACRYLIC PAINT, COLLAGE AND INK ON FOUND PAPER AND CHIPBOARD**
**8.25" × 12"**
**12/18/10**

## 498

*In his fiery eyes of scorn*
*and triumph, you then saw*
*Ahab in all his fatal pride.*

**ACRYLIC PAINT, CHARCOAL AND INK**
**ON FOUND PAPER**
**6″ × 9″**
**12/19/10**

## 499

*Snap! the overstrained*
*line sagged down in*
*one long festoon; the*
*tugging log was gone.*

**ACRYLIC PAINT ON FOUND PAPER**
**7.75″ × 10.75″**
**12/19/10**

## 500

*"Oh, ye frozen heavens!
look down here. Ye did beget
this luckless child, and have
abandoned him, ye creative
libertines. Here, boy; Ahab's
cabin shall be Pip's home
henceforth, while Ahab lives.
Thou touchest my inmost
centre, boy; thou art tied to me
by cords woven of my heart-
strings. Come, let's down."*

**INK ON WATERCOLOR PAPER**
**8" x 11.75"**
**12/19/10**

**501**

*"Come! I feel prouder leading thee by thy black hand, than though I grasped an Emperor's!"*

ACRYLIC PAINT AND INK ON
WATERCOLOR PAPER
8" × 12"
12/21/10

## 502

*At sun-rise this man went from his hammock to his mast-head at the fore; and whether it was that he was not yet half waked from his sleep (for sailors sometimes go aloft in a transition state), whether it was thus with the man, there is now no telling; but, be that as it may, he had not been long at his perch, when a cry was heard—a cry and a rushing— and looking up, they saw a falling phantom in the air...*

**ACRYLIC PAINT AND INK ON FOUND PAPER**
**7.25" × 12"**
**12/21/10**

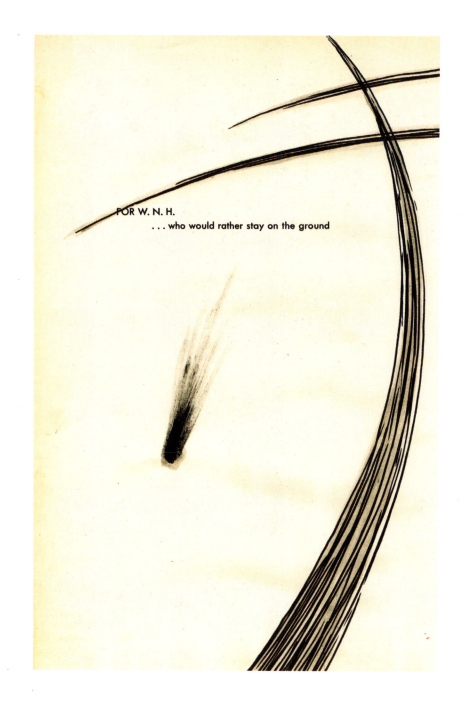

FOR W. N. H.

. . . who would rather stay on the ground

## 503

*"Away! what possesses thee to this? Make a life-buoy of the coffin, and no more."*

**INK, MARKER AND WATERCOLOR ON FOUND PAPER**
**7.75" × 10.75"**
**12/22/10**

## 504

*"I'll have me—let's see—how many in the ship's company, all told? But I've forgotten. Any way, I'll have me thirty separate, Turk's-headed life-lines, each three feet long hanging all round to the coffin. Then, if the hull go down, there'll be thirty lively fellows all fighting for one coffin, a sight not seen very often beneath the sun!"*

**ACRYLIC PAINT ON FOUND PAPER**
**7.5" × 9"**
**12/23/10**

**505**

*"Then tell me; art thou not an arrant, all-grasping, inter-meddling, monopolizing, heathenish old scamp, to be one day making legs, and the next day coffins to clap them in, and yet again life-buoys out of those same coffins? Thou art as unprincipled as the gods, and as much of a jack-of-all-trades."*

**ACRYLIC PAINT AND COLLAGE ON FOUND PAPER**
**8.25" x 11"**
**12/23/10**

**506**

*"Seems to me some sort of
Equator cuts yon old man,
too, right in his middle.
He's always under the
Line—fiery hot, I tell ye!"*

**ACRYLIC PAINT, BALLPOINT PEN,
CHARCOAL AND COLORED PENCIL ON
FOUND PAPER**
**15.5" × 10.75"**
**12/24/10**

# 507

*Next day, a large ship, the Rachel, was descried, bearing directly down upon the Pequod, all her spars thickly clustering with men.*

**BALLPOINT PEN ON FOUND PAPER**
10.75" × 7.75"
12/25/10

## 508

*...and while they were yet in
swift chase to windward, the
white hump and head of Moby
Dick had suddenly loomed
up out of the blue water,
not very far to leeward...*

**ACRYLIC PAINT, CHARCOAL AND INK
ON FOUND PAPER**
**10.75" × 15.5"**
**12/25/10**

## 509

*"My boy, my own boy is among them. For God's sake—I beg, I conjure"—here exclaimed the stranger Captain to Ahab, who thus far had but icily received his petition. "For eight-and-forty hours let me charter your ship—I will gladly pay for it, and roundly pay for it—if there be no other way—for eight-and-forty hours only—only that—you must, oh, you must, and you shall do this thing."*

**INK AND MARKER ON BRISTOL BOARD**
**7" × 8.5"**
**12/26/10**

## 510

*…then in a voice that prolongingly moulded every word—"Captain Gardiner, I will not do it. Even now I lose time. Good bye, good bye."*

**ACRYLIC PAINT, CHARCOAL AND INK
ON FOUND PAPER
10.75" × 15.5"
12/26/10**

**511**

"*They tell me, Sir, that Stubb did once desert poor little Pip, whose drowned bones now show white, for all the blackness of his living skin.*"

**INK AND MARKER ON FOUND PAPER**
**7.75" × 10.25"**
**12/27/10**

# 512

*Ahab,—all other whaling waters swept—seemed to have chased his foe into an ocean-fold, to slay him the more securely there…*

**INK ON WATERCOLOR PAPER**
**6.75" × 10"**
**12/27/10**

## 513

*As the unsetting polar star,
which through the livelong,
arctic, six months' night
sustains its piercing, steady,
central gaze; so Ahab's purpose
now fixedly gleamed down
upon the constant midnight
of the gloomy crew.*

**INK ON FOUND PAPER**
**8" x 11.5"**
**12/28/10**

**514**

*...Ahab seemed an independent lord; the Parsee but his slave. Still again both seemed yoked together...*

COLORED PENCIL AND INK ON
WATERCOLOR PAPER
8.25" × 12"
12/28/10

## 515

*...Ahab gazed abroad upon the sea for miles and miles,— ahead, astern, this side, and that,—within the wide expanded circle commanded at so great a height.*

**ACRYLIC PAINT, CHARCOAL AND INK ON FOUND PAPER**
**15.5" × 10.75"**
**12/29/10**

# 516

*...one of those red-billed savage sea-hawks which so often fly incommodiously close round the manned mast-heads of whalemen in these latitudes; one of these birds came wheeling and screaming round his head in a maze of untrackably swift circlings.*

**INK AND MARKER ON FOUND PAPER**
**8″ × 8″**
**12/29/10**

......SPEED OF LIGHT

THAT LIGHT TRAVELS IN ONE YEAR

4⅓ light-years

light to travel from Alpha Centauri to the earth.

**517**

*...and another ship, most miserably misnamed the Delight, was descried.*

ACRYLIC PAINT, BALLPOINT PEN AND
INK ON FOUND PAPER
10.75" × 7.75"
12/30/10

**518**

*Hither, and thither, on high,
glided the snow-white wings
of small, unspeckled birds;
these were the gentle thoughts
of the feminine air; but to and
fro in the deeps, far down in
the bottomless blue, rushed
mighty Leviathans, sword-fish,
and sharks; and these were the
strong, troubled, murderous
thinkings of the masculine sea.*

**INK ON WATERCOLOR PAPER
8.25" × 8.25"
12/30/10**

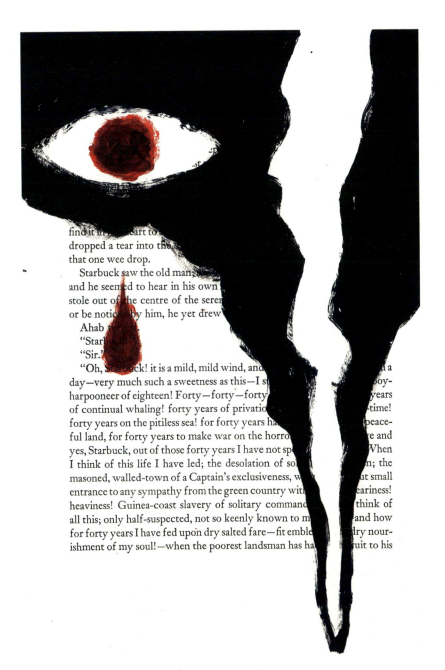

**519**

*From beneath his slouched hat Ahab dropped a tear into the sea; nor did all the Pacific contain such wealth as that one wee drop.*

ACRYLIC PAINT ON FOUND PAPER
6″ × 10″
12/31/10

# 520

*"…forty years on the pitiless sea! for forty years has Ahab forsaken the peaceful land, for forty years to make war on the horrors of the deep!"*

**ACRYLIC PAINT ON WATERCOLOR PAPER**
**8.25" × 12"**
**12/31/10**

**521**

*"Is Ahab, Ahab?"*

INK ON BRISTOL BOARD
7″ × 8.5″
12/31/10

522

*"Aye, toil we how we may, we
all sleep at last on the field."*

**ACRYLIC PAINT AND INK ON FOUND
PAPER**
**7.5" × 9"**
**12/31/10**

## 523

*"There she blows!—there she blows! A hump like a snow-hill! It is Moby Dick!"*

**ACRYLIC PAINT AND INK ON FOUND PAPER**
**15.5" × 10.75"**
**01/02/11**

**524**

*As they neared him, the
ocean grew still more smooth;
seemed drawing a carpet over
its waves; seemed a noon-
meadow, so serenely it spread.
At length the breathless hunter
came so nigh his seemingly
unsuspecting prey, that his
entire dazzling hump was
distinctly visible, sliding along
the sea as if an isolated thing...*

**ACRYLIC PAINT AND CHARCOAL ON
FOUND PAPER
15.5" × 10.75"
01/02/11**

## 525

*But soon the fore part of him
slowly rose from the water;
for an instant his whole
marbleized body formed a high
arch, like Virginia's Natural
Bridge, and warningly waving
his bannered flukes in the air,
the grand god revealed himself,
sounded, and went out of sight.*

**ACRYLIC PAINT AND INK ON FOUND
PAPER**
**10.75" x 15.5"**
**01/02/11**

# 526

*Through and through;*
*through every plank and*
*each rib, it thrilled for an*
*instant, the whale obliquely*
*lying on his back, in the*
*manner of a biting shark,*
*slowly and feelingly taking its*
*bows full within his mouth,*
*so that the long, narrow,*
*scrolled lower jaw curled*
*high up into the open air...*

**ACRYLIC PAINT ON FOUND PAPER**
**6″ × 9″**
**01/03/11**

*The Chase—First Day*

thee, no matter how many in that same way thou mayst have bejuggled and destroyed before.

And thus, through the serene tranquilities of the tropical sea, among waves whose hand-clappings were suspended by exceeding rapture, Moby Dick moved on, still withholding from sight the full terrors of his submerged trunk, entirely hiding the wrenched hideousness of his jaw. But soon the fore part of him slowly rose from the water; for an instant his whole marbleized body formed a high arch, like Virginia's Natural Bridge, and warningly waving his bannered flukes in the air, the grand god revealed himself, sounded and went out of sight. Hoveringly halting, and dipping on the wing, the white sea-fowls longingly lingered over the agitated pool that he left.

With oars apeak, and paddles down, the sheets of their sails adrift, the three boats now stilly floated, awaiting Moby Dick's reappearance.

"An hour," said Ahab, standing rooted in his boat's stern; and he gazed beyond the whale's place, towards the dim blue spaces and wide wooing vacancies to leeward. It was only an instant; for again his eyes seemed whirling round in his head as he swept the watery circle. The breeze now freshened; the sea began to swell.

"The birds!—the birds!" cried Tashtego.

In long Indian file, as when herons take wing, the white birds were now all flying towards Ahab's boat; and when within a few yards began fluttering over the water there, wheeling round and round, with joyous, expectant cries. Their vision was keener than man's; Ahab could discover no sign in the sea. But suddenly as he peered down and down into its depths, he profoundly saw a white living spot no bigger than a white weasel, with wonderful celerity uprising, and magnifying as it rose, till it turned, and then there were plainly revealed two long crooked rows of white, glistening teeth, floating up from the undiscoverable bottom. It was Moby Dick's open mouth and scrolled jaw; his vast, shadowed bulk still half blending with the blue of the sea. The glittering mouth yawned beneath the boat like an open-doored marble tomb; and giving one sidelong sweep with his steering oar, Ahab whirled the craft aside from this tremendous apparition. Then, calling upon Fedallah to change places with him, went forward to

**527**

*...then it was that monomaniac Ahab, furious with this tantalizing vicinity of his foe, which placed him all alive and helpless in the very jaws he hated; frenzied with all this, he seized the long bone with his naked hands, and wildly strove to wrench it from its gripe.*

CHARCOAL AND PENCIL ON FOUND PAPER
8.5" x 7"
01/04/11

## 528

*For so revolvingly appalling was the White Whale's aspect, and so planetarily swift the ever-contracting circles he made, that he seemed horizontally swooping upon them.*

**INK ON WATERCOLOR PAPER**
**8.25" x 12"**
**01/07/11**

**529**

*In an instant's compass, great hearts sometimes condense to one deep pang, the sum total of those shallow pains kindly diffused through feebler men's whole lives.*

**INK AND MARKER ON FOUND PAPER**
**10" × 6.25"**
**01/07/11**

**530**

*...thus to and fro pacing, beneath his slouched hat, at every turn he passed his own wrecked boat, which had been dropped upon the quarter-deck, and lay there reversed; broken bow to shattered stern. At last he paused before it; and as in an already over-clouded sky fresh troops of clouds will sometimes sail across, so over the old man's face there now stole some such added gloom as this.*

INK ON FOUND PAPER
6.25" × 10"
01/07/11

*The Chase—First Day*

The eternal sap runs up in ——es again! Set the sail; out oars; the helm!"

It is often the case that ——tove, its crew, being picked up by another boat, help to wor—— ——oat; and the chase is thus continued with what is cal—— ——t was thus now. But the added power of —— ——ower of the whale, for he seeme—— ——wimming with a velocity whi—— ——ircumstances, pushed on, th—— ——f not a hopeless one; nor c—— ——n unintermitted, intense s—— ——n some one brief vicissi- —— ——, offered the most prom- —— ——e. Accordingly, the boats —— ——heir cranes—the two parts —— ——secured by her—and then —— ——her canvas high up, and side- —— ——e the double-jointed wings of an —— ——e leeward wake of Moby Dick. At —— ——ethodic in—— the whale's glittering spout was regu- —— ——d from the mann—— ——ast-heads; and when he would be re- —— ——gone down, Ahab —— ld take the time, and then pacing the —— ——cle-watch in hand, so s—— as the last second of the allotted hour —— s voice was heard.—"W—— se is the doubloon now? D'ye see —— he reply was No, sir! s—— tway he commanded them to lift —— his way the day w—— —— hab, now aloft and motion- les—— —— he planks.

A—— —— no sou—— —— aloft, or to—— ——ve breadth—— —— the passed h—— —— deck, and—— paused befor—— clouds will so—— some such adde——

**531**

*"Men, this gold is mine,
for I earned it…"*

**COLORED PENCIL, INK AND MARKER
ON FOUND PAPER**
6" x 9.25"
01/08/11

# 532

*"Turn up all hands and
make sail! he travels faster
than I thought for…"*

**COLORED PENCIL ON FOUND PAPER**
**7.75" × 10.75"**
**01/08/11**

## 533

*"Aye, aye!" cried Stubb, "I knew it—ye can't escape— blow on and split your spout, O whale! the mad fiend himself is after ye! blow your trump—blister your lungs!— Ahab will dam off your blood, as a miller shuts his water- gate upon the stream!"*

**ACRYLIC PAINT ON FOUND PAPER**
**10" × 6.25"**
**01/10/11**

## 534

*...Moby Dick bodily burst into view! For not by any calm and indolent spoutings; not by the peaceable gush of that mystic fountain in his head, did the White Whale now reveal his vicinity; but by the far more wondrous phenomenon of breaching. Rising with his utmost velocity from the furthest depths, the Sperm Whale thus booms his entire bulk into the pure element of air, and piling up a mountain of dazzling foam, shows his place to the distance of seven miles and more. In those moments, the torn, enraged waves he shakes off, seem his mane; in some cases, this breaching is his act of defiance.*

**INK ON WATERCOLOR PAPER**
**8.25" x 12"**
**01/11/11**

## 535

*...the White Whale churning himself into furious speed, almost in an instant as it were, rushing among the boats with open jaws, and a lashing tail, offered appalling battle on every side; and heedless of the irons darted at him from every boat, seemed only intent on annihilating each separate plank of which those boats were made.*

**ACRYLIC PAINT AND INK ON FOUND PAPER**
**7.5" × 10.5"**
**01/11/11**

## 536

*That instant, the White Whale made a sudden rush among the remaining tangles of the other lines; by so doing, irresistibly dragged the more involved boats of Stubb and Flask towards his flukes; dashed them together like two rolling husks on a surf-beaten beach, and then, diving down into the sea, disappeared in a boiling maelstrom...*

**ACRYLIC PAINT ON FOUND PAPER**
**10.75" × 15.5"**
**01/13/11**

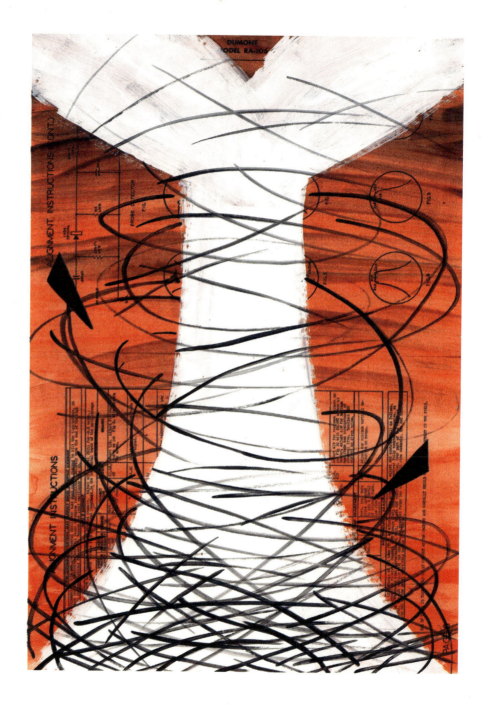

**537**

*But soon, as if satisfied that his work for that time was done, he pushed his pleated forehead through the ocean, and trailing after him the intertangled lines, continued his leeward way at a traveller's methodic pace.*

ACRYLIC PAINT ON FOUND PAPER
7.25" × 10.25"
01/13/11

**538**

*"Great God! but for one single instant show thyself," cried Starbuck; "never, never wilt thou capture him, old man—In Jesus' name no more of this, that's worse than devil's madness. Two days chased; twice stove to splinters; thy very leg once more snatched from under thee; thy evil shadow gone—all good angels mobbing thee with warnings;—what more wouldst thou have?—Shall we keep chasing this murderous fish till he swamps the last man? Shall we be dragged by him to the bottom of the sea? Shall we be towed by him to the infernal world? Oh, oh,—Impiety and blasphemy to hunt him more!"*

**ACRYLIC PAINT AND INK ON
WATERCOLOR PAPER
12" × 8.25"
01/15/11**

## 539

*Ahab is for ever Ahab, man.*

**INK ON BRISTOL BOARD**
**7″ × 8.5″**
**01/15/11**

## 540

*...while still as on the night before, slouched Ahab stood fixed within his scuttle; his hid, heliotrope glance anticipatingly gone backward on its dial; sat due eastward for the earliest sun.*

**INK AND MARKER ON WATERCOLOR PAPER**
**8" × 6"**
**01/24/11**

**541**

*"Aye, he's chasing me now;*
*not I, him—that's bad…"*

**ACRYLIC PAINT ON BRISTOL BOARD**
**7" x 7"**
**01/20/11**

**542**

*"What's this?—green? aye, tiny mosses in these warped cracks. No such green weather stains on Ahab's head! There's the difference now between man's old age and matter's. But aye, old mast, we both grow old together; sound in our hulls, though, are we not, my ship?"*

**INK, MARKER AND WATERCOLOR ON WATERCOLOR PAPER**
**8.25" x 12"**
**01/17/11**

**543**

*Their hands met; their eyes fastened; Starbuck's tears the glue.*

*"Oh, my captain, my captain!—noble heart—go not—go not!—see, it's a brave man that weeps; how great the agony of the persuasion then!"*

**ACRYLIC PAINT AND INK ON FOUND PAPER**
**6.25″ × 10″**
**01/17/11**

# 544

*"For when three days flow together in one continuous intense pursuit; be sure the first is the morning, the second the noon, and the third the evening and the end of that thing—be that end what it may."*

**ACRYLIC PAINT ON FOUND PAPER**
**14.5" × 10.75"**
**01/18/11**

## 545

*While Daggoo and Queequeg were stopping the strained planks; and as the whale swimming out from them, turned, and showed one entire flank as he shot by them again; at that moment a quick cry went up. Lashed round and round to the fish's back; pinioned in the turns upon turns in which, during the past night, the whale had reeled the involutions of the lines around him, the half torn body of the Parsee was seen; his sable raiment frayed to shreds; his distended eyes turned full upon old Ahab.*

**ACRYLIC PAINT ON FOUND PAPER**
**15.5" x 10.75"**
**01/19/11**

## 546

*...Moby Dick was now again steadily swimming forward...*

**ACRYLIC PAINT ON WATERCOLOR PAPER**
**12″ × 8.25″**
**01/20/11**

**547**

*At length as the craft was cast to one side, and ran ranging along with the White Whale's flank, he seemed strangely oblivious of its advance…*

ACRYLIC PAINT AND INK ON FOUND PAPER
10.75" × 15.5"
01/21/11

## 548

*Hearing the tremendous rush of the sea-crashing boat, the whale wheeled round to present his blank forehead at bay; but in that evolution, catching sight of the nearing black hull of the ship; seemingly seeing in it the source of all his persecutions; bethinking it—it may be—a larger and nobler foe; of a sudden, he bore down upon its advancing prow, smiting his jaws amid fiery showers of foam.*

INK ON WATERCOLOR PAPER
12" × 8.25"
01/22/11

**549**

*Retribution, swift vengeance, eternal malice were in his whole aspect, and spite of all that mortal man could do, the solid white buttress of his forehead smote the ship's starboard bow, till men and timbers reeled. Some fell flat upon their faces. Like dislodged trucks, the heads of the harpooneers aloft shook on their bull-like necks. Through the breach, they heard the waters pour, as mountain torrents down a flume.*

*"The ship! The hearse!—the second hearse!" cried Ahab from the boat; "its wood could only be American!"*

**ACRYLIC PAINT AND INK ON FOUND PAPER**
**15.5″ × 10.75″**
**01/23/11**

## 550

*"Towards thee I roll, thou all-destroying but unconquering whale; to the last I grapple with thee; from hell's heart I stab at thee; for hate's sake I spit my last breath at thee. Sink all coffins and all hearses to one common pool! and since neither can be mine, let me then tow to pieces, while still chasing thee, though tied to thee, thou damned whale! Thus, I give up the spear!"*

**INK AND MARKER ON WATERCOLOR PAPER**
**8.25" x 12"**
**01/23/11**

## 551

*...then all collapsed, and
the great shroud of the sea
rolled on as it rolled five
thousand years ago.*

**INK ON WATERCOLOR PAPER**
**12" × 8.25"**
**01/24/11**

## 552

*On the second day, a sail
drew near, nearer, and
picked me up at last. It was
the devious-cruising Rachel,
that in her retracing search
after her missing children,
only found another orphan.*

**COLORED PENCIL AND INK ON FOUND
PAPER**
**8.5" × 11"**
**01/29/11**

## ACKNOWLEDGMENTS

A project of this scope simply would not have been possible without the friendship, support, and encouragement of the following people:

My wife, Ione, who did absolutely everything but draw for eighteen straight months while I did nothing but draw. Lee Montgomery, Janet Parker, Meg Storey, Diane Chonette, and everyone else at Tin House Books, for taking on this monster and turning it into a real and beautiful book. My agent, Seth Fishman, who worked tirelessly and sometimes thanklessly for this and who believed in me every step of the way. The artist Sophie Blackall, for a simple e-mail that changed everything. Brian Stevens, who has supported my art from the very beginning, when it was just xeroxed and stapled and sold for a dollar. Scott Baxter, whose long-distance friendship throughout this project made the dark times seem a lot lighter. My friends in the PANEL Collective, especially Tom Williams (the art Jesus!), Dara Naraghi, Andy Bennett, Sean McGurr, Craig Bogart, Brent Bowman, and Ross Hardy. Shawn Cheng, the best artist I have ever known, for advice and friendship above and beyond. Zak Smith, for blazing a trail in so many ways. Joe Kuth, the first person to ever publish my art in a real book. Jeffrey Meyer, for having an uncompromising vision of art while still maintaining a sympathetic ear when I was treading water. Gib Bickel and Daryn Guarino, for a solid foundation. Sean McKeever and Jeff Stang, for

two-a-days. Aaron Cael, who painted the best portrait of me I have ever seen. Daryl L. L. Houston, who liked my art enough to make it a permanent part of him. The poet Hannah Stephenson, for turning my art into verse. The poet JoAnne McKay, for bringing my art to the United Kingdom. Aaron Martin Fitzwater, a brother from another mother and a constant companion in art. Kyle Wallace and Rebecca Caglianone, who were with me when it all started. Angela Kroner, whom I miss every day. My far-flung family, especially Aunt Kris and Aunt Sandy, whose love has never flagged. Meg Guroff, the first person to find out about this project and the first to give me a voice outside my blog. Leighton, Alice, and Abby, my friends in Kirby. Will Hansen, for a perspective I badly needed and advice I couldn't have done without. Tobin Becker, an old friend from my undergrad years, whose offhand comment on Facebook sparked this endeavor. Professor Elizabeth Renker at the Ohio State University and Professor George Cotkin at the California Polytechnic State University, for seeing the value of all this and helping me make it to the end. And, finally, everyone who visited the blog, left a comment, or sent me an e-mail. This was a long, long journey and I could never have reached the end without you.

Matt Kish was born in 1969 and lives in the middle of Ohio. After stints as a cafeteria cook, a hospital registrar, a bookstore manager, and an English teacher, he ended up as a librarian. He draws as often as he can, often with whatever he can find. He has tried his hand at 35mm black-and-white photography (with real film and real chemicals), making comics and zines, a bit of collage, and lots of pen and ink. *Moby-Dick* is his favorite novel.